Ken Marschall's Art of Titanic

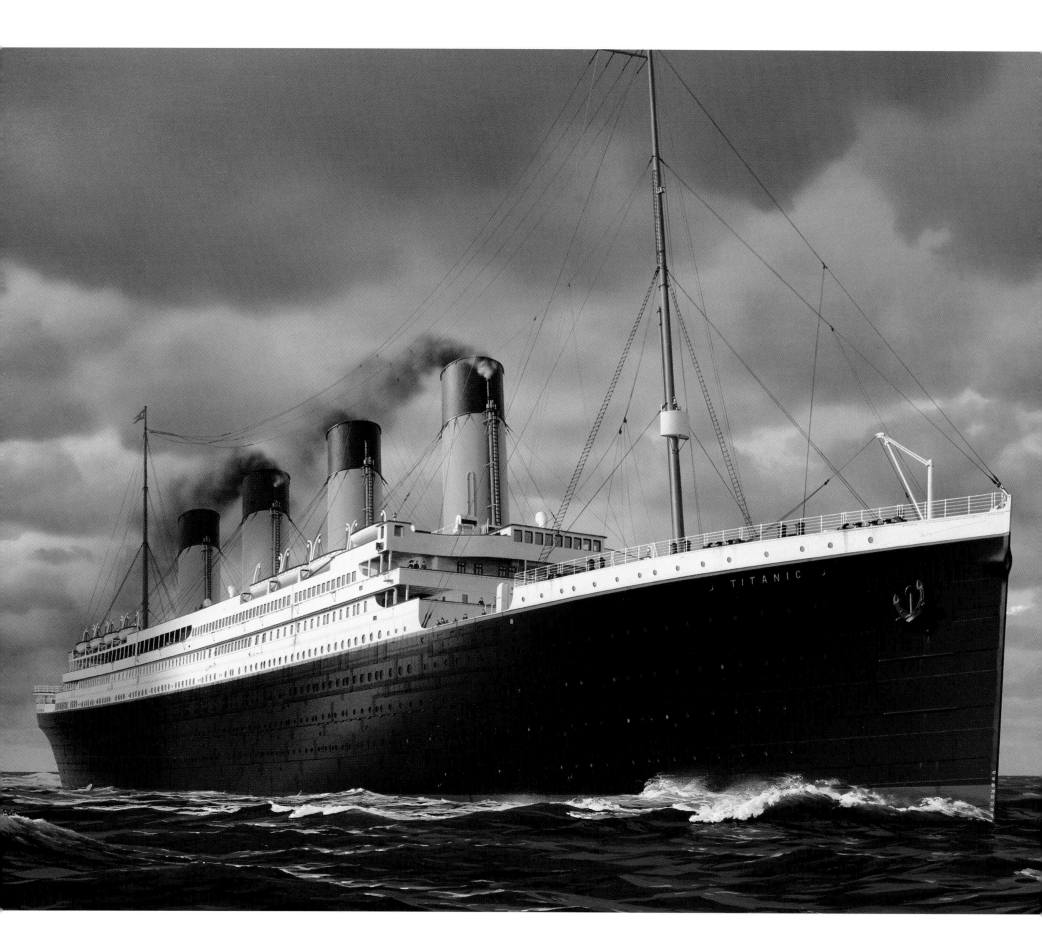

Ken Marschall's Art of

Titanic

Foreword by James Cameron

Text by Rick Archbold

A HYPERION/MADISON PRESS BOOK

First published in the United States in 1998 by
Hyperion
114 Fifth Avenue
New York, N.Y. 10011

ISBN 0-7868-6455-9

Produced by
Madison Press Books
40 Madison Avenue
Toronto, Ontario, Canada
M5R 2S1

Printed and bound in Canada
10 9 8 7 6 5 4 3 2 1

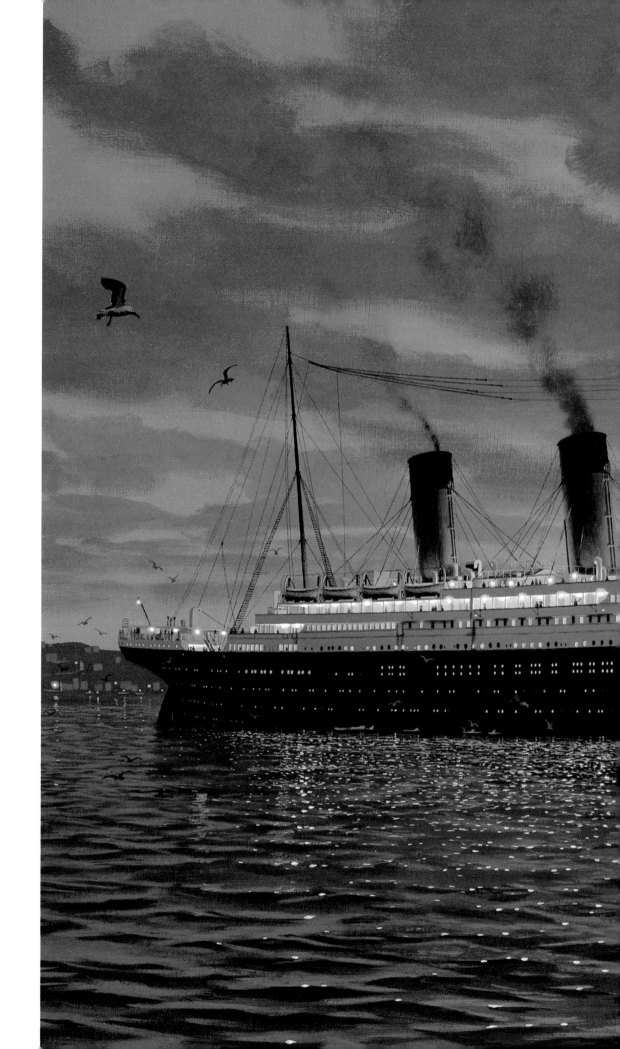

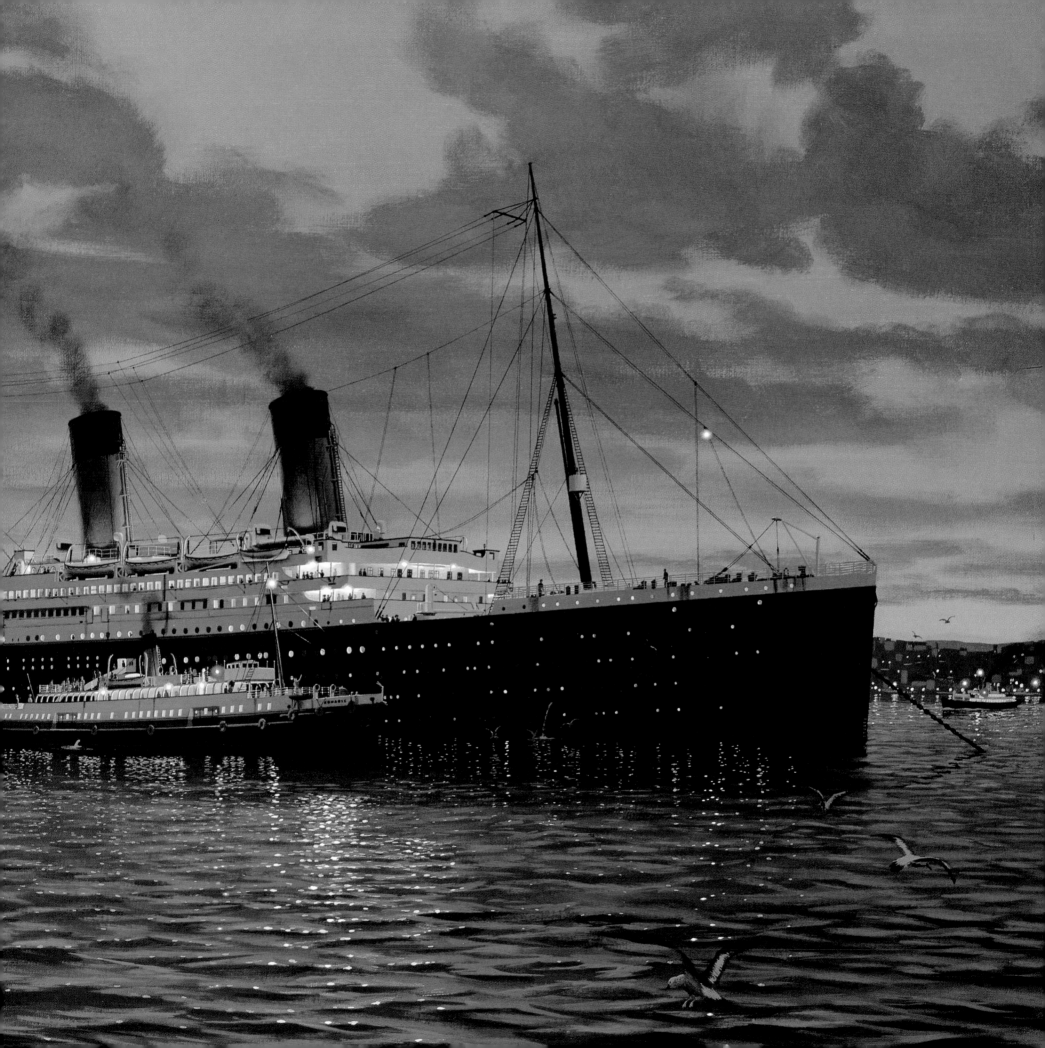

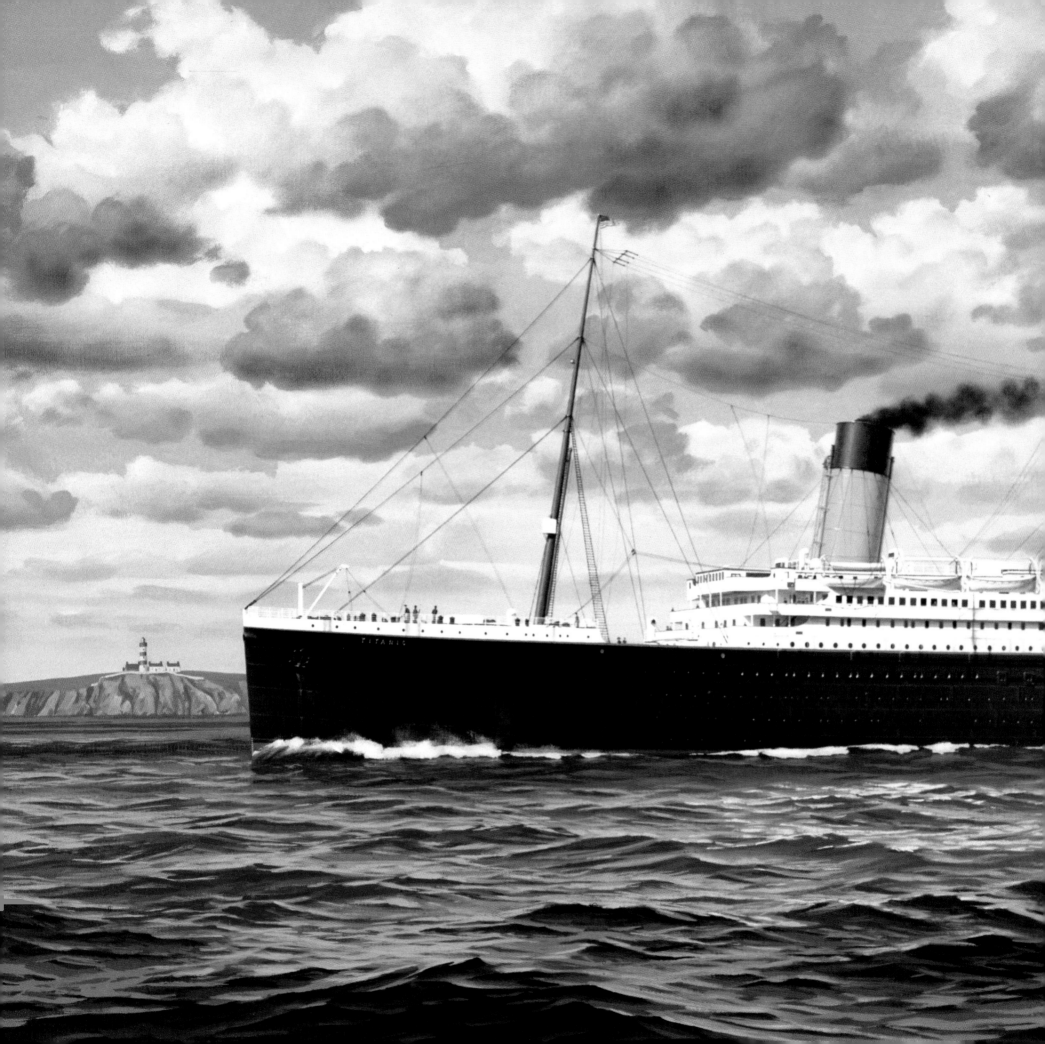

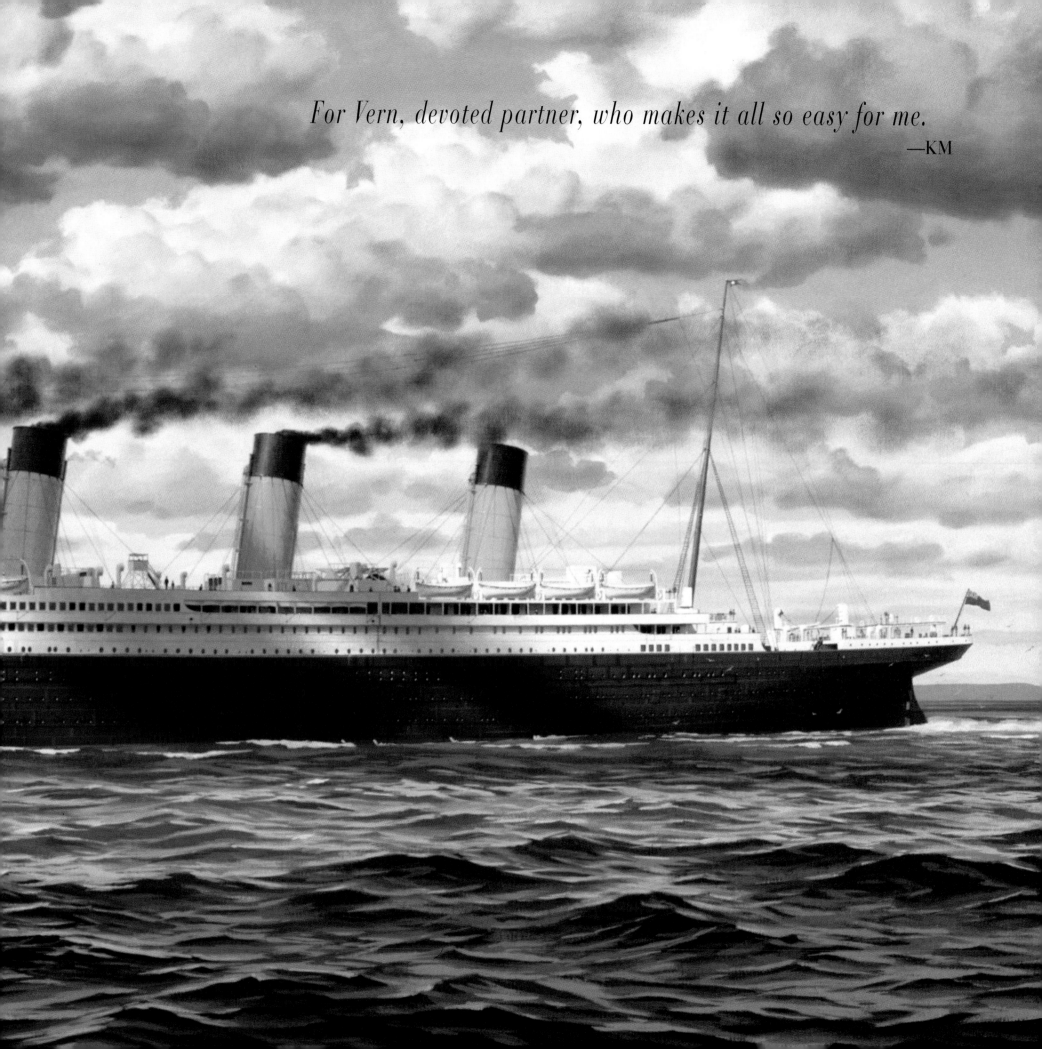

For Vern, devoted partner, who makes it all so easy for me.
—KM

"*Given the world today, one might suppose that people would no longer be gripped by the Titanic. Not so. She has never been more with us than now.*"

Walter Lord,
The Night Lives On

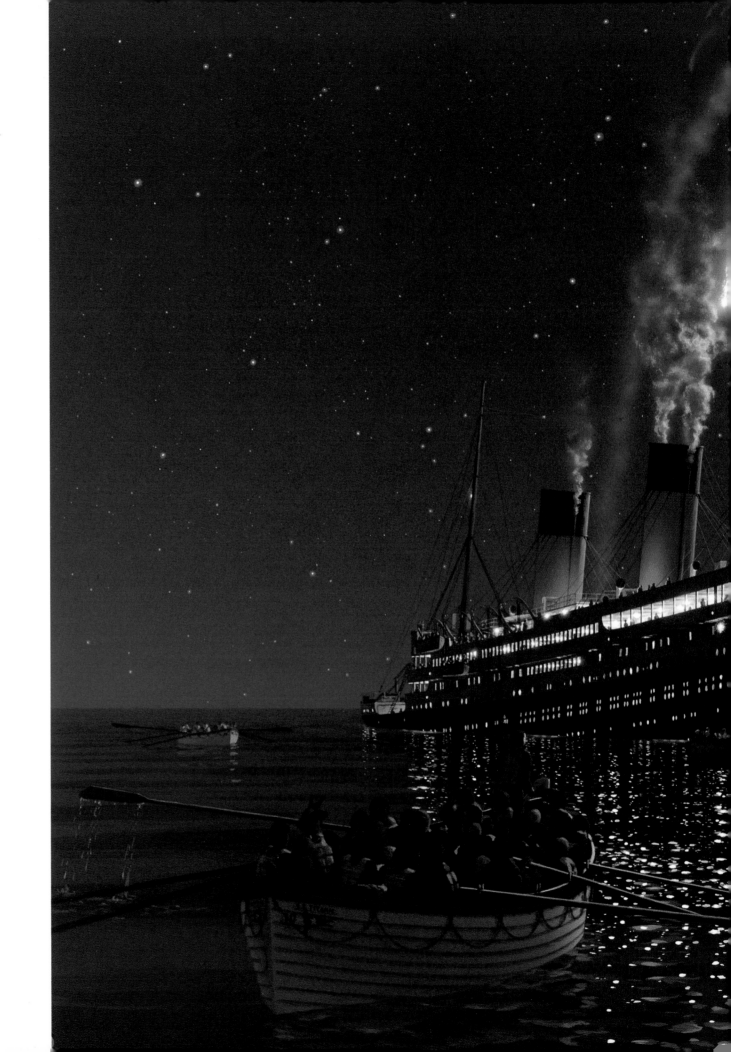

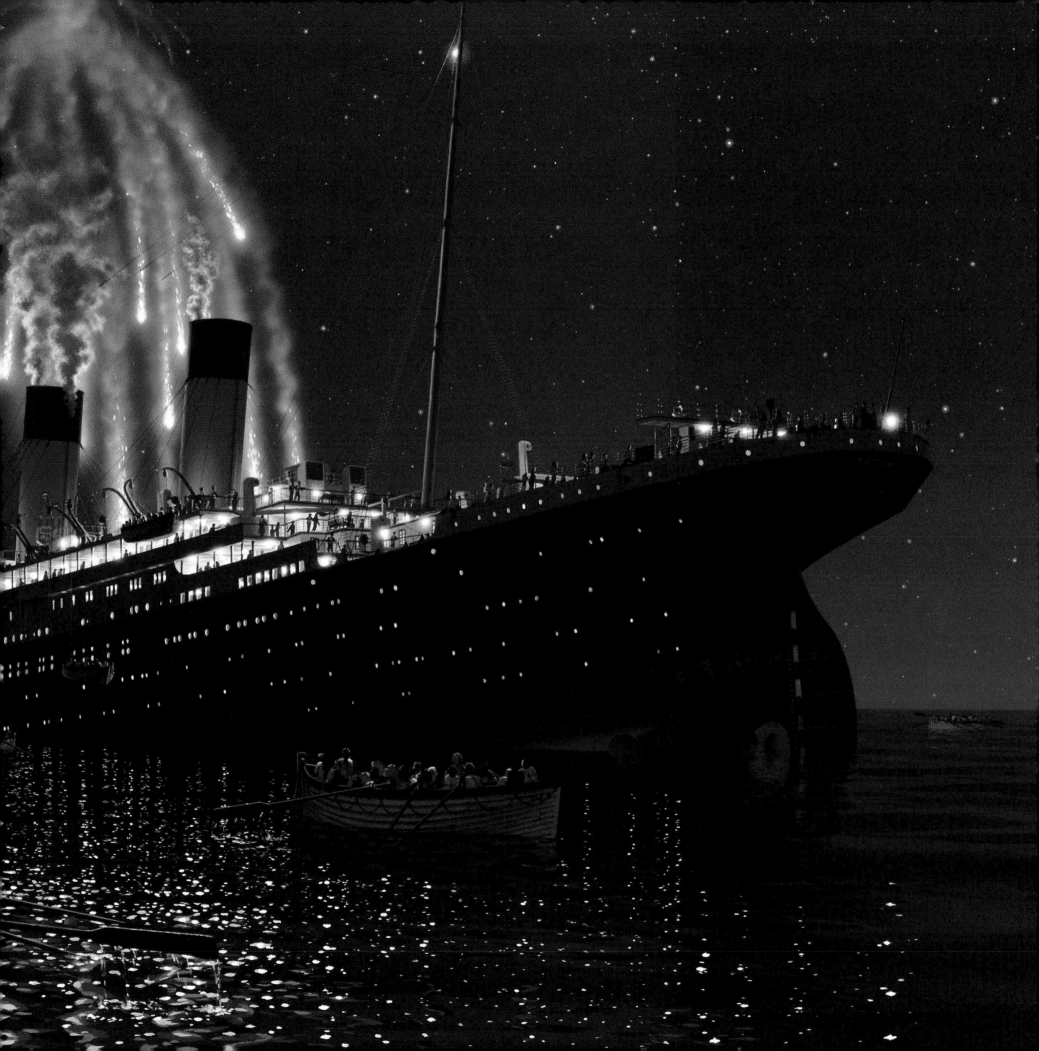

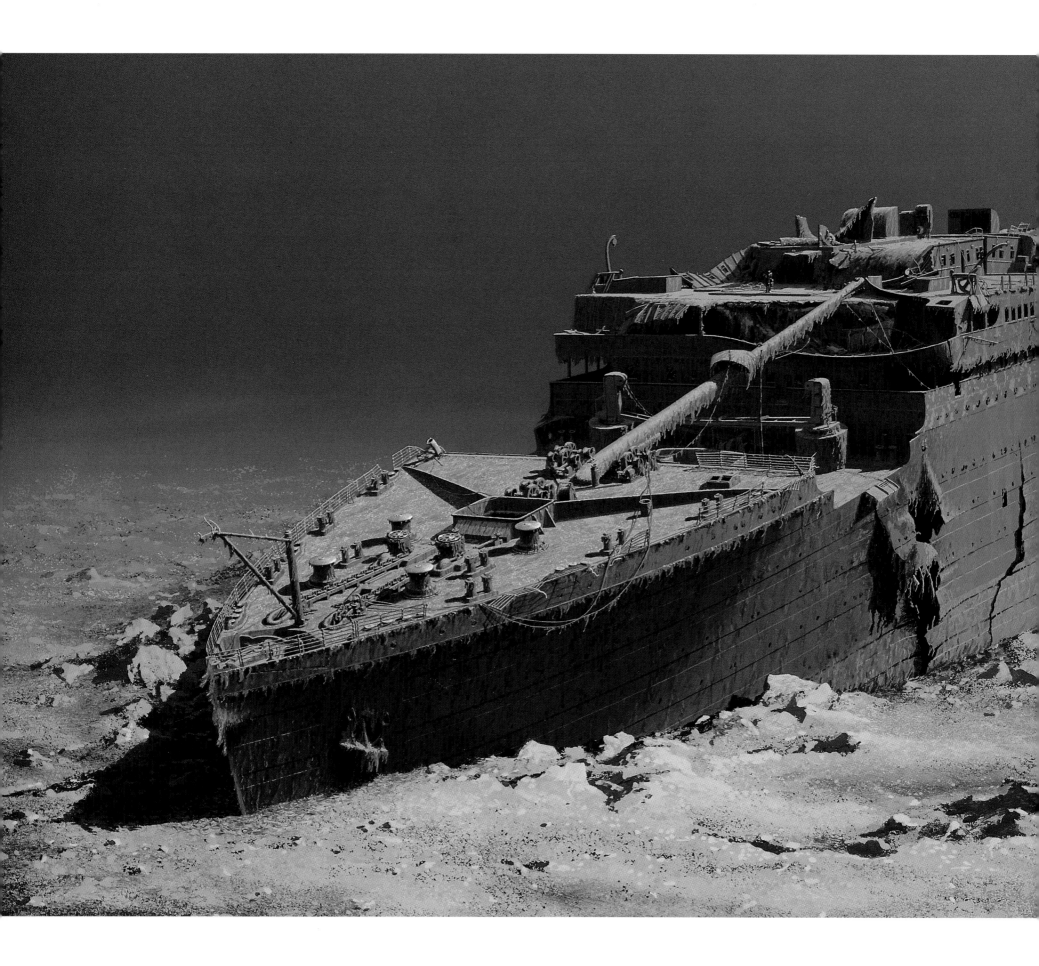

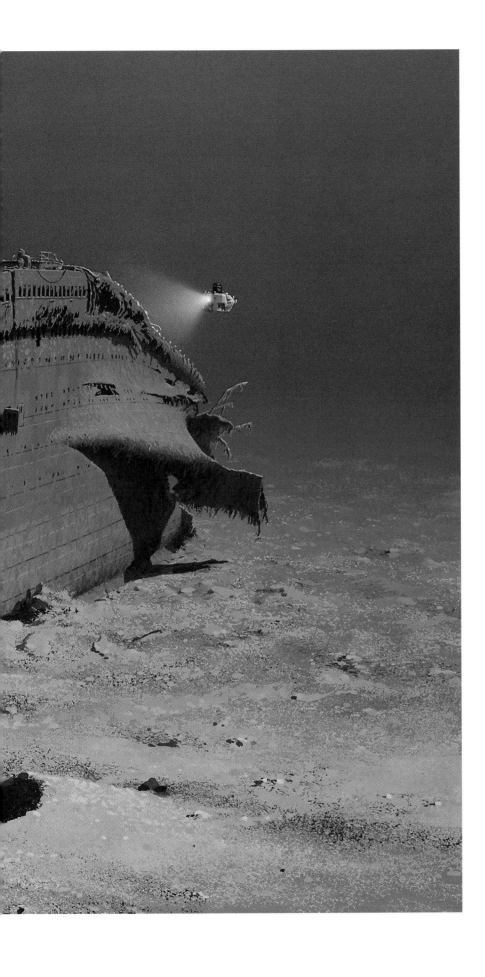

Contents

Raising Titanic

Foreword by James Cameron

I can still picture Ken Marschall standing on the set of *Titanic*. He's dressed in late-twentieth-century garb, but otherwise the scene is pure 1912. Ladies in elegant attire walk arm in arm, enjoying the fresh sea breeze and commenting on how calm the sea has been during the April maiden voyage. Nattily outfitted gents, puffing cigars and talking business, lean over the rail. A child plays with a top while his parents smile from their deck chairs. Ken Marschall is where he belongs, on board the ship he loves and understands better than almost anyone else.

I can't claim to have Ken's encyclopedic knowledge of the *Titanic*, but by now my passion for the ship and her story must be equal to his. My own interest in the liner began with the discovery of the wreck by Robert Ballard in 1985. This, and his subsequent exploration of the wreck, brought the story into the present. And it occurred to me that there had never been a film that integrated what we've learned about the *Titanic* since its discovery with what we know of the events of April 1912.

As I began thinking seriously about making the film *Titanic*, I read everything I could get my hands on concerning the subject. One book that had enormous impact was *Titanic: An Illustrated History* by Don Lynch, with paintings by Ken Marschall. When I turned the book's pages, I couldn't get over how detailed the paintings were. Yet they

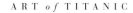

◆

(Right) James Cameron's haunting first view of the wreck, from his 1997 movie *Titanic*.

emanated personality, and Ken had somehow captured the mythic essence of the ship. He had lit and rendered each scene with a filmmaker's eye. He had composed each frame with a sense of drama and focus. In an eerie way, his paintings almost seemed to be stills from a movie that hadn't yet been made. And I thought to myself, the technology of movie making has come so far that I can make these paintings live. It became my goal to accomplish on film what Ken had done on canvas, to will the *Titanic* back to life.

It wasn't until my second dive down to the wreck in the summer of 1995 that the full impact of what I was attempting hit home. On my first dive, I'd spent twelve hours in the Russian submersible *Mir I* in a trancelike focus, my total being concentrated on filming the wreck. The second time down, it suddenly hit me. I was on the deck of the *Titanic*. Over eight decades dissolved in an instant. I was walking on the deck with those soon-to-be famous—or infamous—passengers: J. Bruce Ismay, who saved himself instead of staying with the vessel that had been his brainchild; Captain Edward J. Smith, who had never faced a real crisis in his twenty-five-year career; and Thomas Andrews, who'd supervised the ship's design and construction—for me one of the real heros that night for the way he helped direct the evacuation, then went down with the ship he loved.

Back on board the surface ship after that dive, I wept for the fifteen hundred souls who perished when the great liner sank. I knew the *Titanic*'s story so intimately from all the research I'd done, but having "stood" on the real deck, I realized that my project, my film, was doomed to failure unless it could convey the emotion of the night as well as the fact of it. That experience led me to create the characters of Jack and Rose, the fictional couple whose love story is meant to humanize the tragedy, to draw you in and allow you to visit the most interesting parts of the ship. If I succeeded, the movie would come full circle: from being a film about the *Titanic*, to being a love story that merely happens to be set on the ship, back to being about the truth of the *Titanic* after all.

Ken Marschall has also wept for the *Titanic*. And when I invited him to work on our film project, I quickly learned that his feelings for the ship went far beyond the fascination of a buff or the acquisitiveness of a collector. Like me, he wanted to bring her back to life.

Ken's first contribution came when I was revising the shooting script. He and

historian Don Lynch spent several long days at my Malibu house going over what I'd written, line by line. I quickly discovered that in these two experts I'd met my match in terms of devotion to accuracy. They questioned everything. And their knowledge of the ship and the people who sailed on her was simply amazing. They helped me achieve what became a sacred goal of our production: to honor the facts without compromise. I wanted to be able to say to an audience without the slightest twinge of conscience, "If you boarded a time machine that landed on the *Titanic*'s deck, this is what you would have seen."

**James Cameron examining one of
Ken Marschall's paintings.**

✦

As our team's visual historian, Ken kept the sets and models as accurate as we could make them. His remarkable pictorial archive, including all his paintings, became our image bank. His broad collection of *Titanic*-related artifacts became our reference library. Ken was too busy with other projects to continue his formal role during the actual filming, but he often visited the Baja California set. And every time he did, he'd find inaccuracies we tried to fix. If you think I'm a perfectionist when it comes to the ship, you haven't met Ken Marschall. If he'd been *Titanic*'s director, the movie might have taken twice as long to make!

Leafing through the pages of this marvelous book, *Ken Marschall's Art of Titanic*, I find myself reliving the magnificent story of the ship, from the birth of a great idea, through its building and launching and its tragic maiden voyage, to its dramatic discovery.

Ken and I are both devoted to the same thing: We want to raise the *Titanic*, not from her deep-ocean grave, but in spirit. Ken's paintings helped me do this in *Titanic*. He helped me bring back the past and make it live in the present—in both its heart and its soul. All honor to him.

James Cameron
Santa Monica, California
July 1998

Finishing
the
Voyage

Ken Marschall's
Titanic *Art*

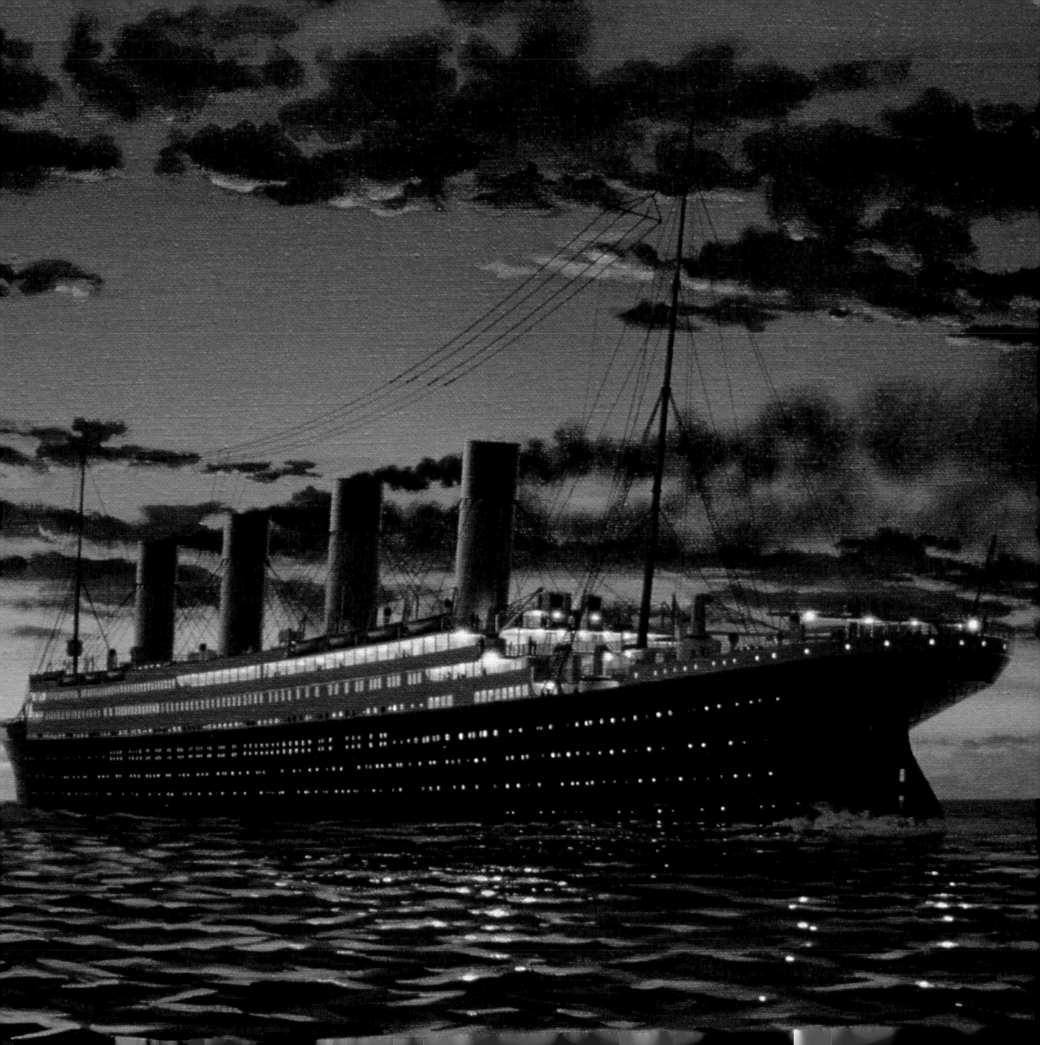

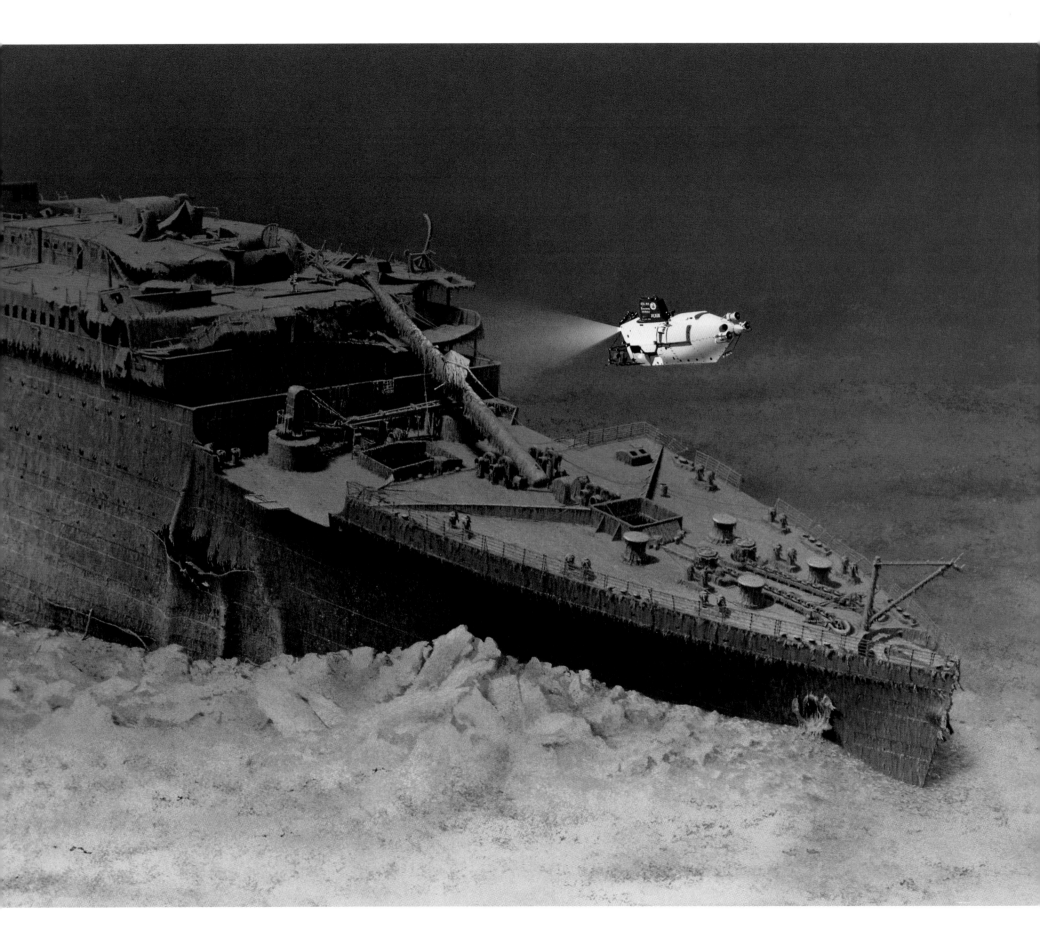

Ken Marschall's Titanic *Art*

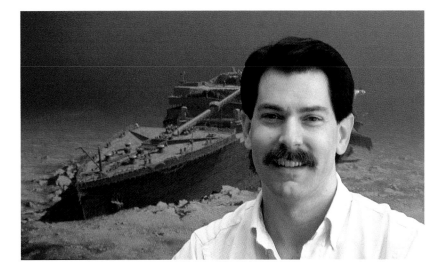

It is September 1, 1985, and Ken Marschall is close to tears. He has just learned that Robert Ballard has discovered the wreck of R.M.S. *Titanic*. Ken knows the tears could seem silly. He's a grown man, after all—thirty-four, almost thirty-five, years old—but he can't help himself. He's simply spent too much of his life thinking about the *Titanic*, learning about the ship, and, most of all, painting every step in her short and tragic career, recreating her as she must have been: the one liner that is unsinkable in memory, if not in fact.

More than ten years later, recognizing how pivotal the wreck's discovery was for him, Ken has gained some distance from the emotion of that moment, but he doesn't apologize for it: "When you're so passionate about a subject, it makes sense. Even the day the wreck was discovered, I felt this incredible shifting taking place. A whole new chapter was opening up. Until then, the *Titanic* had existed only in my imagination, as a kind of fantasy. Now it had come back to life."

Ken remained glued to his TV for the next few days as details of the discovery trickled out. He had always maintained that the wreck would be intact; it simply wasn't possible for him to imagine it any other way. He had even painted the wreck as he thought it might look, sitting whole and upright, with one funnel still standing, almost as if ready to set sail again.

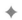

(Above) The artist and one of his paintings of R.M.S. *Titanic*.

(Opposite) In 1986, the submersible *Alvin* takes a close-up look at the wreck.

Ballard's initial reports from the expedition were confusing and disturbing. He claimed that the ship was in "museum condition," yet the discovery that had led him to the wreck was a boiler from deep inside the ship, lying at a distance from the rest of the vessel. Did this mean, as some had theorized, that the massive boilers had ripped loose from their mounts when the ship's stern pointed skyward, then crashed through a succession of bulkheads to finally blast through the bow? Ken had always argued against such an unlikely event. But what other explanation could there be?

Then Ballard reported that he was having trouble finding the stern. The Woods Hole oceanographer's initial expedition was relying on his soon-to-be-famous "dope on a rope," a deep-towed camera sled that could glimpse only a tiny portion of the wreck at any time and that was prey to every vagary of underwater current and surface weather. It was this camera, which took videotape pictures of the ocean bottom and sent them back to the surface along a two-and-a-half-mile-long fiberoptic cable, that had actually "discovered" the ship. In these early days, Ballard's vision of the wreck was sketchy at best. Even after his exploration of the wreck site by manned submersible a year later, many gaps would remain in the underwater picture.

By September 3, 1985, however, it was beginning to look painfully certain that the *Titanic* had broken in two. Suddenly, accounts by the numerous survivors who'd reported watching the ship's hull tear apart just before she sank, but whose testimony had been largely ignored at the inquiries into the disaster, became credible. "It was shocking at first and disturbing," Ken remembers.

Ken Marschall painted his first picture of the *Titanic* in 1967 and entered it in his high school art show in Pasadena, California. The painting is an accomplished work for a sixteen-year-old, but it was rejected by the judges as being too realistic and therefore not "art." Instead of letting this response discourage him, it made him more determined. He would paint things as he saw them, not as others wanted them to look.

Soon he received an endorsement that really meant something, an actual commission to paint the *Titanic*. This was quite a revelation: an activity he pursued for fun could be worth something to someone else. The gentleman who commissioned the painting had seen Ken's first effort and recognized the teenager's potential.

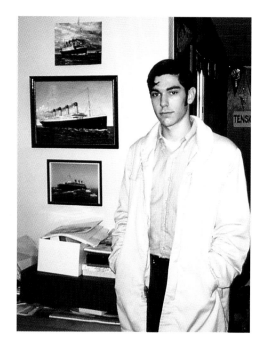

Seventeen-year-old Ken Marschall in his room. On the wall behind him hang (from top to bottom) the maquette, or preliminary study, for his first *Titanic* commission, his first painting of the *Titanic*, and a photograph of the *Queen Mary* Marschall took as she steamed into Long Beach on December 9, 1967. Ken and his friend Chris Bragdon made a special trip to watch the famous liner come in.

✦

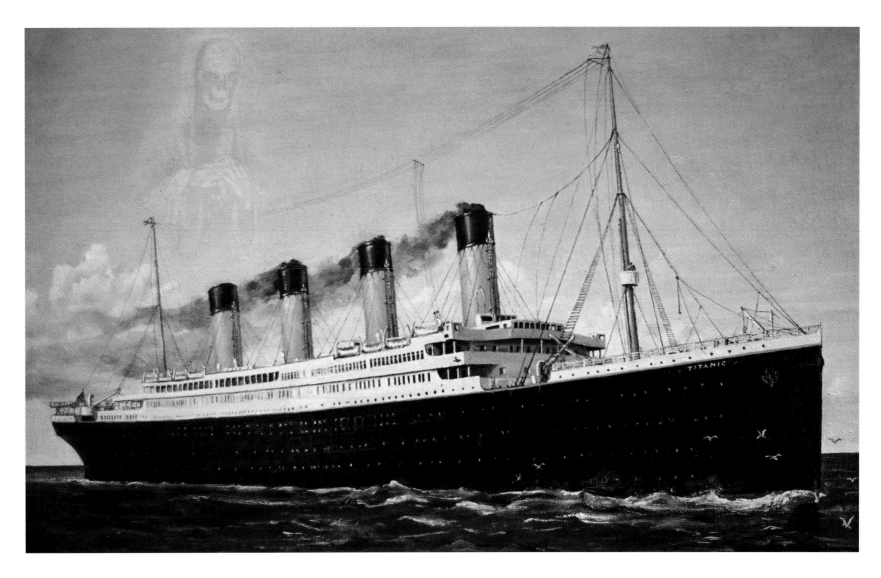

(Above) Ken Marschall's first *Titanic* painting, 1967. Ken came up with the idea of the cloud (upper left) that on close examination becomes the Grim Reaper. Rick Parks, who was better at painting figures, executed this ominous portrait. (Below) Three stages of Marschall's second *Titanic* painting and his first commission—a layout on tracing paper, the painting in progress, and the final product. The young artist used the blowing smoke and wind-whipped spray to suggest a strong crosswind. For many years, he says, this remained his favorite *Titanic* portrait.

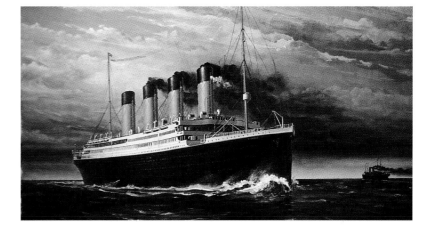

Thus, by his senior year of high school, Ken Marschall had brought together the two childhood passions that would form the bedrock of his later life: painting and the *Titanic*. In those early days, however, not even Ken imagined these interests would lead him anywhere. How could painting ever become a real job? And the *Titanic*, well, that was just a hobby.

From the time Ken could hold a crayon, he drew: on walls, on bedsheets, on paper, and, on one notable occasion, on his parents' brand-new carpet. This was just after the Marschall family had moved into a spacious house in the hills above Whittier, California, one of Los Angeles' many suburban satellites. Ken was three, soon to turn four.

It was the heyday of Jell-O dessert. Little Ken decided, however, that Jell-O was not reaching its artistic potential by serving as a mere meal finisher. The way his mother remembers it, he found all of her packages of gelatin powder—each flavor a different color—then artfully poured them over the pale gray carpet in the den. Ken was busily sprinkling water over his masterpiece—he wanted to bring out the brilliance of the colors and make the "painting" set—when his mother walked in. The carpet had to be replaced.

Neither of them remembers whether Ken was punished for this precocious act of artistic rebellion, but his parents had already become accustomed to his creative adventures. Most of the time, his love of drawing made him an easy child to raise. Unlike many boys, including Ken's rambunctious brother, Bruce, fourteen months his junior, Ken could be left alone to quietly

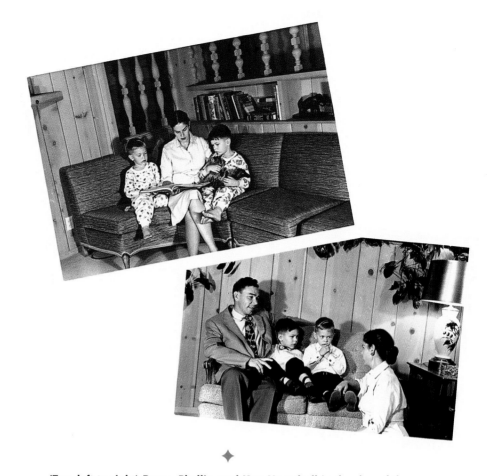

◆

(Top, left to right) Bruce, Phyllis, and Ken Marschall in the den of the family home near Whittier, California. (Above) The entire Marschall family circa late 1954. (Inset left) When Marschall was about thirty he drew this sketch of his younger self from one of his mother's snapshots.
(Below) The upper sketch, done at about the age of ten, confirms that ships were favored subjects at an early age. In the lower sketch, drawn as Ken was beginning to learn about the *Titanic*, he shows the hole made by the iceberg on the wrong side of the ship!

amuse himself for hours. He received his first set of oil paints when he was in fourth grade. He also tried out several bags of modeling clay. Both these media are not usually attempted until a later age. Sculpting wasn't for him, but the oil paints soon needed replacing with more extensive and expensive sets.

Ken's early subjects ran heavily toward things that moved: trains, spaceships, airplanes, cars—and ocean liners. When his parents separated the year Ken turned seven, he worked out his feelings in art, drawing pictures of planes crashing, trains colliding, and ships sinking.

This was also the year Ken met Rick Parks, another talented artist in the making. The two were encouraged by their second-grade teacher, Mrs. Palmer, who seems to have fostered a warm, mutually nurturing rivalry that lasted until Rick's death from leukemia in 1996 at the tragically young age of forty-six. As youngsters, the two were inseparable. Their talents and personalities complemented each other perfectly: Rick was good at drawing people and action scenes; Ken preferred places and things. Rick was outgoing and funloving; Ken was shy and serious. Even after their lives took them in different directions and to different states, they kept in touch. Occasionally, they even managed to work on a commission together.

When Rick died, Ken was devastated. He says it was only then that he realized how everything he had painted since Mrs. Palmer's class had been created with the unspoken goal of gaining Rick's approval. His thoughtful criticism was always on the mark and wonderfully generous. "Rick and I would constantly challenge each other in a friendly competitive way," he says now. "I'd learn from him and he'd learn from me. He was so expressive and giving in his praise." When Rick died, Ken went through months of thinking there was no point in painting anymore.

Rick shared many of Ken's other boyhood enthusiasms: architecture, astronomy, photography, science fiction, movie special effects, archeology, and transportation in almost any form, from submarines to spacecraft. So did Chris Bragdon, a friend Ken made soon after his mother moved the family

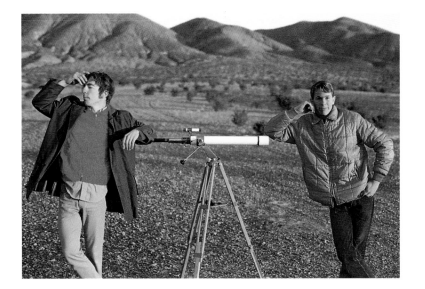

Marschall's two closest boyhood friends, Chris Bragdon (left) and Rick Parks, pose in one of their favorite desert spots for star gazing with a telescope borrowed from Ken's father.

◆

to Pasadena in 1960. Ken, Chris, and Rick occupied themselves with elaborate artistic and scientific projects. All three were fascinated by astronomy, so they decided to build their own star-tracking photography rig. Chris, who was the most technically minded, figured out how to design the tracking device after a visit to the observatory at Mount Wilson. He borrowed a spare twenty-four-hour timer from the pool-cleaning motor in the family pool, added a pivot arm suitable for mounting a small telescope and camera, then powered the whole thing with a car battery. Amazingly, the contraption worked.

Almost once a month, for about three years, Ken, Chris, and Rick would drive out to a favorite spot in the desert far

from city lights and set the tracking telescope so that it moved with the stars, allowing for time-exposed photos to be taken. One of their proudest accomplishments was a beautifully clear shot of the comet Kohoutek, published in the Pasadena *Star News*. At night they would lie in their sleeping bags, gazing up at the Milky Way, imagining what it would be like to travel to a distant galaxy.

When Ken and Chris decided to build a model of the *Titanic*, the idea was as much Chris's as Ken's. But it was Ken who had first caught the *Titanic* bug.

One day when Ken was about fourteen, he and his brother Bruce were spending the weekend at their father's home in Whittier, only a forty-five-minute drive from Pasadena. As they often did, Ken and Bruce had parked themselves on the couch in the den to watch a Saturday TV matinée. Ken was already something of a movie aficionado; when he sat down, he seldom budged until the film was over. But the movie on this particular day caught his attention in a way few others had. It starred Barbara Stanwyck as Julia Sturges, an Edwardian society lady, traveling home to America on the *Titanic* with her two children.

Mrs. Sturges had just left her husband, a European socialite played by the debonair Clifton Webb, and was taking the children home to America. Just before the ship sails from Cherbourg, Richard Sturges boards. As the *Titanic* steams toward disaster, the estranged parents battle for the hearts and minds of their two children.

This Twentieth-Century Fox version of the sinking of

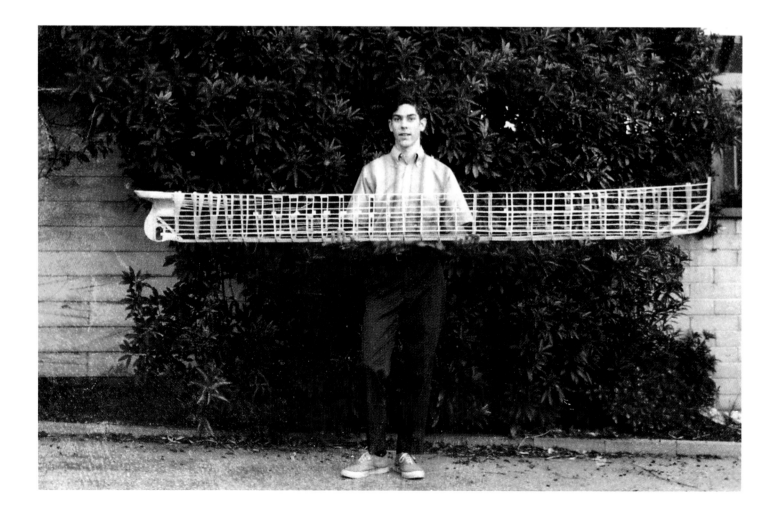

Marschall holds the unfinished balsa-wood model of the *Titanic* that he worked on with Chris Bragdon. The scale was 1:100, making the model 8.82 feet long.

✦

the *Titanic* had been around since 1953, but Ken had never seen it before. He was fascinated. "I remember thinking, 'What an amazing story; it must be fiction.' It just seemed too fantastic—the largest ship in the world, its maiden voyage, all those wealthy people on board, and every one of them believing the *Titanic* was unsinkable." To his teenaged eyes, the special effects were astounding, but one can't help but wonder whether his first interest in the ship was triggered by the connection he felt to the predicament of the Sturges family.

Whatever the reason, a seed was planted, but it did not take root until Ken took his first extended ocean voyage. Not long before he and his wife separated, Ken's dad had bought the first in what was to be a series of cabin cruisers. When Ken and his brother visited, they would often make the two-and-a-half-to-three-hour trip to Catalina Island, spending a night or two in the harbor of Avalon or at the isthmus. Ken instantly took to being on the water. In his strongest memory of these days, he is perched on the bow, holding onto the handrail, his bare feet dangling over the sides, lost in the rise and fall of the swells. He would sit there, entranced, for the whole trip: "Every now and then dolphins would race along with us. Otherwise, it was just the wind in my face and looking at the waves and feeling the surge and fall of the boat. It felt like I was flying."

In the summer of 1965, Ken's experience of ocean travel expanded considerably. His father booked passage for his second wife, her two daughters, and his two sons from Los Angeles to Southampton, England, aboard MV *Fairsea* of the Sitmar Line. The *Fairsea* was a smallish passenger ship, just under five hundred feet in length. The long trip to England, by way of the Panama Canal with stops in Curaçao and Lisbon, grew longer when the ship developed engine trouble. By the time the ship's engineer had fixed the problem, they were well behind schedule. The voyage ultimately lasted twenty-eight days. Ken delighted in every minute of it.

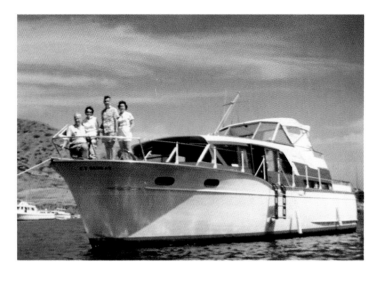

♦

(Above) Ken's father, Charles Marschall (second from right), his second wife, Helen, and two friends stand on the bow of his Chris-Craft Conqueror in Cat Harbor at the Catalina Island isthmus circa 1964. (Below) A postcard of MV *Fairsea*, which introduced the young Ken Marschall to the joys of ocean travel. The ship was a single-propeller "motor vessel" (hence MV), built in 1941 and retired from service in 1969 after an engine-room fire.

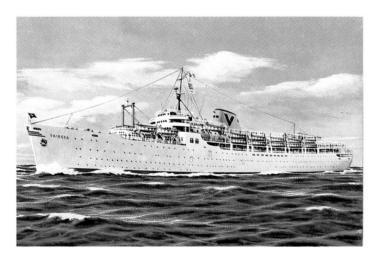

"Back then, there weren't the rules there are today. My brother and I could go anywhere: right up to the tip of the bow and down into the engine room. I fell in love with the sensation of being on an ocean liner. This big ship plowing up and down through the waves, the way the sun sparkled on the water, all the sea smells and ship smells, just sitting in a deck chair with my feet up on the rails, feeling the thrumming of the engines far below."

Soon after he returned home, he bought a copy of *A Night to Remember*. Reading Walter Lord's famous account of the *Titanic* disaster deepened Ken's fascination with the story. Not long afterward, he and Chris Bragdon decided to build their model of the ship. The two teenagers scoured the Pasadena Public Library for any information they could find about the liner: photos, descriptions, old newspaper accounts. Once they had exhausted this local resource, they drew their own plans and started to build a nearly nine-foot-long balsa-wood replica in Ken's room. About the time they had completed the hull and were ready to work on the superstructure, they concluded that their plans simply weren't comprehensive enough. Ken decided to ask Walter Lord for help.

In 1966, more than ten years after *A Night to Remember* was first published, then made into a successful movie, Lord was unquestionably Mr. *Titanic*. He received hundreds of letters a year, many of them from teenaged buffs like Ken, asking for more information. Ken sent Walter a list of questions that must have made the great man blanch, but he patiently answered every one in detail, including where to obtain builder's plans of the ship. A few months later, Ken was back asking him for more.

Ken Marschall with Walter Lord in the fall of 1984, nearly twenty years after their correspondence began.

"I'll do my best on your latest salvo of questions," Walter wrote Ken on December 16, 1967. That this busy and successful writer found time to reply to each request is a tribute to Lord's extraordinary graciousness. But the correspondence is also evidence of Ken's persistence and of his rapidly increasing knowledge of the ship. When he and Chris finally obtained the builder's plans from Harland & Wolff, they realized just how far off their model was. Suddenly, the project seemed pointless, and they lost interest.

But the connection with Walter Lord opened a door to another world, a global network of *Titanic* buffs. Through Walter, Ken became a member of the association that is now known as the Titanic Historical Society. (He is a dedicated member of the Society to this day.) Before long, he decided to try painting the ship. Soon his letters to Walter consisted mostly of queries relevant to his *Titanic* art. He sent Lord photos of his first two paintings, the one for the high school art show and his first commission. Lord was impressed.

"I want to tell you what a beautiful picture of the *Titanic* your second one is," Lord wrote on June 10, 1969. "Personally, I would be proud to have painted either, but the later one especially stirred all those feelings in me that go with the love of great ships." The author went on to make a few minor suggestions, but clearly he had recognized Ken's special talent. Soon Lord was offering to act as Ken's informal agent, helping him make contact with maritime buffs who might want to commission paintings. Before long he decided to commission an original Marschall himself: "I'd like it in daytime," he wrote, "perhaps Queenstown harbor, or (and this idea really intrigues me)

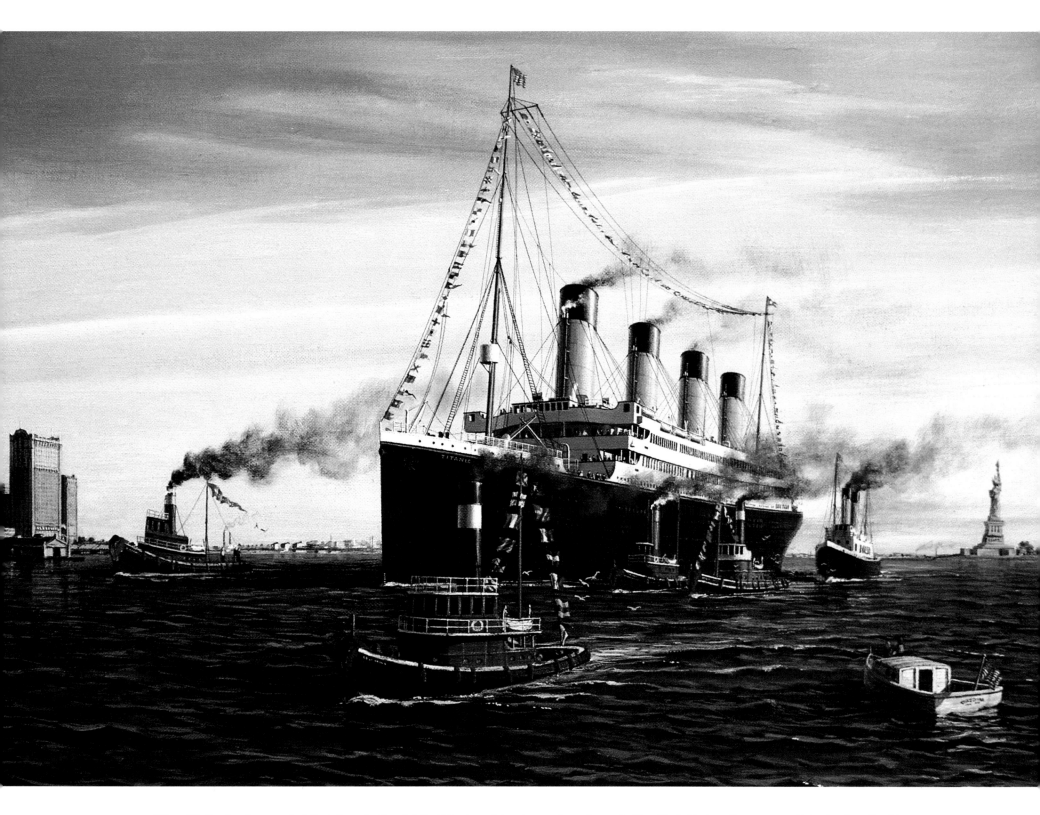

When Walter Lord suggested that Marschall paint the *Titanic* arriving to a gala welcome in New York Harbor, the young artist seized on the idea. Although the ship as rendered looks "too narrow" to Ken now, he remembers taking great pains to get the American flag right. According to his research, the forty-six-star version still flew on April 17, 1912, even though Arizona and New Mexico had recently joined the Union, bringing the total to forty-eight states.

◆

(Above) Rick Parks (left) and Ken Marschall each engrossed in his own artwork. (Below) When Ken (left), Rick, and Chris got together, they often went flying out of Burbank's airport. Although Ken was the only one of the three who didn't earn his pilot's license, he logged many hours at the controls.

◆

perhaps coming into New York! You'd have a lot of fun with that: just think of the game of getting the skyline right."

The idea took hold. Walter even sent Ken his own sketch of what the painting might look like, proposing that the view be facing south-southwest and that the scene be set in late afternoon so the sun would be in the right position to illuminate the New York skyline. "Actually, the *Titanic* was scheduled to arrive in the morning," he wrote Ken, "but the whole thing is fantasy anyway, so we can do what we like. When people ask why she's arriving so late, I'll simply say because she slowed down to avoid the ice!"

Ken never had any trouble in school so long as he was interested, and his interests were wide ranging, but as his high school graduation approached, he began to wonder what sort of career to follow. He did not think painting was a realistic way to make a living. He'd always been fascinated with architecture, but he wasn't interested in becoming an architect, so he began to think about using his talent for drawing as a commercial artist or an architectural renderer—the person who transforms a set of blueprints into a painting that appears to have three dimensions.

In the fall of 1968, he enrolled in a two-year art program at Pasadena City College. He enjoyed some of the classes but was bored by others—or didn't see the point. "Life drawing was challenging, but it wasn't something you needed to know to become an architectural artist. I got tired of sketching naked fat people wearing straw hats."

Soon another long-held interest moved into the foreground. The space program was at its zenith, and Neil Armstrong had just walked on the moon. Ken was so inspired by the feat that he wrote Armstrong a fan letter and sent it to the astronaut with his first *Titanic* painting. In reply, he received an autographed photo of Armstrong, along with a personal thank you. By this time he had decided to chart a different course: mathematics and astronomy. Maybe he could work in an observatory or get involved in the space program.

But eventually this enthusiasm, too, petered out. After several years of postsecondary education, Ken decided it was time for a change. In early 1973, after having dropped out of college, he and Chris Bragdon pooled their resources and moved to the desert.

The two of them purchased a mobile home and set up house in a trailer park in Canyon Country, then a sparsely populated semidesert north of

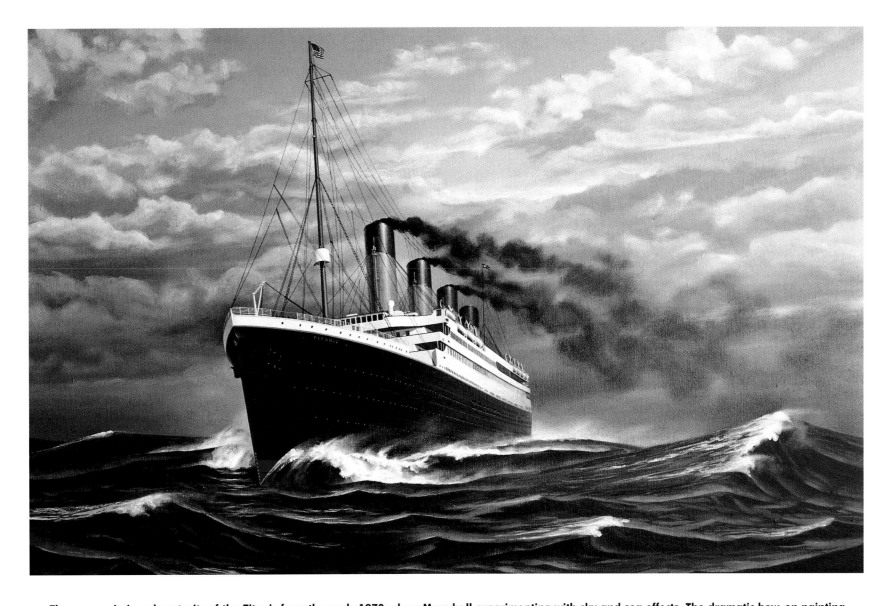

Three commissioned portraits of the *Titanic* from the early 1970s show Marschall experimenting with sky and sea effects. The dramatic bow-on painting (above) shows the ship coursing through a sea far rougher than any she encountered in real life.

✦

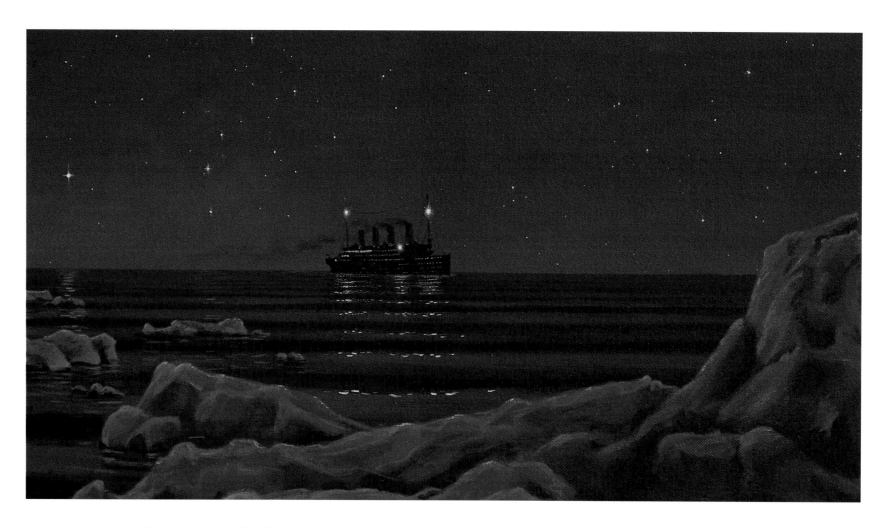

Three paintings of the disaster from 1971 reveal both the young artist's attention to detail and his sense of drama. For the scene above, he researched the exact star and planet positions. In the collision painting (below left) he magnified the iceberg so that it towers over the ship. In the sinking scene (below right) the ship lists more alarmingly than it would have in reality.

◆

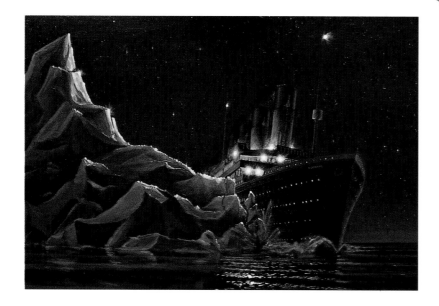

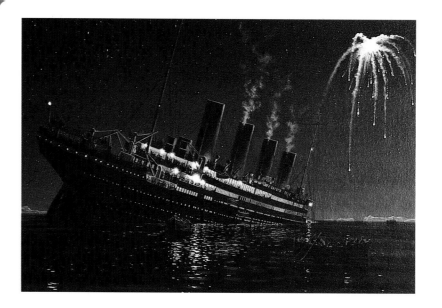

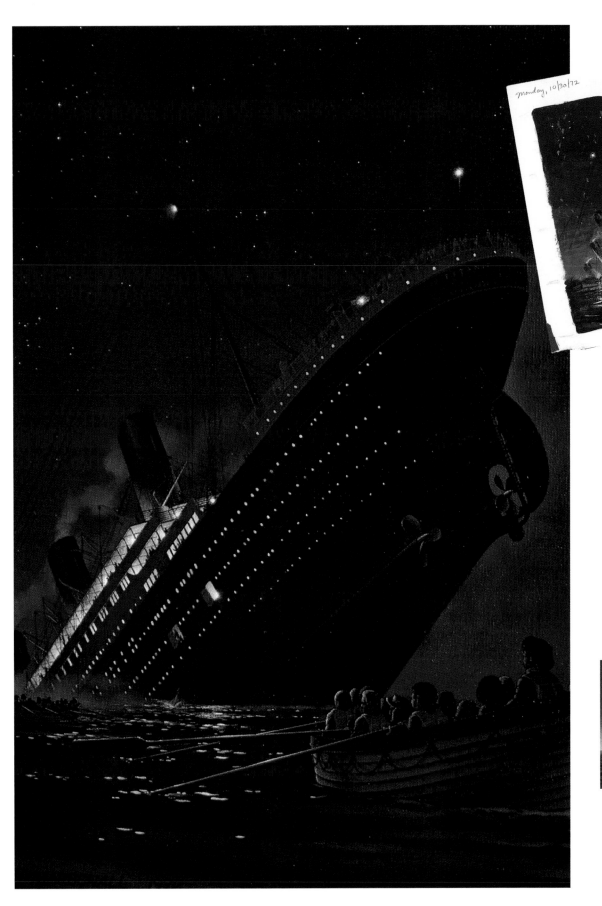

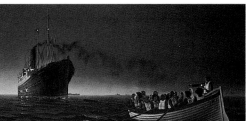

(Left) Marschall's 1972 painting of the *Titanic* just before its lights finally went out was inspired by a scene from the 1953 movie, *Titanic*, which had first piqued his interest in the ship. The swatches of color beside the maquette (above) show the artist experimenting with sky tones. (Below) Marschall's earliest painting of the rescue depicts Lifeboat No. 2 from which Fourth Officer Joseph Boxhall signals the *Carpathia* with a green flare.

✦

Los Angeles. Living was cheap—only about fifty-five dollars in monthly mobile home payments plus the sixty-three-dollar monthly rent to the park. Chris, who had his pilot's license, worked at Burbank Airport performing ground maintenance on a fleet of small planes owned by a flying school. Ken lived off his art.

By now, through Ken's Titanic Historical Society connections, he was regularly receiving commissions for *Titanic* paintings. Occasionally, he would be asked to paint other subjects—another ship such as Cunard's great *Queen Elizabeth,* or pet portraits for his friends—but the *Titanic* was his livelihood.

He was now well enough known as a *Titanic* expert that related work occasionally came his way. Soon after moving to the desert, Ken was hired to advise on the details of a plastic model kit of the *Titanic* being designed by Entex Industries. The thirty-inch model is still available. In 1977 he became a consultant on *Raise the Titanic!*, helping perfect the film's fifty-five-foot-long *Titanic* model, the largest replica of the ship yet built. Later he would design and paint the poster for a documentary called *Search for the Titanic*, which chronicled the futile hunt for the wreck orchestrated by Texas oil tycoon Jack Grimm during the early 1980s.

After a couple of years in the trailer, making ends meet but with no formal "career," Ken began to wonder what he was going to do next. He had always been drawn to movies,

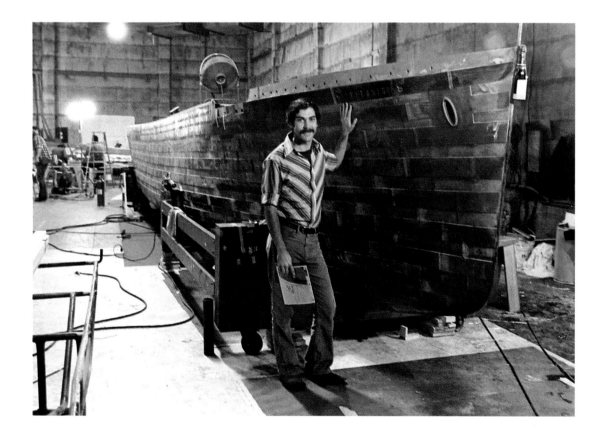
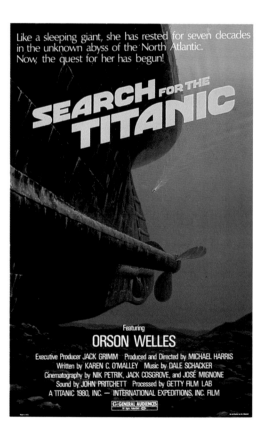

(Above left) Marschall stands proudly beside the partly completed model he helped perfect for the movie *Raise the Titanic!* (Above right) Marschall's poster promoting *Search for the Titanic* represents one of his first attempts to portray the wreck—several years before it was found.

especially to ones with complex special effects. He'd grown up not far from the film world's epicenter and still lived within its radius. So, in 1976, he enrolled in a night course in motion-picture special effects at the University of Southern California. There he learned the basics of one of the most venerable and essential of the cinematic arts—matte painting—under the tutelage of many experts in the field, including the legendary Albert Whitlock.

Countless films, going back to the work of George Melies in the 1890s, have relied on matte painting to some degree. The technique is simple to describe but fiendishly difficult to execute. Inside a studio or on location, a director shoots a scene that isn't all there. If, for instance, the scene showed elegantly clad dancers swirling around a ballroom during the original take, a black card would cover part of the front of the lens. This would blank out the area above the dancers' heads and keep that part of the film unexposed. The matte painter would then finish the scene and paint in the missing elements: the chandeliers, the frescoes, the gleaming gilt. Then the film would be run again, this time with the black card blanking out the already-exposed area. If the matte painter did the job well, the painting and the live action would blend seamlessly. The line where the painting meets the real set is called the matte line. If the matte line is invisible, the matte painting is a success.

In late 1978, after nearly six years in the desert, Ken sold the trailer and moved to an apartment in Redondo Beach (Ken had bought Chris Bragdon's share when the latter moved out a couple of years earlier). Through a friend, Ken heard about an opening for an artist and matte painter at Graphic Films Corporation, a small company located in the Hollywood Hills that specialized in animations for NASA and other space-oriented clients. Ken, now twenty-eight, had no paper credentials beyond his single extension course at USC. The company asked to interview him anyway, telling him to bring samples of his work.

Bruce Block, the interviewer, remembers that Ken brought in a couple of ship paintings and a few pictures of dogs and cats—not much to recommend him for the job. Nonetheless, Block gave him the standard test, telling him to get a still camera, find a suitable shot, do a blow-up, and then create a matte painting overlay. Block never expected to see Ken again: "You had to be really motivated to do all this," he says, and you had to have real talent.

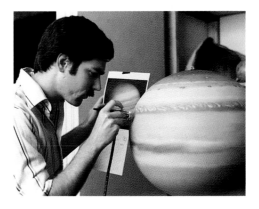

(Above) Working with a photograph of Jupiter sent back from *Voyager I,* Marschall airbrushes a model to be used in a Graphic Films documentary. (Below) As a freelancer, Marschall specialized in matte painting and "glass shots," a similar technique. Here he is working on a glass shot for a film to be shown at MGM's Florida theme park.

◆

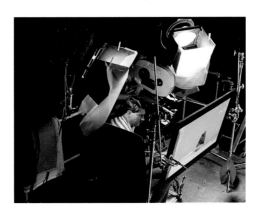

A few days later, Ken returned with the assignment complete. He'd gone to Disneyland, taken a photograph of Main Street, and blown it up to about 11" x 14". He'd then turned the background into turn-of-the-century St. Louis. It was practically perfect. Block was so impressed that he went straight to his boss and told him, "We've got to hire this guy." Ken stayed with the company for four and a half years, soaking up as much wisdom as he could from senior artist Gordon Legg, one of Walt Disney's original animators.

When a dip in business forced Graphic Films to lay him off, Ken had already established himself as a freelance matte painter. While still employed, he and Bruce Block had formed a company called Matte Effects. The partnership has lasted to this day. Their first big commission (in 1983) was the Emmy Award-winning mini-series *The Winds of War.*

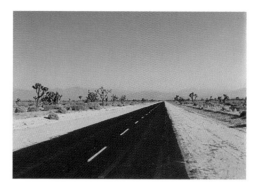

Among their early jobs was a matte painting for a movie by a then

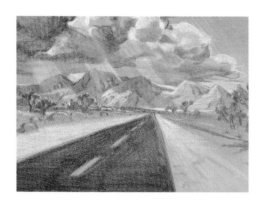

nearly unknown director named James Cameron. Ken recalls his reaction when he first heard that the film was to be called *The Terminator.* "The name reminded me of a movie from a few years earlier called *The Exterminator,* one of those low-budget gun-blasting napalm-exploding stupid violent movies for gum-chewing teenagers." Bruce assured him he would be painting only one scene, at the very end of the movie, where Linda Hamilton drives off toward the distant mountains just before the credits roll.

(Inset left) James Cameron's conceptual sketch for the final scene of *The Terminator.* (Top to bottom) Three stages of *The Terminator* matte painting show the original location, the chosen scene with the background blacked out, and the final version—with distant mountains and threatening clouds painted by Ken Marschall in the distance.

Ken didn't even set eyes on the director until after he'd done the initial painting, but he was already impressed with Cameron's attention to detail. The director had done a preliminary sketch of the scene, showing how he wanted it to look. Ken was surprised at how good the sketch was. "When I saw it, I thought, 'This guy can draw,'" he remembers.

The commission seemed straightforward enough. The scene as shot consisted only of a car receding along a straight strip of road; everything in the distance had been blacked out. Ken's job was to paint in the background: the Joshua trees and the desert landscape on either side of the highway, the distant mountains, the menacing sky.

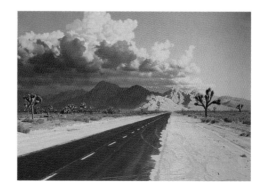

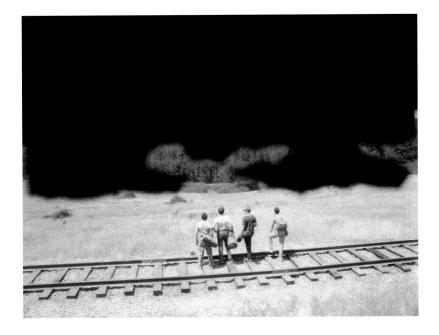

Two before and after matte paintings from the early 1980s: *Stand by Me*,
directed by Rob Reiner (above left) and *Spacehunter—Adventures in the Forbidden
Zone* (above right), one of Columbia Picture's forays into the realm of 3-D movie
making. The scene of the French luxury liner *Normandie* arriving in New York
(left), painted for the Home Box Office movie *The Josephine Baker Story*,
gave Marschall an opportunity to recreate another famous ocean liner.

Usually it took only one or two screen tests before a director was satisfied. But this time, Ken could not seem to get the painting right. First, the mountains were wrong, so Ken went back and made changes. Then the clouds needed work. This to-ing and fro-ing went on through over a dozen versions. Cameron seemed absolutely impossible to satisfy, the worst kind of perfectionist. Finally, he did accept the painting, though grudgingly. "Well, I guess it will have to do," Ken remembers him saying. "I don't know how we can make it any better."

Ken always stayed in the background and let Bruce do all the talking. He was never actually introduced to the director, though he sat in the same screening room with him once. It hardly mattered. He had no desire to work with Cameron again, and fortunately, other jobs kept coming. By the time he next saw the director, he would have painted more than two hundred matte paintings in movies as varied as *Baby Boom* and *Spacehunter*.

When asked how his experience as a matte painter has affected his *Titanic* art, Ken is cautious. "Working on matte paintings you really bend over backward to take out any sense of style. The paintings have to look cold and hard and real. You can't have them look painterly or Christmas-cardlike. They must be boring and accidental. Trees can't be pretty. Skies are just skies. Certainly I learned more about what things really looked like, about the effects of light and shadow, about the colors that make artwork look real." It was a lesson that reminded Ken of the credo of an influential high school art teacher, Rollie Younger. "If you want to be a realist," Mr. Younger would say, "see what's really there, not what you *think* is there."

During the early eighties when matte painting filled his professional life, Ken's *Titanic* passion receded somewhat, but it never came close to disappearing. His involvement in the Titanic Historical Society (THS) continued—he never missed a convention—and he vacationed on ocean liners whenever he could. After his first big commission as a freelance matte artist, he booked passage on the *Queen Elizabeth 2* and took his mother on a trip to England. And whenever he traveled, he sought out *Titanic* survivors and visited places connected to the ship and her story.

For a *Titanic* buff, meeting someone who actually sailed on the maiden voyage is as close as you can get to being on the ship itself. In the late sixties and early seventies, quite a few survivors were still alive, and Ken met a number of them at THS conventions. Most

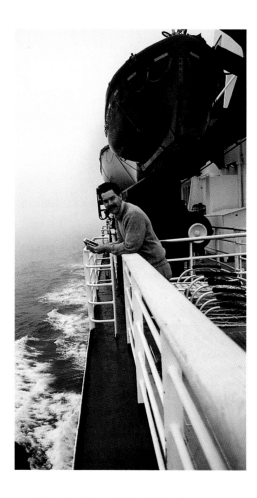

Marschall travels by ship whenever he can. Here he is leaning over the rail of Cunard's QE2, the last of the great trans-Atlantic ocean liners. He has made three crossings on the QE2.

◆

"Titaniacs," as they are sometimes called, were satisfied to shake the survivor's hand and add his or her autograph to their collection. Not so Ken Marschall. Even in his early days as a *Titanic* buff, he took every opportunity to expand his knowledge of the ship in a remarkably scholarly fashion.

Ken first met Edwina Troutt, by then Mrs. Edwina MacKenzie, in the late 1960s. Edwina had been twenty-seven when she joined the second-class passengers on the *Titanic*'s maiden voyage. Ken delighted in her vivid and candid memories of the experience. He was particularly taken by her description of the *Titanic* as "a happy ship" and her droll impersonation of her gloomy Irish roommate, Nora Keene, who predicted disaster for the unsinkable *Titanic* from the moment she boarded at Queenstown. When the ship began to sink, Nora jumped out of bed with the words, "I told you! What did I tell you?" Winnie, and the twenty-odd other survivors Ken has met over the years, helped bring the ship to life. As he says now, "They put a face on the *Titanic*. They made the ship into a living, breathing thing."

You could say that Ken was collecting survivor stories the way he collected other items of *Titanic* memorabilia. While Ken freely admits to being an incorrigible pack rat by nature—he says he seldom throws anything out except at gunpoint—he does not collect things only for the sake of collecting. He gathers artifacts as a way of getting closer to the ship, of getting to know and understand it better. Each of the twenty-two newel faces he has acquired from the *Olympic*'s staircase foyers was carved by an individual craftsman, and each is unique. The same group of artisans crafted similar newel posts on the *Olympic*'s sister ship *Titanic*. On the extremely rare occasion that he has parted with something from his collection, he says it's "like pulling a tooth." More important, Ken's collecting fed his art. Everything he could learn about the ship, every piece of the story he could add to his cache, made his paintings more accurate and more real. Most useful of all were the photographs.

It is probably safe to say that Ken Marschall's personal archive of *Titanic* images and related material is more extensive than that of any other public or private collection in the world. When it comes time to paint a new view of the ship or assist in one of the many other *Titanic* projects Ken works on, he dips into this archive to find every photo that might give him a new clue. As anyone who knows him will tell you, he's a demon for details.

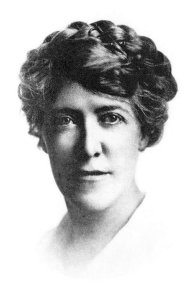

A circa 1914 portrait (above) of Edwina Troutt MacKenzie and (below) Edwina with Ken more than seventy years later. When Ken Marschall knew her, this *Titanic* survivor displayed a delightful sense of humor. "Do you like music?" she might ask. And if you said, yes, she'd say, "Well, here's a band," then hand you a rubber band. According to Ken, she remained lively and uncomplaining right up to her death in December 1984, a few months after Marschall and historian Don Lynch had thrown a party for her hundredth birthday.

◆

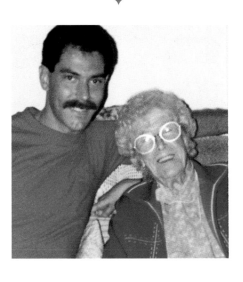

Ruth Becker survived the *Titanic* with her mother, younger sister, and baby brother Richard (above). Don Lynch (below right) drew on many of her memories in the writing of *Titanic: An Illustrated History*. Ken vividly recalls the first time she watched *A Night to Remember*, which she first saw in a video version. The next morning at breakfast she told him that as she was lying in bed trying to get to sleep she remembered something she "hadn't thought of all these years." When her mother sent her back down to their cabin on F-deck to fetch some blankets, the ship seemed "absolutely deserted. I didn't see a single soul."

✦

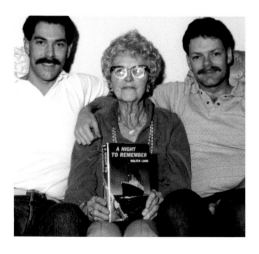

Few people can equal Ken's dedication to *Titanic* research, but one of them is certainly Don Lynch, now the Titanic Historical Society's chief historian. When Ken and Don first met, Ken was already something of a legend in *Titanic* circles, while Don, who is seven years younger, was still in college and only beginning to amass the knowledge that would eventually make him the reigning authority on the *Titanic*'s passengers. But it was Don who discovered Ruth Becker.

In 1982, Don invited Mrs. Ruth Blanchard to join a group, which included Edwina MacKenzie, that was traveling to attend that year's THS convention. Mrs. Blanchard, formerly Ruth Becker, had been a twelve-year-old passenger in second class, traveling with her mother, younger sister, and baby brother. When Don contacted Ruth, she at first declined his invitation to go to the convention but consented to a visit. The next weekend Ken and Don drove up to meet her.

Then eighty-two, Ruth had succeeded in putting the ship out of her mind for most of her life. Most of her friends didn't even know of her *Titanic* connection. Perhaps in part because her story had not been retold and embellished with time, her memories of the maiden voyage were unvarnished, yet marvelously detailed. Ken and Don hit it off with her immediately, soon becoming almost family members. She always referred to them as "the boys." When Ruth talked about the *Titanic*, Ken recalls, "it was just as if she were talking about something that had happened three weeks ago."

In July of 1985, Ken decided he was making enough money to move out of his apartment in Redondo Beach and buy a small house nearby. Whenever friends dropped by his new digs that first August, the conversation was all about Robert Ballard's expedition and what he would discover if he found the ship.

The three days following the ship's discovery on September 1, 1985, were "insane," Ken recalls. The phone rang off the hook as friends, acquaintances, and journalists from around the world called to talk to him about what it all meant. In *Titanic* circles he'd long ago established a reputation for knowing the ship better than anyone. His knowledge of the details of its construction, combined with his artistic imagination, enabled Ken to find meaning in each fragment of twisted wreckage.

Less than one year later, when Ballard led an expedition to explore

the wreck by submarine, Ken found himself once again watching from the sidelines. What he would have given to be inside the tiny submersible *Alvin* as it descended for the first time to the *Titanic*'s last resting place! Not that he'd been idle in the run-up to Ballard's famous dive into the past. Working only with videotapes from the TV news and from photos of the wreck published in *Time* and *National Geographic*, Ken had created a painting portraying the wreck as he now believed it actually looked. He overlaid a photo of his artwork with a piece of clear plastic on which he had reproduced the *Time* header, along with a mock title, "Exploring a Legend— *Titanic* Gives Up Her Secrets," then sent it to the magazine. He knew it was about as likely to land on the cover of *Time* as the *Titanic* was likely to rise from the deep.

A few days later, *Time*'s cover department called. "We never do this," the caller told him. "We don't consider unsolicited artwork, but we *love* this." *Time* made no promises but asked Ken to work further on the painting to make it as accurate as possible. The only way he could get more detail, however, was to call the Woods Hole Oceanographic Institution, Ballard's home base. Ballard was still at sea, exploring the wreck, but someone there might know something. When Ken called and explained who he was and why he was calling, he was put right through to Ballard's office. By marvelous coincidence, the oceanographer was on the radio phone in the next room.

An intermediary passed Ken's questions on to Ballard, then relayed Ballard's answers back to Ken. In the space of a few minutes, Ken had all the information he needed, including the news that the wheelhouse superstructure was gone. It was his first conversation with the already famous oceanographer.

Ken sent off the revised painting to *Time*, then waited. Finally, after an agonizing week, the news arrived: Ken's cover was a go; it would be on the stands the next Tuesday. He went out and bought about fifty copies. "That was just about the biggest thing that had ever happened to me," he says now. At the party he threw to celebrate, Ruth Blanchard was the guest of honor.

Ken subsequently learned that his was believed to be the first unsolicited cover to be accepted in the magazine's history. The issue went on to outsell all but one other that appeared in 1986. The greatest tribute, however, came from Ballard himself, the man who knew the wreck better than anyone but had until now seen it only in pieces. "When I saw Ken's painting, it stopped me dead in my tracks," he later said. "Here I'd been crawling around the wreck for two weeks in a cramped little sub with the equivalent of a flashlight, with only a hazy notion of what the ship actually looked like. Yet Ken Marschall had captured the whole ship for the rest of the world to see." Ken is modest about this accomplishment, but his friend and *Lusitania* expert Eric Sauder goes much further than Ballard, "If it weren't for Ken Marschall, we still wouldn't know what the wreck really looks like."

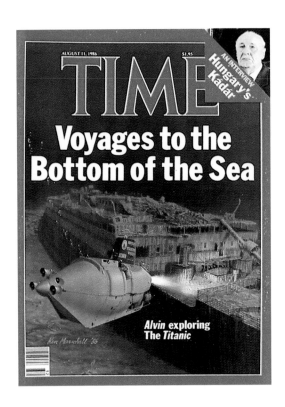

Seeing his painting on the August 11, 1986, cover of *Time* magazine was one of the high points of Ken's career.

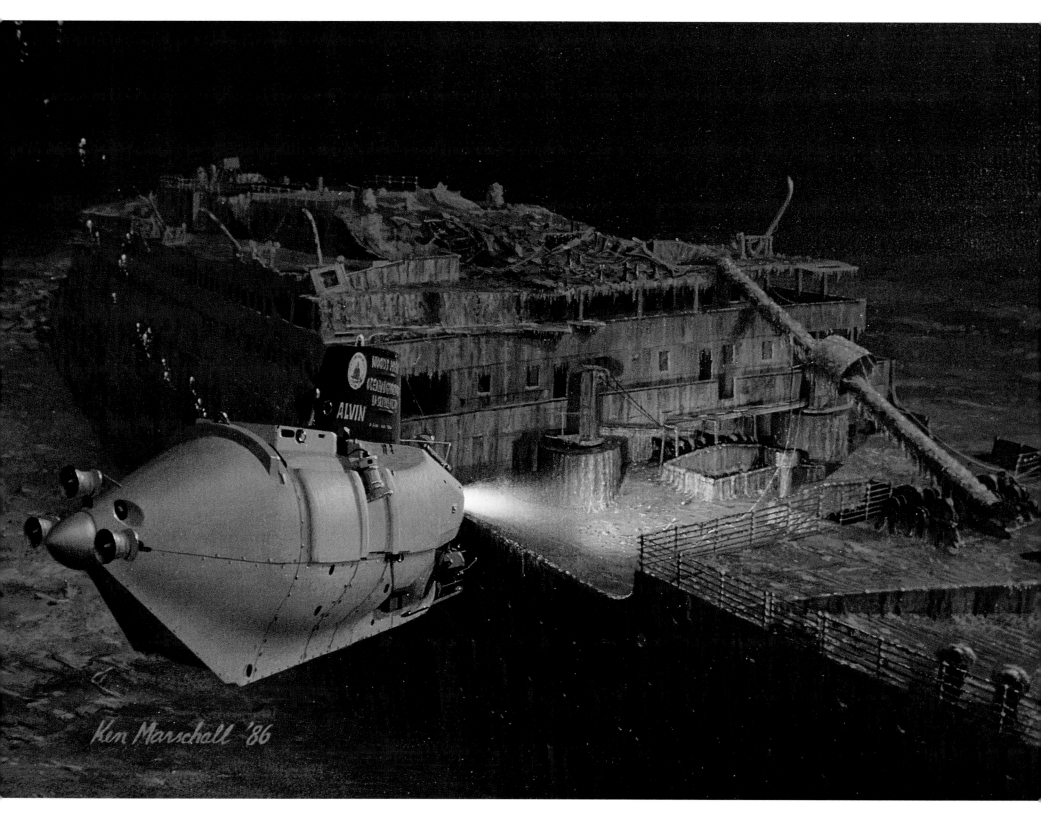

The most difficult aspect of the *Time* cover painting was guessing what the ship looked like where it had torn in two.

All Robert Ballard had been able to tell Ken was that it "seemed to fall off into nothing."

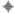

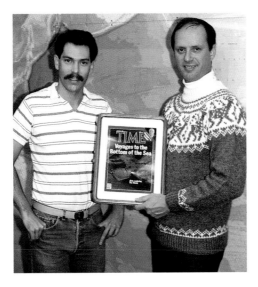

(Above) Ken poses with Robert Ballard during his trip to the Woods Hole Oceanographic Institution in the fall of 1986 to do research for the book *The Discovery of the Titanic*. (Below) Thousands of overhead shots from the camera sled, such as the one, below, of one of the ship's cranes and, bottom, the crow's nest, provided the raw material for Ken's painstaking piecing together of the wreck.

◆

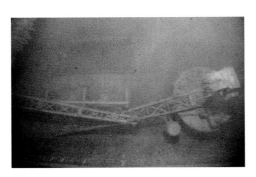

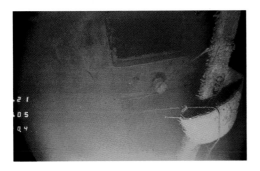

The *Time* cover marks a clear watershed in Ken's life. Before that, he was a successful matte painter with a private *Titanic* passion. Afterwards, he was *the* interpreter of the wreck and the ship as it once was for an increasingly mass audience. Matte painting began to recede into the background as more and more *Titanic* commissions poured in—most of them for books.

The first, and still the most successful, of these publications, many of them collaborations with Robert Ballard, was *The Discovery of the Titanic*, published in the fall of 1987, which introduced Ken Marschall's *Titanic* art to a vast audience. In its various editions, *Discovery* has sold over a million copies worldwide. Here, for the first time, are Ken's haunting paintings of the sunken ship, images that have defined the way we think about the world's most famous shipwreck.

To prepare himself for painting the wreck for the book, Ken spent several days at Woods Hole, staring at endless videotape footage and thousands of still photographs of the wreck. Hugh Brewster, editorial director of Madison Press, the Toronto company that produced the book, remembers his astonishment at Ken's patience and dedication to the task. What to Brewster looked like a pile of rubble on the ocean floor before Ken's practiced eye instantly became identifiable pieces of the ship. "It was really Ken who identified most of the items in the debris field," says Brewster. "He was not only the artist for the book, but also our visual historian."

In an uncanny way, the search for, discovery of, and rendering of the *Titanic* wreck into art have brought together the various strands of Ken's life. Painting the wreck involves practically every one of his boyhood passions: science, history, art, photography, archeology and ocean liners. Only a few years earlier, Ken's depictions of the submersible *Alvin* landing on the *Titanic*'s deck and sending the tethered robot *Jason Junior* inside the wreck would have been the stuff of science fiction. In his wreck paintings, Ken must also dissolve the line between fantasy and reality, just as he did in his matte work. No matter how many deep-sea photographs he uses as reference, he will never be able to see the whole scene at once. He has to fill in the gaps and make what isn't there as real as what is.

When Ken paints, whether it's a scene of the wreck or a portrait of the ship in its glory, he works with his art board laid flat, and so cluttered with reference material that only the tiny square he's actually painting is visible. "Ken is

painstaking about everything," says Brewster, and it shows. Other artists marvel at the degree of detail in his paintings, detail not always evident in book-sized reproductions. He is never happier than when he can get it perfect.

Dennis Kromm, who commissioned Ken's painting *Passing Kinsale Head* (pages 6-7), claims that no reproduction shows its "incredible detail: the tiny red White Star burgees on the lifeboats, the gossamer lines stretching down from the funnel tops. But Ken's great gift is that he never gets bogged down in detail at the expense of the whole. His paintings have a sense of time and space. You are in a particular place on a particular day with specific weather and light conditions. I could swear I smell salt air when I look at his sea scenes."

Undoubtedly, Ken's skill at capturing reality owes much to his career as a matte artist. Above all, Ken is a master at using light to heighten effect, to create a mood. His paintings of the wreck are the outstanding examples of this. The ocean at *Titanic*'s depth is pitch black, blacker than outer space, yet his wreck paintings are a luminous dark blue. And there is usually a ghostly source of light that couldn't really be there, lending an aura of mystery. So convincing are these works that they have become the only way we can imagine the ruined ship. When James Cameron created his underwater scenes for the movie *Titanic*, he made them look like Ken's paintings.

The high point of Ken's book publishing career so far has been *Titanic: An Illustrated History*, with text by Don Lynch. This lavish tome married many of Ken's best *Titanic* paintings—including many new commissions—with a detailed account of the *Titanic* story from inception to maiden voyage to sinking to discovery. The book was a dream come true. At the time of its publication Ken believed he'd reached the peak of his career, that nothing could better this—except, that is, working on a $200 million *Titanic* movie.

When Ken heard that James Cameron was contemplating a film about the *Titanic*, his first reaction was enthusiasm. He had not forgotten Cameron's fierce perfectionism, which had been obvious during the production of *The Terminator* back in 1983—but this was exactly what Ken hoped for any modern movie treatment of the ship. Cameron's career since then had increased Ken's admiration: "He had such a reputation for huge, technically efficient and impressive special effects films such as *The Abyss* and *Terminator II*, that I was very excited. If anyone could get the *Titanic* right, Cameron could." This led to Ken's second reaction: How can I help Cameron with the movie?

Given Ken's experience in film and his *Titanic* expertise, his ambition sounded reasonable. And he wasn't yet aware that Cameron had been inspired, in part, by his paintings. "When *Titanic: An Illustrated History* came out, the vividness of the imagery that Ken created made me realize that, with all the great new digital composite technology we have, we could actually realize his paintings. We could put people in those images—moving people—and bring them to life," says Cameron. The director even took a copy of *Illustrated History* into his meetings with studio executives to show them what the movie would look like. As soon as he learned that Ken wanted to be involved, Cameron asked him to join the production team.

Ken and Don Lynch helped critique early drafts of Cameron's script. Then Ken worked for three months in the art department of Cameron's production company, Lightstorm Entertainment, as historical consultant to the set designers. It was during this period at Lightstorm that Cameron finally figured out where he'd met Ken before. One day during a meeting, the director suddenly gave Ken a funny look. "You," he said accusingly, "you did the matte painting for *The Terminator*." Ken winced. "Yeah, I'm guilty," he replied. "No, no, no," Cameron continued.

"I know it was not a happy experience for you, but it wasn't your fault. The painting is fine. It was my fault. I shouldn't have designed the scene that way. It was out of context." Here was a side of the director that is seldom covered in the press.

Later during preproduction, Ken donated his expertise to Digital Domain, the company in charge of special effects—including the forty-four-foot model used for many of the more spectacular sequences. But unlike Don Lynch, who acted as historian on the film, Ken had no formal role while the movie was being made. He was too busy working on new paintings for yet another ocean liner book, *Lost Liners*, due out shortly after the film's then-scheduled summer 1997 release.

But he was always welcome on the set on the coast of Baja California, where in the fall of 1996 a giant replica of the ship began rising from a huge seawater tank next to the beach. Despite Cameron's by now legendary obsession with detail, Ken was worried that the *Titanic* set wouldn't live up to his expectations. When it comes to the ship, Ken's sense of perfectionism is more than equal to Cameron's. Ken had already had to overcome his initial disappointment that the script revolved around a fictional love story—grudgingly admitting that the romance between Jack and Rose was the only way the director could take the camera on board everywhere he wanted to while still keeping a mass audience enthralled. But he'd had more trouble accepting the decision to make the replica slightly smaller than the ship's actual size.

Contrary to many reports, the ship that Cameron built is not smaller in scale, but slightly shorter in length. Since this meant that the funnels stood slightly closer together than in reality, they were shrunk somewhat to preserve the correct sense of proportion. The lifeboats were made slightly smaller as well. Otherwise everything on the ship was full size: the deck heights, the ship's width, the bridge, the bollards, the deck chairs. But it still bothered Ken that with all Cameron's resources and determination to get every detail right, he had decided to build something less than a full-size ship.

His reservations evaporated, however, when he visited the set in mid-November. By this time, the "ship" was almost complete: the front of the bridge was finished, and the forward well deck, with perfectly copied giant cargo cranes, stood ready for the camera. As Ken walked onto the well deck that day, he felt his knees buckle. He sat down on a bollard and stared up at the bridge, so familiar after nearly thirty years of study, and shook his head.

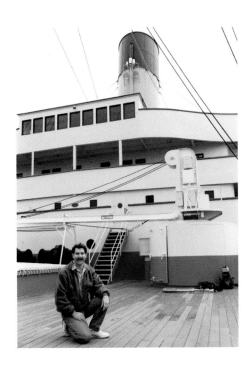

Marschall kneels in the forward well deck of James Cameron's *Titanic* set. On that day in 1996, any worries he had about the accuracy of the sets vanished.

◆

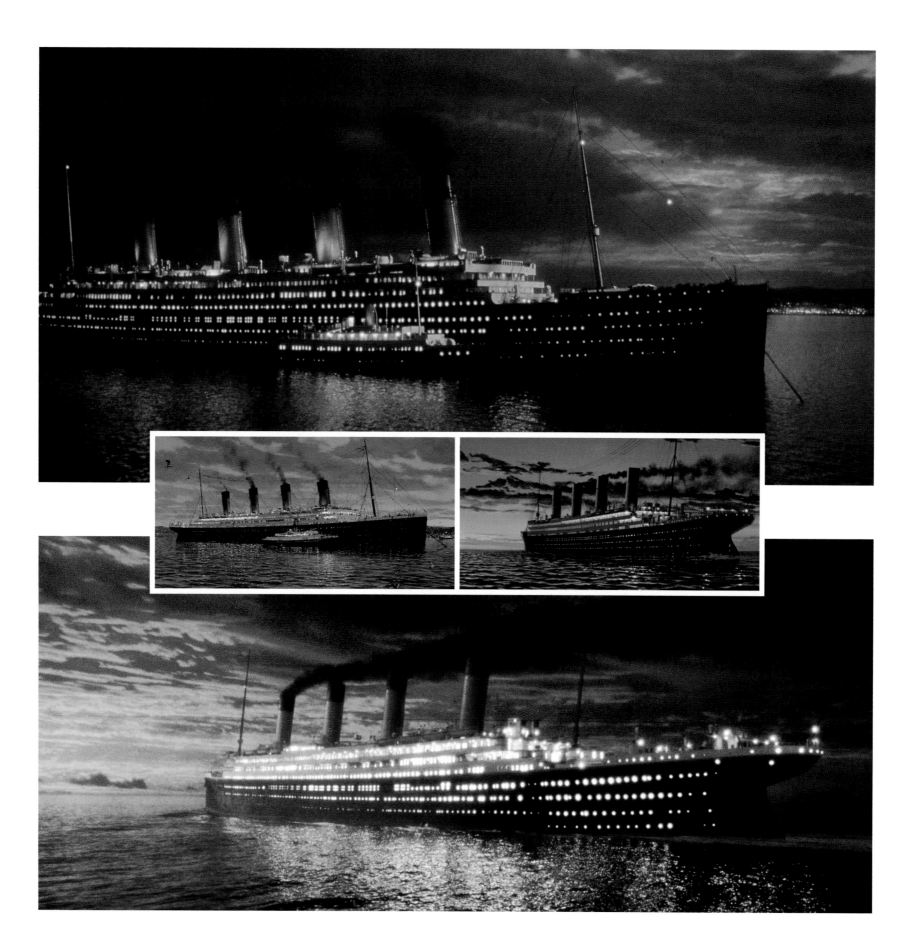

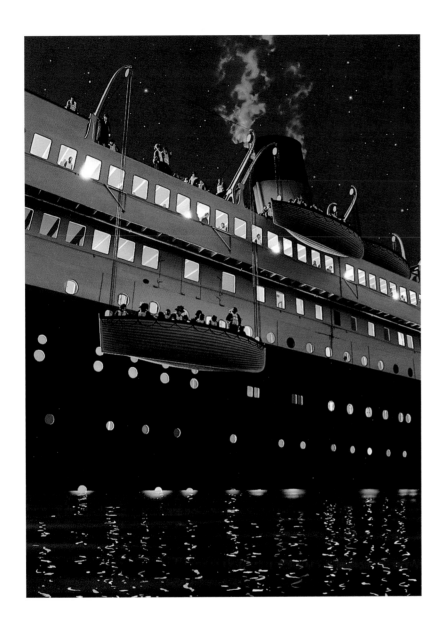

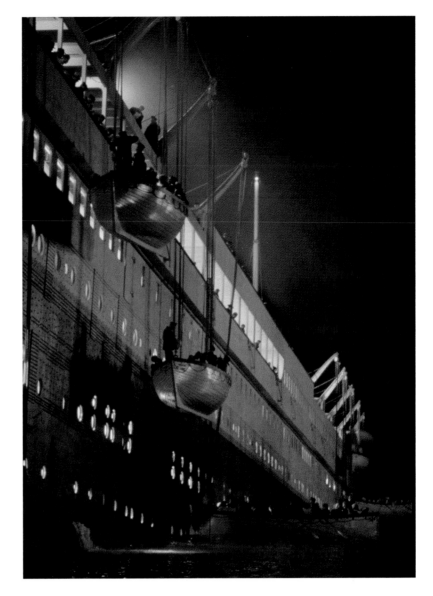

(Opposite) Several scenes from the movie show a parallel vision to Marschall's paintings. Compare the movie's Cherbourg scene (top) with the painting (inset left) and the movie's moment of sailing into the sunset (bottom) with Ken Marschall's (inset right). To create these views, James Cameron filmed a scale model of the *Titanic* against a blank background, then inserted a real sky. The water and reflections were created digitally. (Above) Lifeboat No. 7 is lowered in a Marschall painting and in a similar moment (right) in *Titanic*.

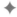

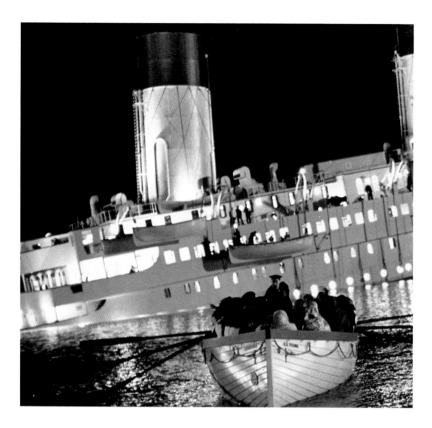 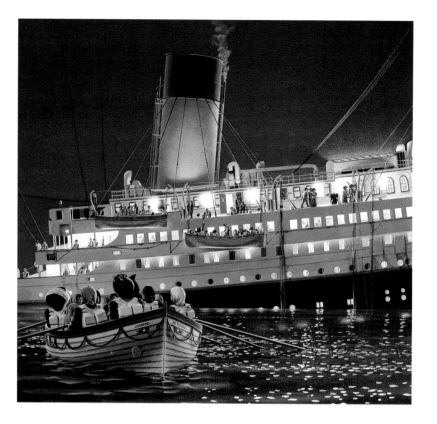

(Above) Because Cameron completed only the starboard side of the *Titanic* replica for the movie, the film had to be flopped (flipped to mirror-image position) whenever he needed a view of the port side (above left). (Below) In both the movie (left) and the Marschall painting (right), the *Titanic*'s bow glows with an unearthly light emanating from a submersible perched on the foredeck.

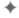

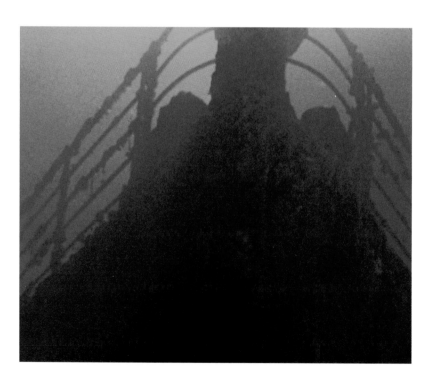 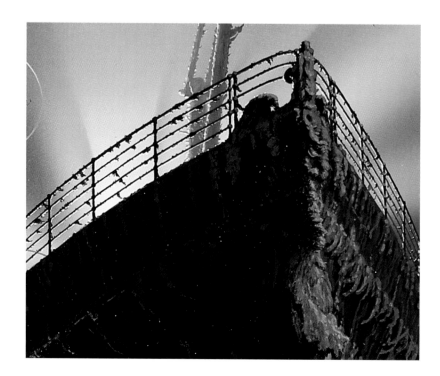

"Never in my wildest dreams had I thought this moment would happen, that I'd be on the deck of the *Titanic*," he recalls. As a child, he had fantasized about traveling in a time machine. Now it was as if he *had* gone back in time, thanks to James Cameron.

The movie surpassed Ken's expectations. "Cameron's *Titanic* is many times better than any version ever filmed before," Ken says now. "There are mistakes, things that fell through the cracks, but I just have to live with that. The world is not perfect, and I've got to stop trying to make it perfect."

One wonders if he really means it.

The unprecedented success of *Titanic* has spilled over into Ken's life in many ways. For one thing, shortly after the movie's release, the paperback edition of *Titanic: An Illustrated History* jumped onto the bestseller list. But it is the film's long-term impact on this unsinkable subject that most interests Ken, who remains remarkably modest about his accomplishments and disarmingly unspoiled by his recent successes.

"We're on the crest of a wave right now," he says, "but even when that wave passes, the water level—the level of

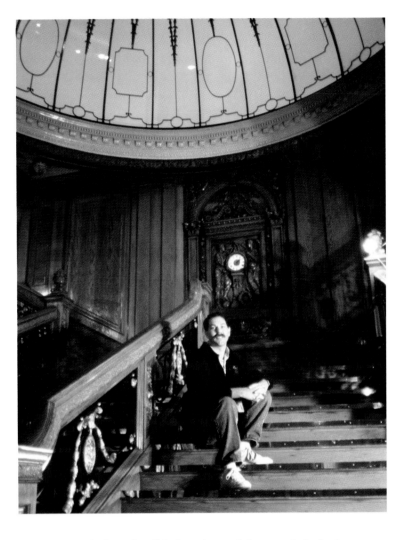

Beneath the splendid glass dome of Cameron's lovingly recreated Grand Staircase, Marschall imagines the elegant *Titanic* elite descending for dinner on the last night.

✦

Titanic interest—will remain much higher than it ever was before." But where does Ken Marschall go from here? It seems that all his dreams have come true, save one: The *Titanic* hasn't yet completed her maiden voyage.

In the wake of the movie's megasuccess, at least one consortium has announced plans to build a full-scale replica of the *Titanic* and re-enact the maiden voyage—minus the iceberg. If such a scheme ever actually comes to fruition, Ken will be a passenger. "If the ship ever sails again, I'd be on board in a heartbeat," he promises. Then he would finally be able to realize what he has, until now, only been able to visualize through art.

When Ken first watched *Titanic* all those years ago, he was captivated by the characters played by Barbara Stanwyck and Clifton Webb, but the ship itself soon became his first love. "More than anything else, I was fascinated by the fact that it was the maiden voyage, that this beautiful ship never completed a single crossing. It felt so unfair to me. Maybe since then I've had an unconscious drive to somehow bring the ship back to life, to recreate what is no longer there."

For Ken Marschall, the voyage is far from finished.

Titanic *Gallery*

It began with great promise and ended in great tragedy. On April 2, 1912, the Royal Mail Steamer Titanic *departed Belfast for a brief but successful series of sea trials. Later that day she was on her way to Southampton, where she would join her year-old sister, R.M.S.* Olympic, *in providing regular trans-Atlantic service between Europe and America. Because the* Titanic *had slightly more enclosed space than the* Olympic, *she could claim to be the largest ship in the world. The press and public dubbed her unsinkable. Her loss would be the most shocking sea disaster in history.*

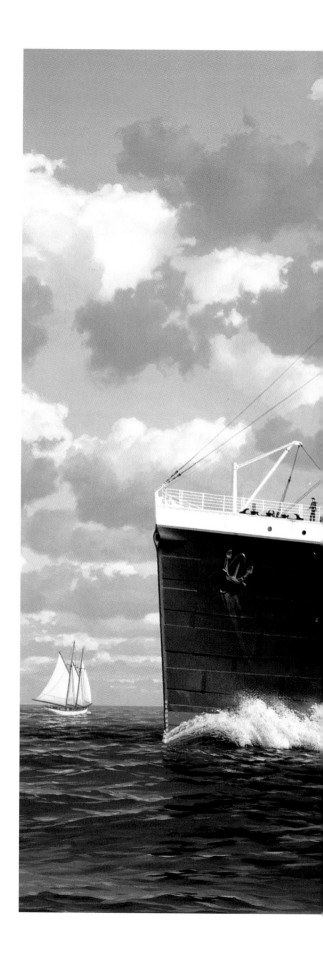

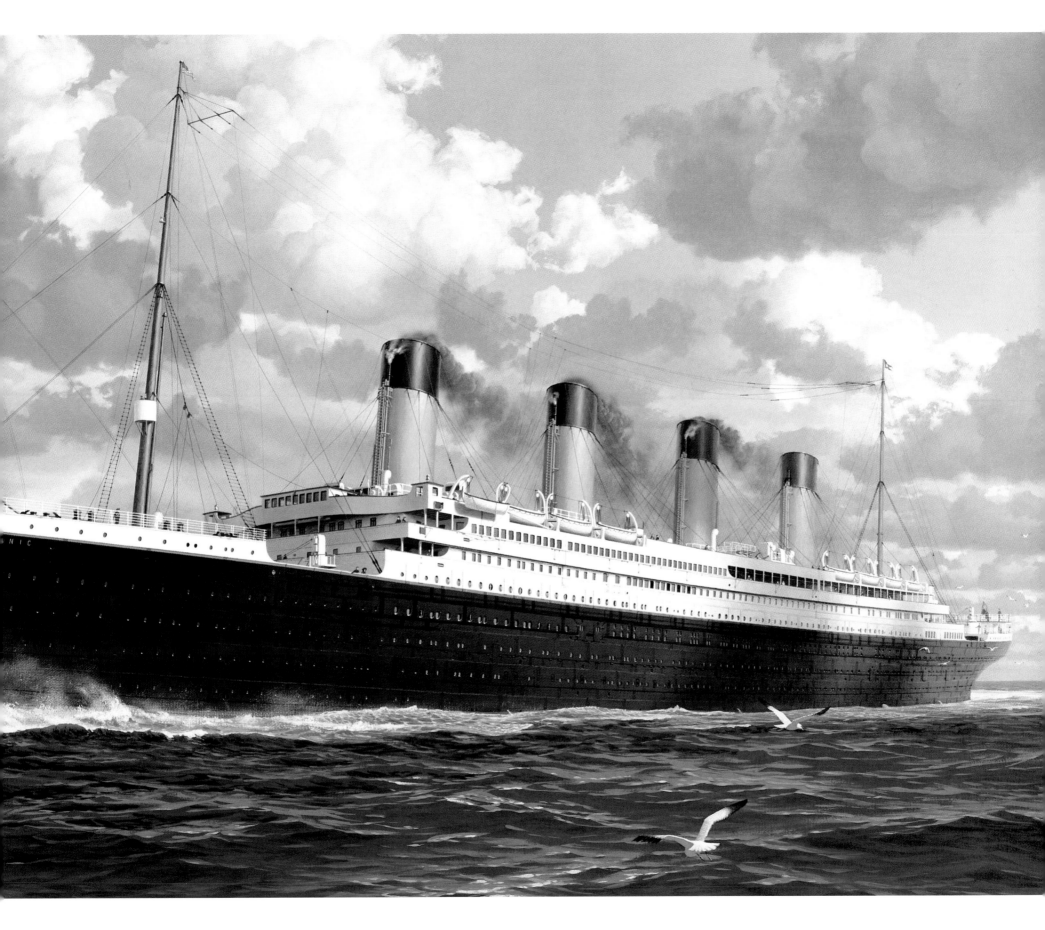

In a sense, the *Titanic*'s maiden voyage began on the evening of April 2, 1912, when the ship left Belfast to steam the 570 miles to Southampton. But until Ken Marschall came across a brief newspaper reference on microfiche in the Southampton Public Library, no one recalled that the *Titanic* and her sister ship, the *Olympic*, had passed each other off Portland, England, on the evening of April 3, as she neared the end of her voyage. The *Olympic* was outbound for New York, at the beginning of a second successful season on the trans-Atlantic run. The *Titanic* was rounding the southern extremity of the British Isles for the final leg of her journey. In all likelihood, the brand-new *Titanic*, carrying no passengers who could complain at even a slight delay, swerved slightly from her course long enough to make visual contact with her sister—the only time the two great liners ever passed at sea. The possibility inspired one of Marschall's more memorable paintings, the one that appears overleaf.

Marschall has always been drawn to the early part of the *Titanic* story, when the ship was still full of promise. His paintings of the liner towering over Southampton's White Star Dock; of the tugs gently moving her away from the quay; of her brief stopover in Cherbourg, France, to pick up the passengers who had taken the train from Paris; and of the final call at Queenstown (now Cobh), Ireland, exude a sense of optimism. Here is the "happy ship" that survivor Edwina Troutt MacKenzie described for him, the ship at her best.

As the pictures in the pages that follow demonstrate,

The Voyage Begins

Marschall goes to extraordinary lengths to ensure each painting's accuracy. He researches the time of day, the weather, and the setting—even visiting the actual place—so that each moment he portrays is as true to history as possible.

Sometimes this research comes back to haunt him—witness his marvelous depiction of the *Titanic* at Cherbourg on the evening of April 10, 1912 (page 59). In 1977, when this painting was completed, all evidence suggested that, after leaving Southampton, the ship arrived in Cherbourg and anchored just before nightfall, a magic moment to recreate. Recently, however, two photos have surfaced, both apparently showing the ship in Cherbourg harbor in broad daylight. Fortunately, the departure definitely did take place after dark. So the painting remains true to the story, with the ship anchored at twilight; it just doesn't portray the moment Marschall originally thought it did.

Certainly, Ken Marschall relies heavily on the photographic record when he does his research. And the opening days of the trip were reasonably well documented by Francis M. Browne, a thirty-two-year-old teacher studying to become a Jesuit priest. Browne and his traveling companions, the Odell family, disembarked at Queenstown, taking their priceless photographs with them before the ship headed out to the open Atlantic.

Marschall's accuracy is legendary. But it is his ability to create a mood through his attention to light and sky and water that gives his compositions their staying power. By the time you reach the final painting in this section, you will have met R.M.S. *Titanic* as she should have been remembered.

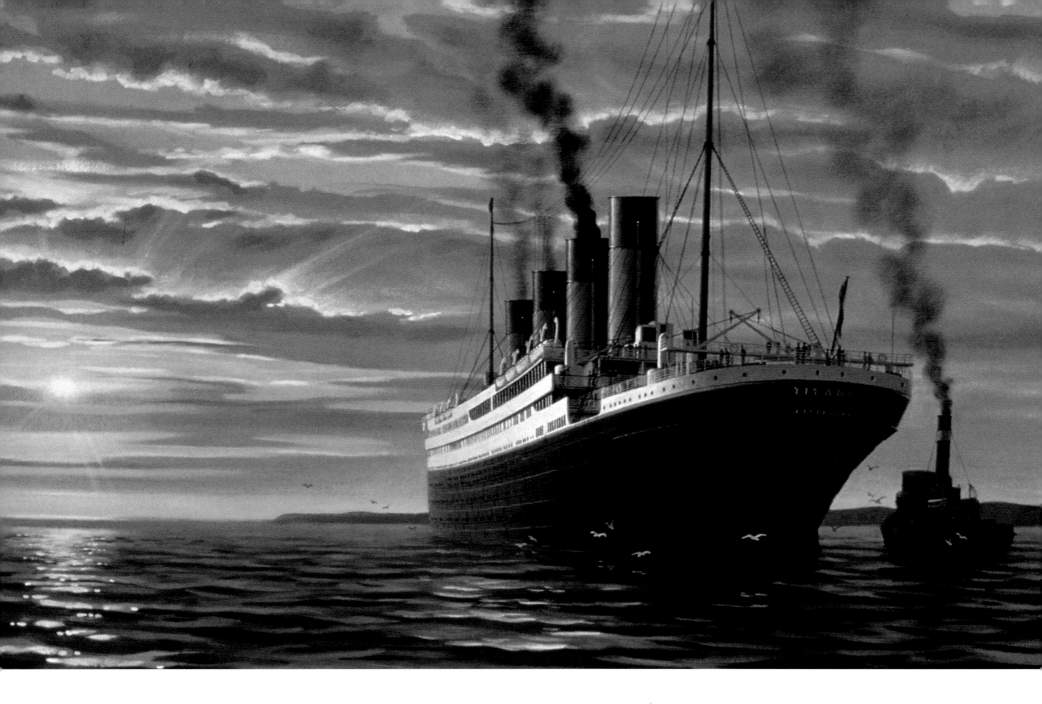

(Above) At sunrise on April 2, 1912, the *Titanic* sails into Belfast Lough to begin her sea trials. Later that day, she would depart for Southampton. The sketch at right shows the most dramatic moment of sailing day, April 10, 1912. Just after the tugs had dropped their lines and the *Titanic* was gathering way under her own steam, the American liner *New York* broke its stern moorings and drifted out toward the passing ocean liner. Marschall captures the most perilous moment of this episode, when the *New York* is a mere four feet away from the *Titanic*'s side. The smaller ship is heeling over as it is pulled by the suction created by the larger ship's passing. Only quick action from the *Titanic*'s pilot, who ordered the engines reversed, and the captain of a nearby tug, who had a line attached just in time, prevented damage that would almost certainly have delayed the voyage.

◆

For all his devotion to accuracy, Ken Marschall isn't afraid to make an educated leap or a romantic extrapolation. And he readily admits that the passing at sea of the *Titanic* and the *Olympic* on April 3, 1912, almost certainly did not happen exactly as he has painted it. For one thing, he has set the scene just before sunset, a heightened moment that etches the *Titanic* against the long light of the late afternoon. In fact, the evidence suggests that the event took place somewhat later—while there was still some daylight but after the sun had set. Marschall can't even prove the two ships passed within sight of each other. But if they didn't, this painting seems to say, they should have.

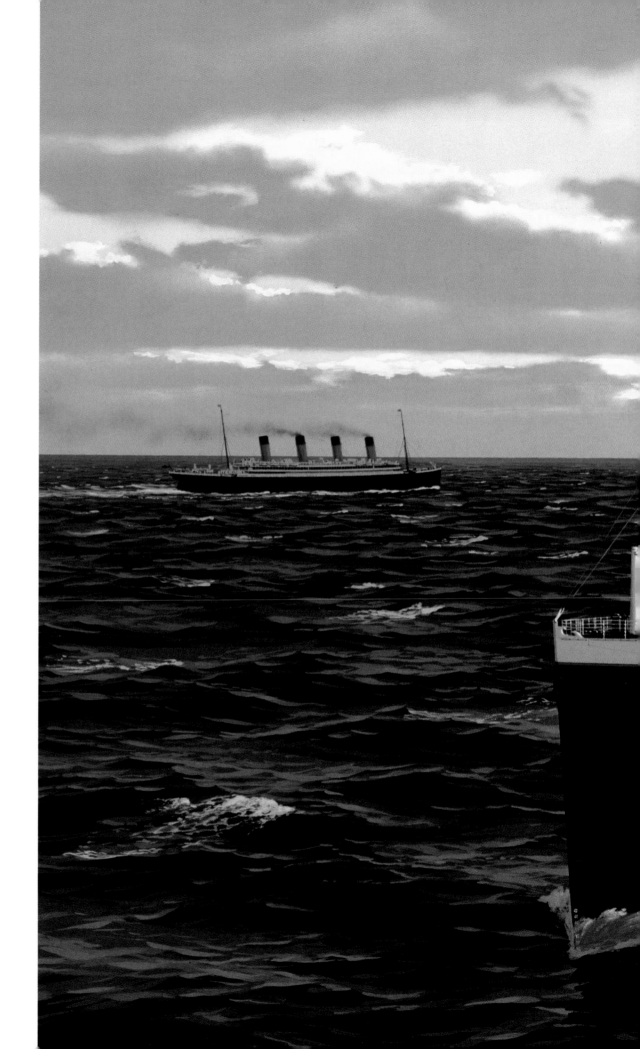

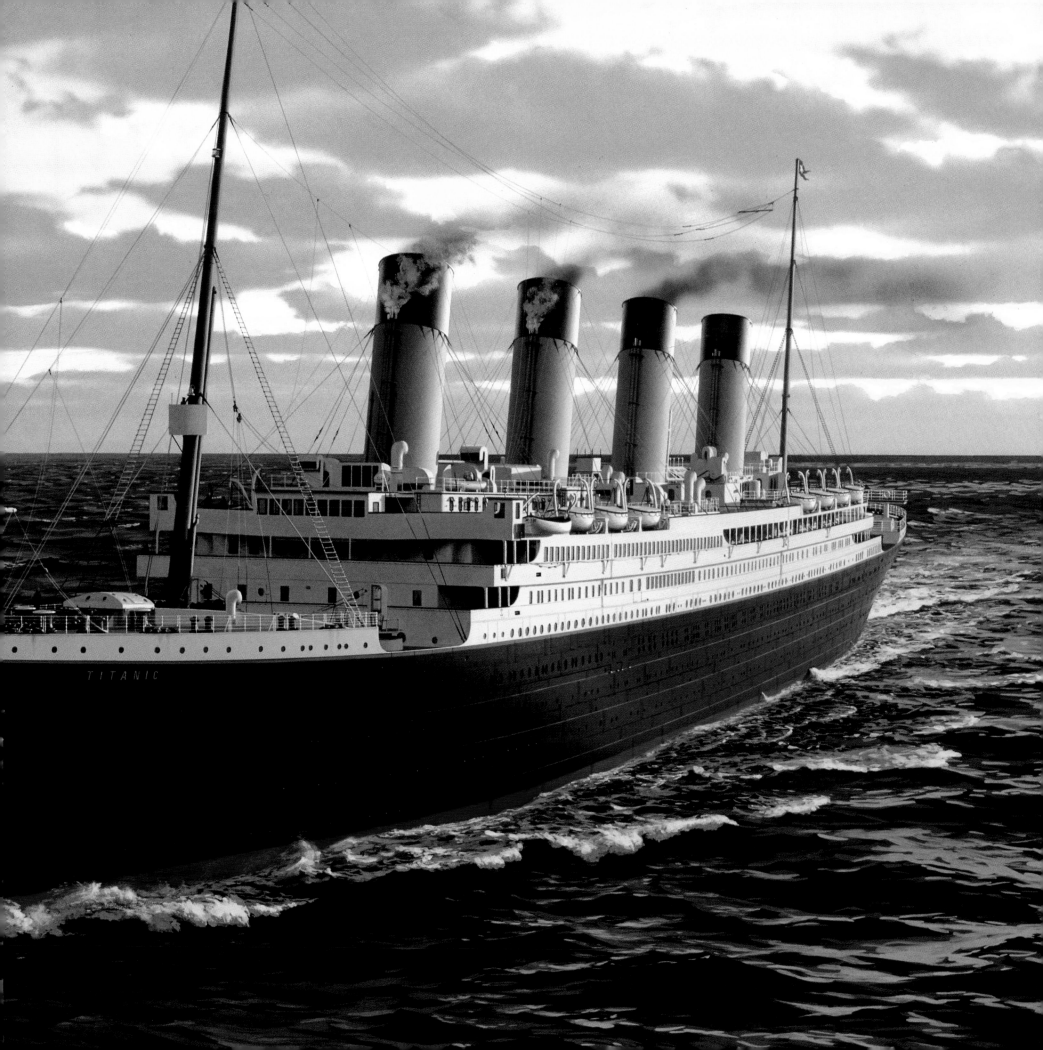

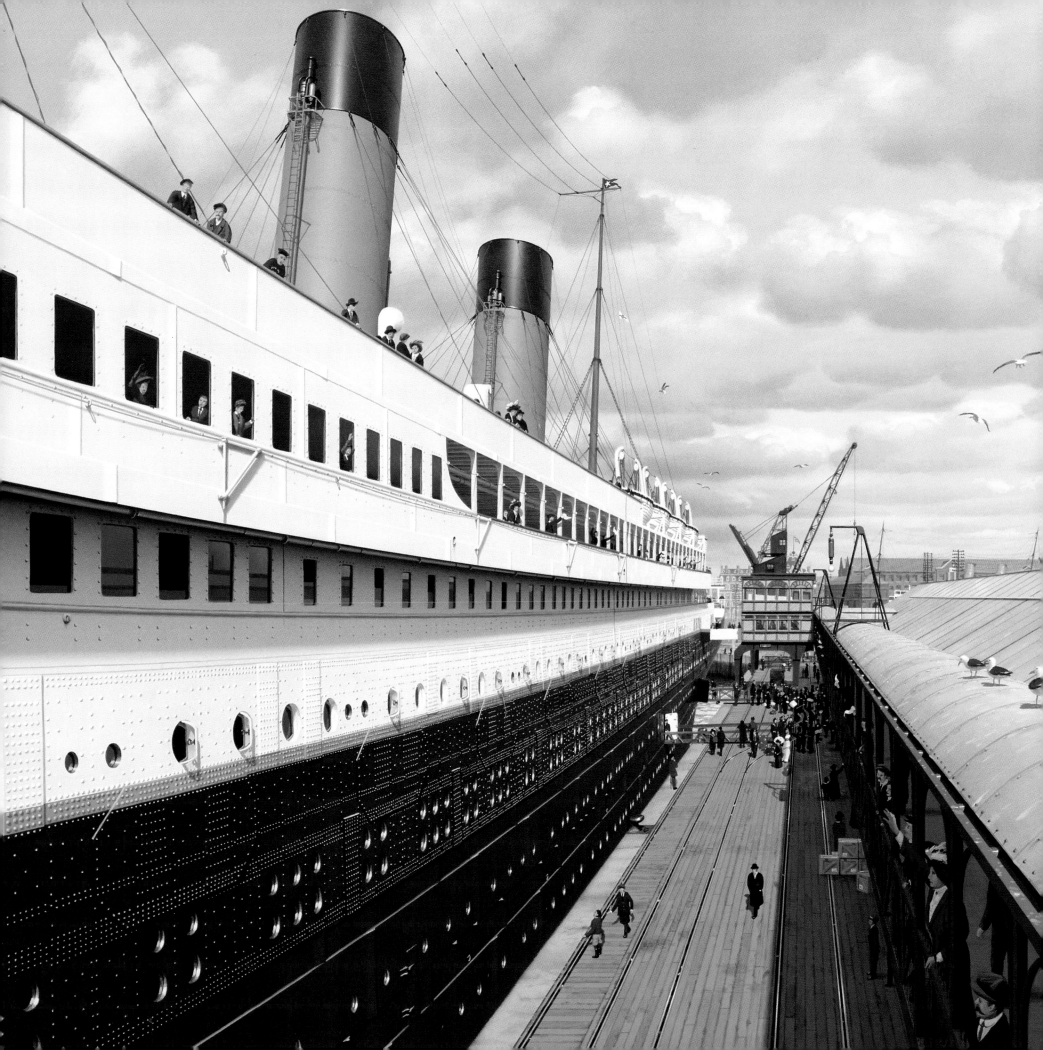

Sailing Day

✦

It is about 11:30 on the morning of April 10, 1912, a half-hour before sailing time. The White Star Dock, which only a few hours before was crowded with people and baggage, now stands almost deserted. The boat train is about to return to London. Every element is precisely in place. Even the South Western Hotel in the background looks exactly as it did on this day at this moment, right down to the dropped time ball on the flagstaff (seen behind the crane at center), which descended every morning at 10:00 A.M. The ship is shown in a very wide-angle view in order to encompass a greater amount of her length and height, including two of her funnels. She has been reproduced minutely, right down to each rivet holding the shell plating in place. To paint these accurately, Marschall plotted the entire rivet pattern by carefully following the original Harland & Wolff blueprint.

Before Ken Marschall applies brush to board, he often prepares a detailed layout, like the one above left, to work out the composition. Once he is satisfied, he transfers the layout to the painting surface. The first area he paints is sky and cloud. The ship and, in this case, the Southampton White Star Dock and sheds follow. The cutaway (above right) was painted for Marschall's picture book for children, *Inside the Titanic*.

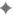

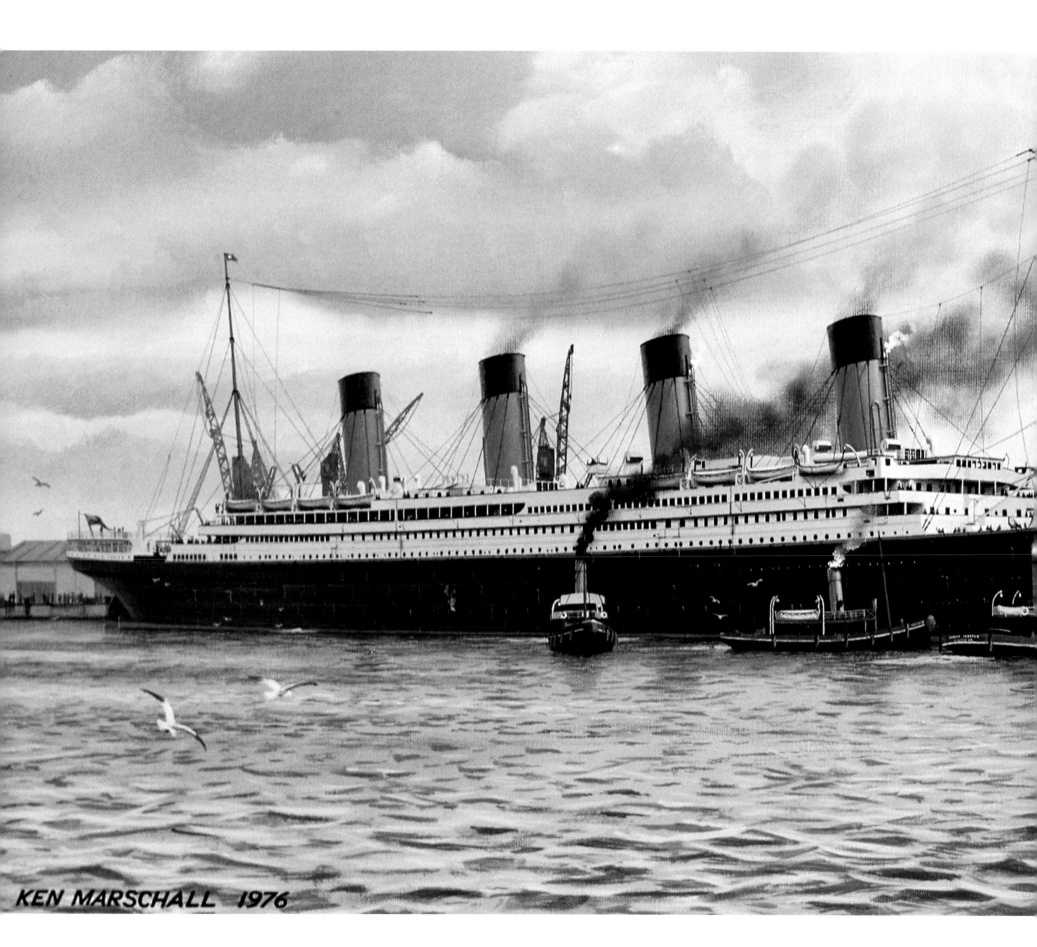

KEN MARSCHALL 1976

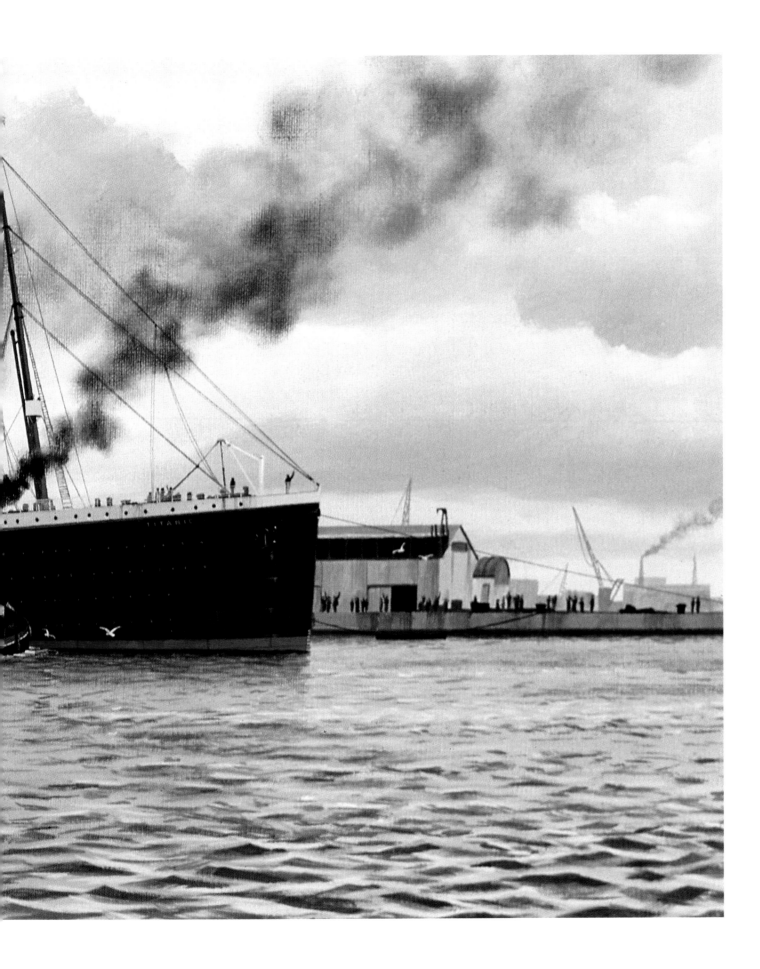

It is just past noon on April 10, 1912, as tugs draw the *Titanic* away from the White Star Dock. Steam gushes from her whistles as she gives a last farewell. In command on the *Titanic*'s brand-new bridge as the maiden voyage begins is George Bowyer, a veteran Southampton pilot. Beside him stands Captain Edward J. Smith (above), Commodore of the White Star Line, savoring the first moment of his final voyage before retiring, the magnificent cap to a distinguished career.

Cherbourg

◆

The White Star tender, or tug, *Nomadic* has just come alongside with a load of passengers as the *Titanic*, lying at anchor in Cherbourg harbor on the evening of April 10, glows with golden light emanating from nearly every window and porthole. One can almost hear the strains of the ship's orchestra serenading the passengers assembling for dinner, the excited buzz of conversation, the sense of being part of something special that is about to begin. For Marschall, this painting shows the ship at the peak of her pride as the biggest and most luxurious liner in the world.

The year after Marschall completed this painting, his friend Allen Hubbard took a trip to Paris. Admiring the view of the Seine from the Eiffel Tower, he suddenly turned to his wife and exclaimed, "Look! That's the boat in Ken's painting!" Amazingly, Hubbard was right. The tender *Nomadic*, retired from service in 1970 after a remarkable fifty-eight-year career, had been floated up the Seine to Paris, where it became a pierside restaurant, its owners at first completely unaware of the *Titanic* connection.

Generally, Marschall shies away from broadside views, which tend to be static and lacking in drama. For the painting on the following spread, however, which shows the *Titanic* off Queenstown, Ireland, in the early afternoon of April 11, a broadside view made historical sense. The tidal current determines the ship's direction at anchor. The lighthouse at Roche's Point (still standing today) provides a lovely punctuation point. And the tender *America* helps break the monotony of the long hull. But Marschall wasn't satisfied until, some years after completing this painting, he added the gulls, which draw the viewer's eye into the picture.

◆

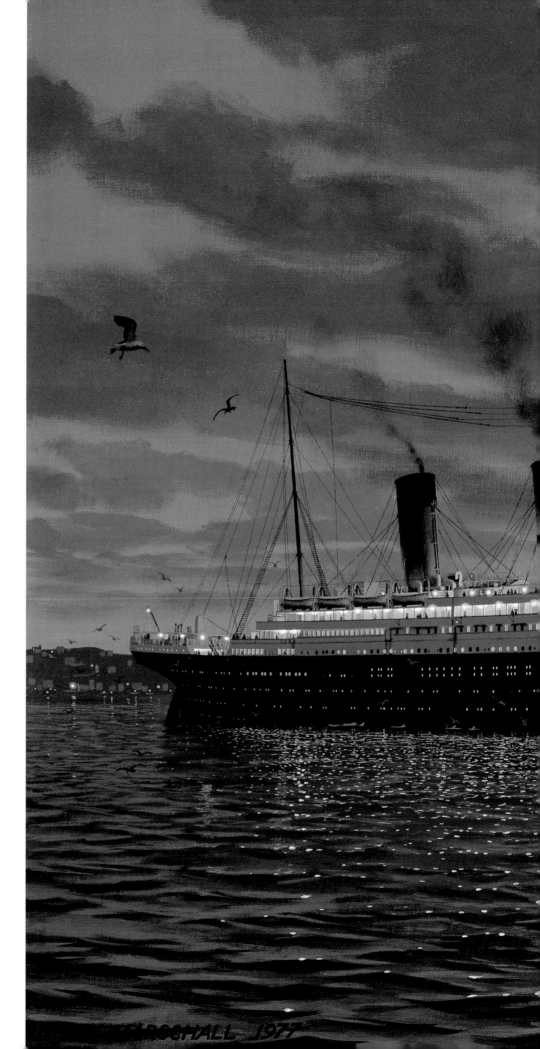

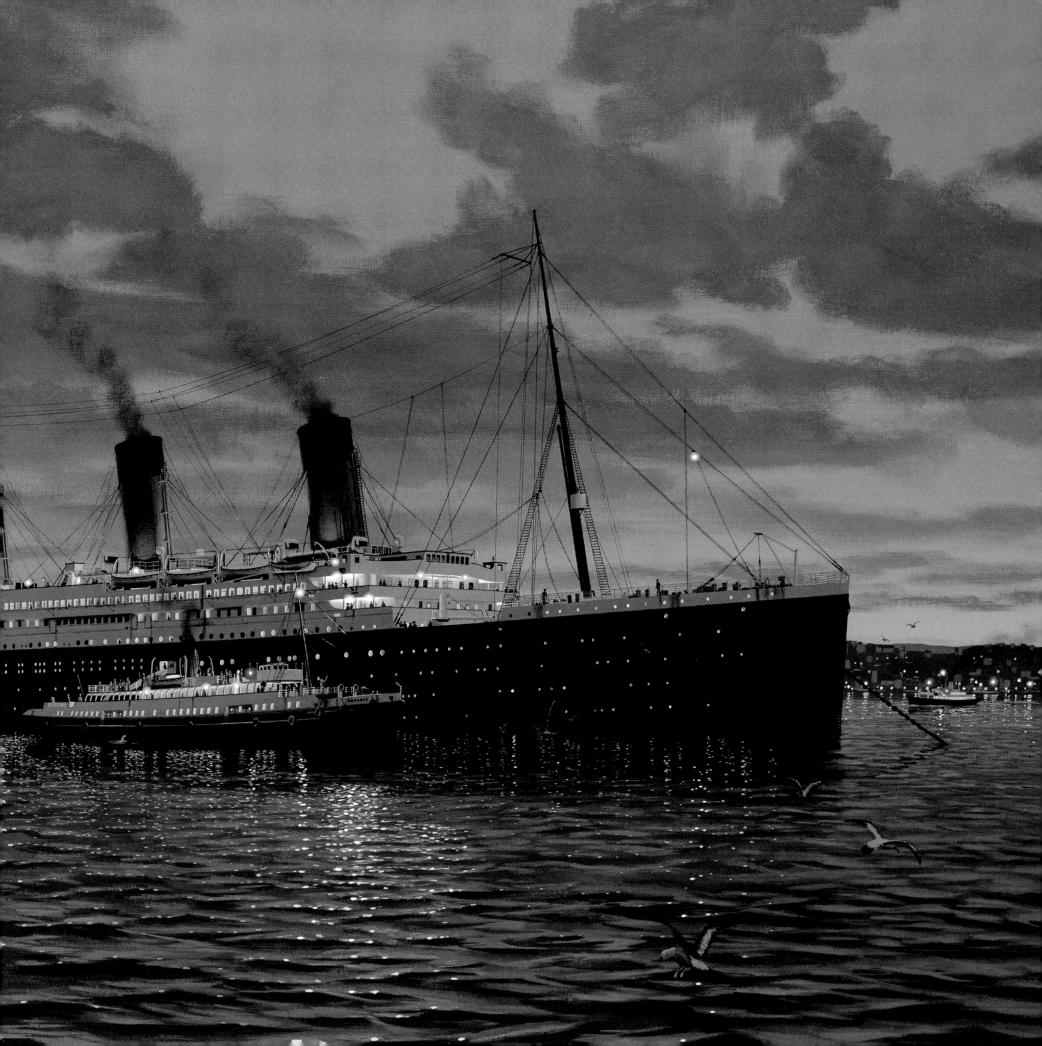

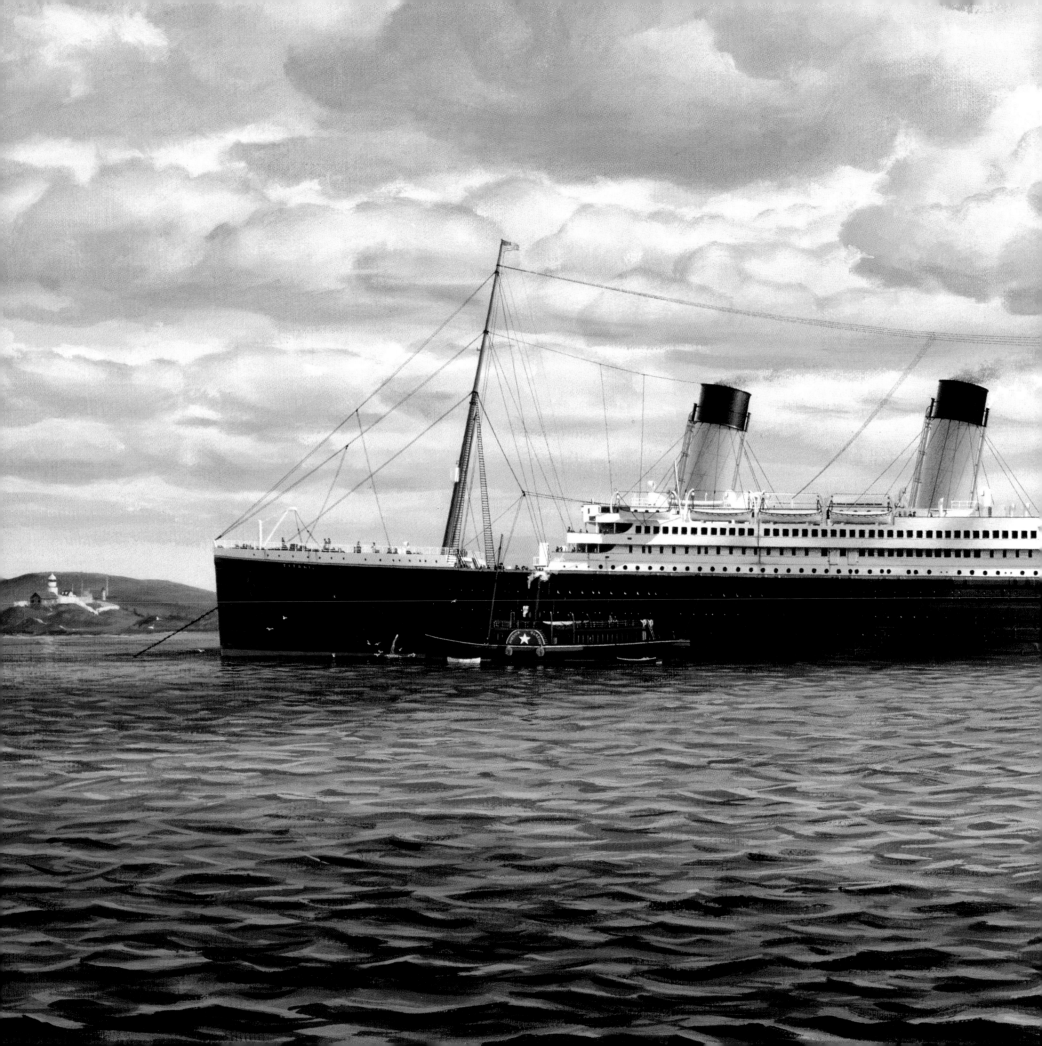

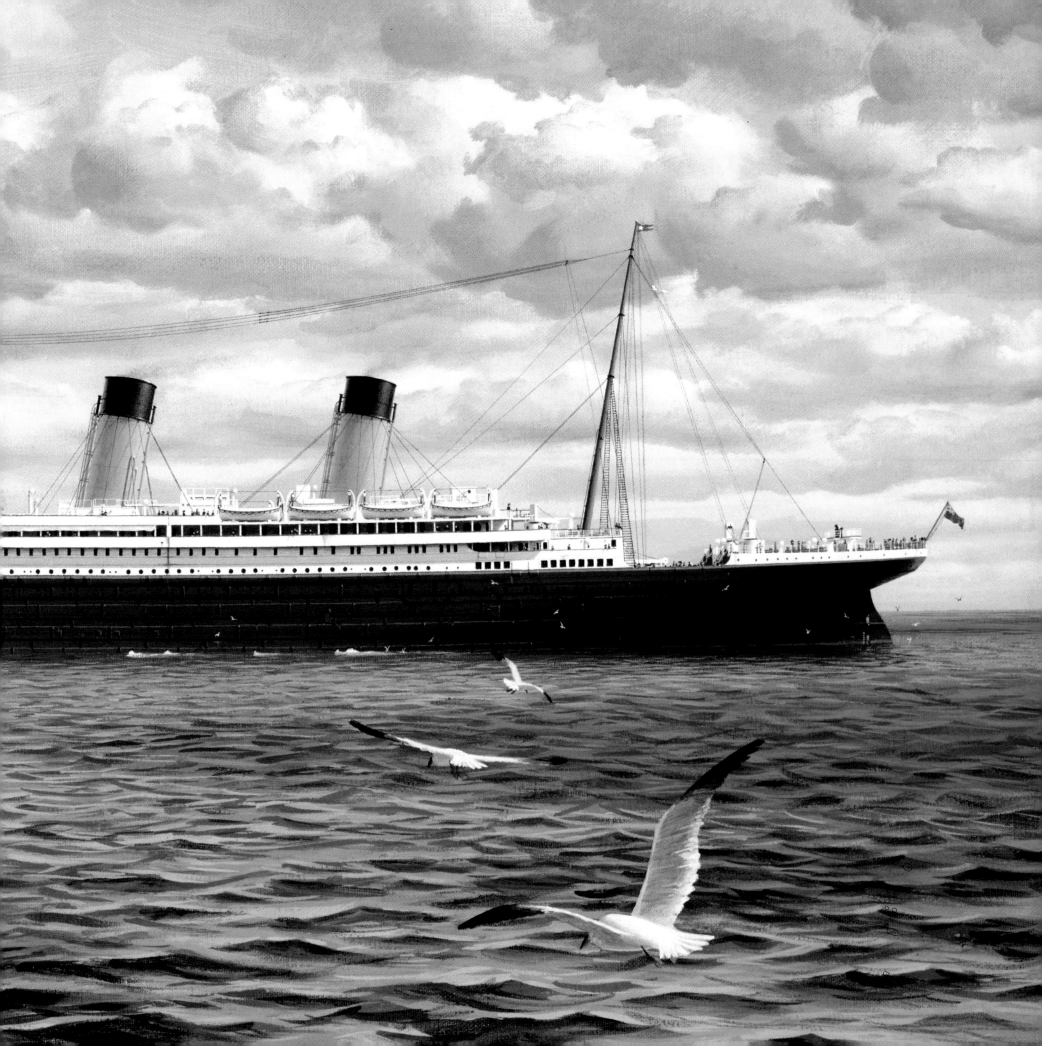

At Sea

On the afternoon of April 11, 1912, the *Titanic* passed the Old Head of Kinsale at the southern tip of Ireland and headed west across the North Atlantic. As the Irish coastline faded from view so did the ship's connection to dry land and daily concerns. For the next three and a half days, the more than 2,200 passengers and crew would be living in a self-contained world where real time was replaced by ship's time, a sliding scale that adjusted imperceptibly to each shift in time zone and where the routines of shipboard existence took precedence.

For the *Titanic* artist, the last European landfall also means a departure into the unknown. No subsequent photograph of the maiden voyage is known to exist. All we have to go on are the memories of survivors to help form our own images. Naturally, this is the section of the voyage where the imagination turns inward to the ship's interior, its public rooms, private suites, cramped steerage cabins, and noisy engine rooms—the spaces where the great and the not-so-great participated in a wonderful parade of late Edwardian life. In First Class, this assembly was a colorful one, led by ladies in expensive gowns recently purchased in Paris and men impeccably turned out in formal evening attire.

Many of the fine points of the *Titanic*'s interior remain mysteries. Apart from the standard newspaper portraits taken while the ship lay at Southampton, there is little visual material to rely on. And the *Titanic* differed in significant, if sometimes subtle, ways from her near-identical—and better-documented—sister, the *Olympic*. For many years, for example, the painting that decorated the First Class smoking room was known to us only by its artist, Norman Wilkinson, and its title, *Plymouth Harbour*. But recently the artist's son came forward with a photo of the painting in time to include an accurate reproduction of it on James Cameron's movie set.

One of the more tantalizing mysteries for someone as detail-conscious as Marschall is the forward Grand Staircase, crowned by its splendid glass dome, unquestionably the pièce de résistance of the *Titanic*'s fine interior. Yet he only has images of the *Olympic*'s Grand Staircase as reference.

From his study of the builders' plans and eyewitness accounts, and from the photographs that do exist of the *Olympic*, Ken Marschall has imagined himself in almost every corner of the *Titanic*. But given the lack of pictorial documentation, he has painted few scenes set within the hull. The notable exception is the Grand Staircase itself, which he has depicted just before Sunday dinner and, later, at the tragic moment two and a half hours after the collision, when water first crashed through the dome. But he has created several revealing cutaway views of the ship, including a magnificent cutaway of the whole liner in profile, that allow us to wander the *Titanic* with him.

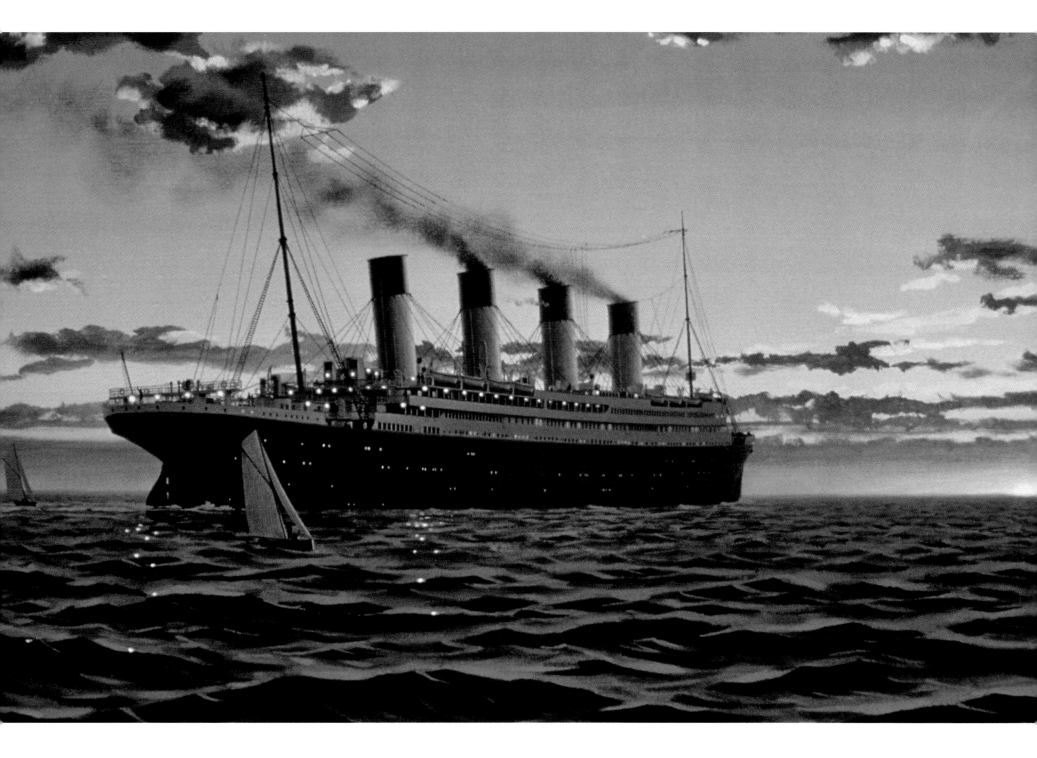

Marschall calls this painting *The Final Farewell*. It represents that poignant moment on the evening of April 11 when the *Titanic* steams out of sight of land and into the setting sun. She has left Europe behind. The promise of America is days away. She and her passengers have entered another realm.

Marschall places two small sailboats in the foreground to add visual interest without compromising accuracy. Not visible is a French trawler that has passed so perilously close to the *Titanic*'s bow that the ship's wave splashed her crew. The men in the tiny craft cheered. The huge ship answered with a blast from its enormous steam whistles. Then she sailed off into history.

A Painting in Progress

✦

Marschall painted this striking portrait of the *Titanic* under steam for the jacket of *Titanic: An Illustrated History*. Everything about the composition suggests power and foreboding. The ship is seen as if photographed through a wide-angle lens, giving it an almost supernatural presence. The sky is threatening, the water troubled but not violent. (Compare the water in this painting from 1992 with the less accomplished water in some of his earlier compositions.) The warm light cast by a setting sun to the left of the picture frame catches the funnels and the starboard side of the superstructure, while the bridge remains in shadow.

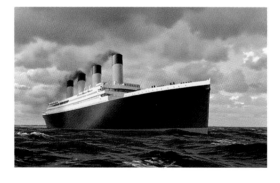
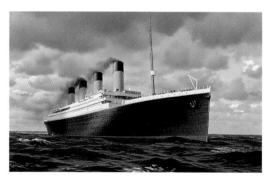

Using photographs and archival material as reference, Marschall begins by blocking in the shape of the ship (top left). Then he gradually fills in the sea and sky, as well as other parts of the ship, like the foremast. Fine detail, texture, and darker colors are the last to be added, giving the finished painting (right) greater depth and contrast.

✦

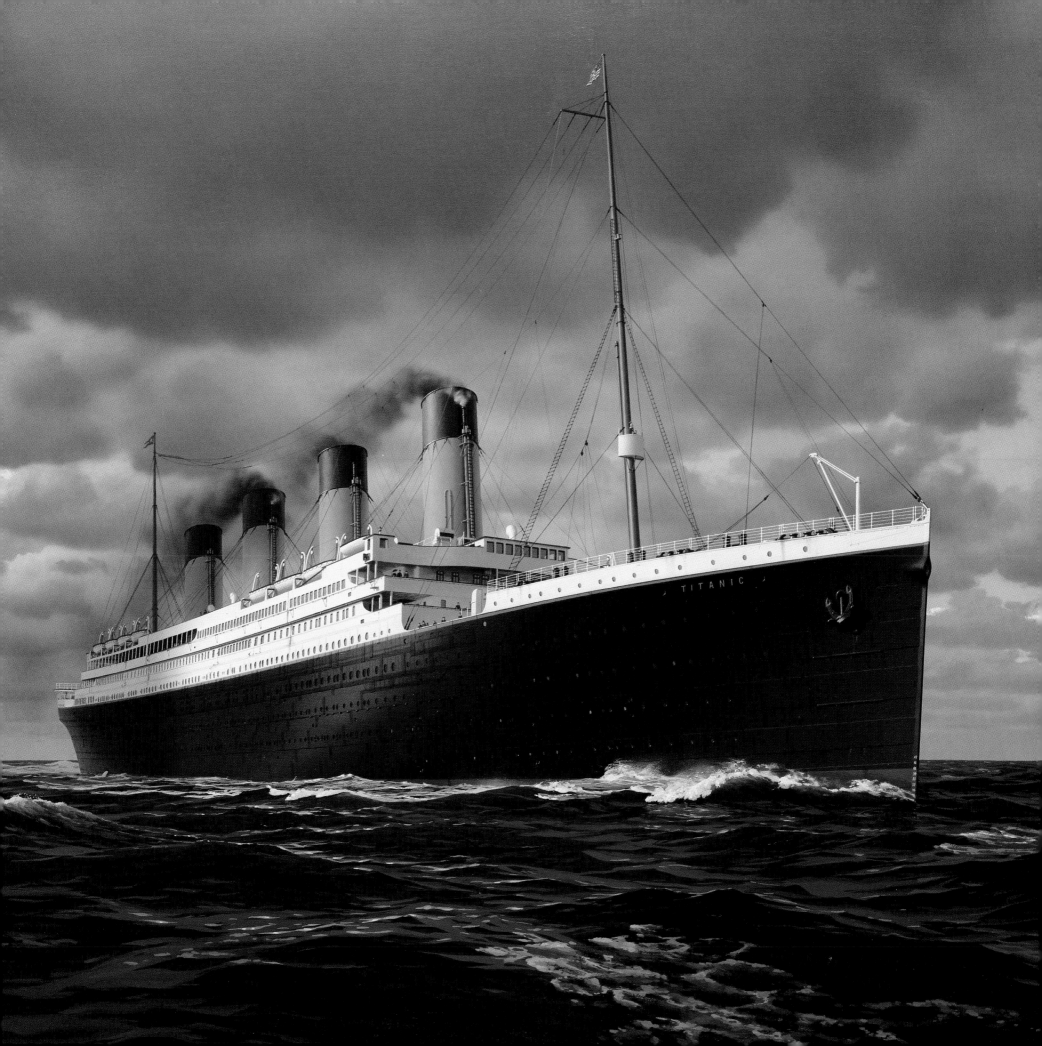

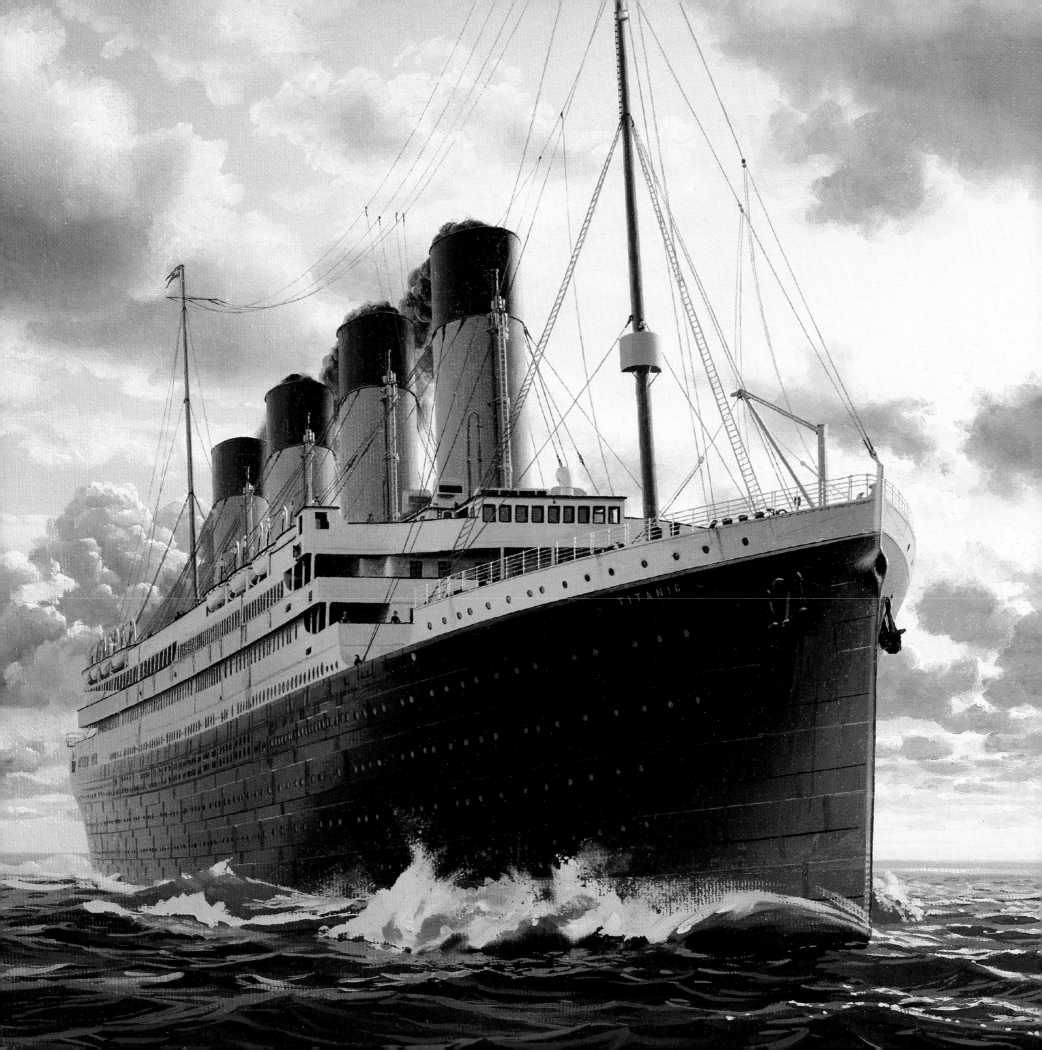

The portrait on the left stands as Ken Marschall's favorite. It appeared on the cover of *Exploring the Titanic*, Robert Ballard's account of the discovery of the wreck for young readers. Here the *Titanic* comes at the viewer more directly but less threateningly than in the painting on the previous page—out of a happier sky and churning an almost ebullient bow wave. The scene is gloriously backlit by the rising sun as the ship makes her steady course across the empty sea.

For the cover of another children's book, *Inside the Titanic*, Marschall painted the dramatic cutaway illustration of the bow shown on the right. From cargo spaces to Third Class and crew quarters, the minutiae of the ship's forward interior are clearly visible.

(Overleaf) The *Titanic* in cutaway.

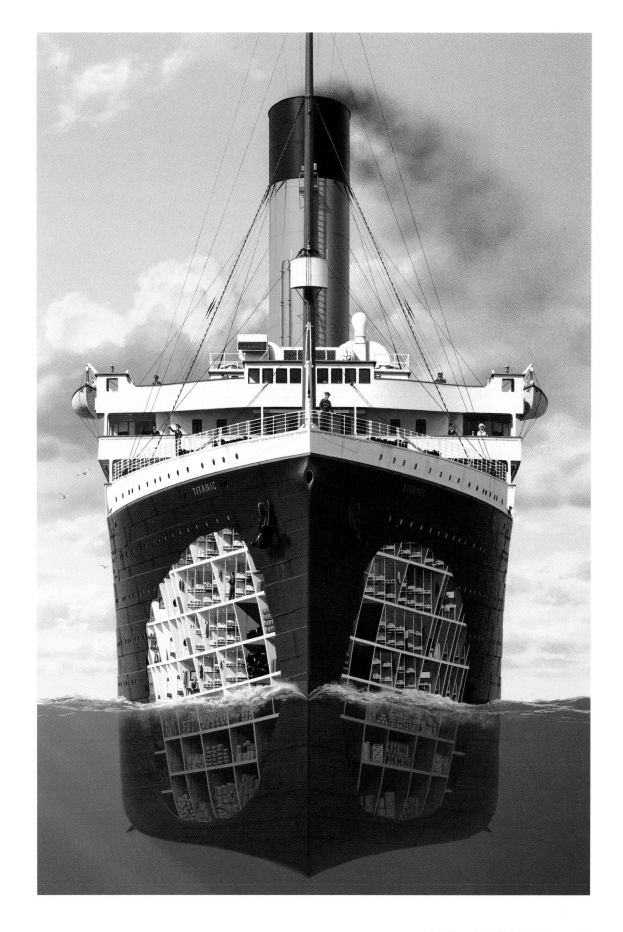

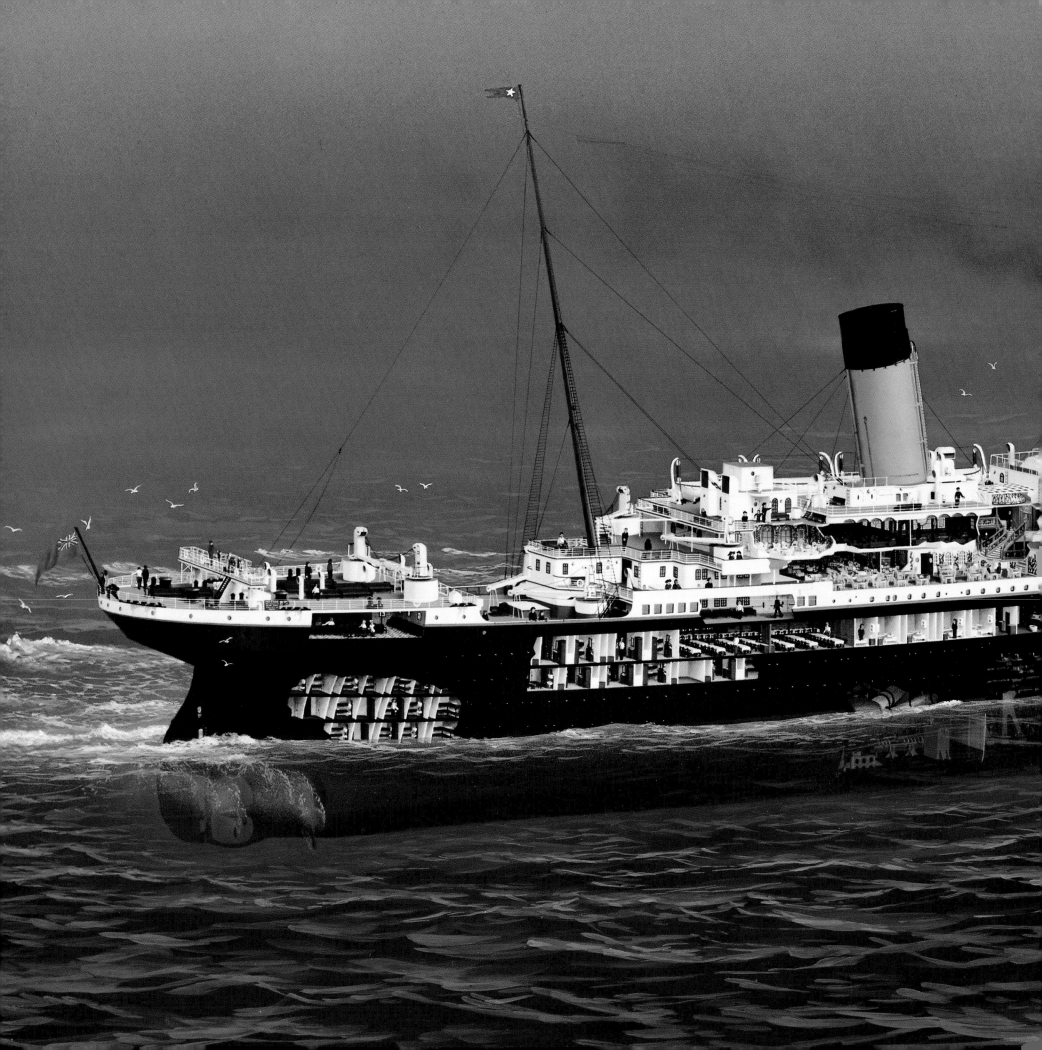

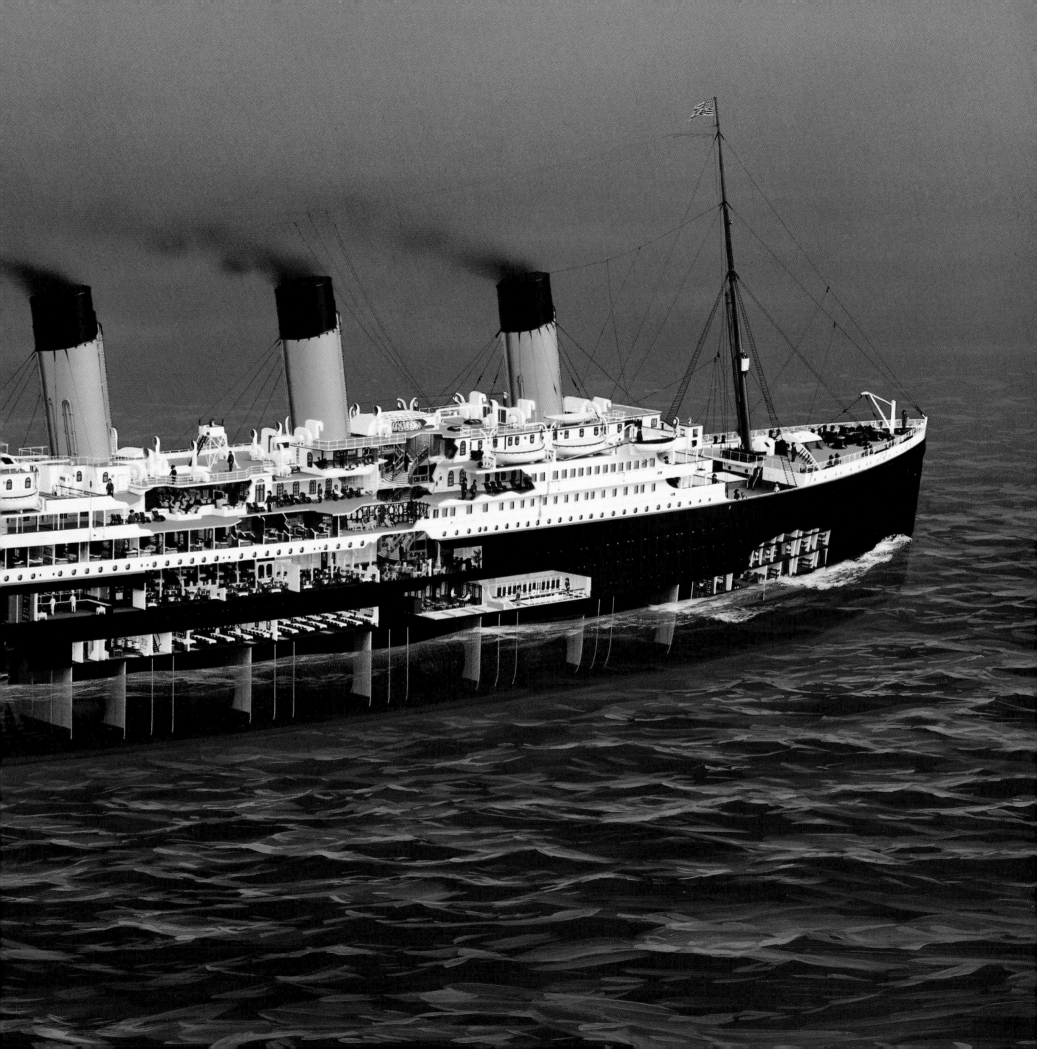

✦

One of the great delights of Marschall's pictorial chronicle of the *Titanic* story is his cutaway painting of the ship in profile (previous page). Of all Marschall's works of *Titanic* art, this one took the most time and required the greatest dedication to getting things right. In a way, the painting is like a guided tour of the ship—but not of every nook and cranny. Echoing the uncertain state of knowledge about the ship's interior, the painting hides as much as it reveals, leaving the viewer to fill in the gaps with his or her imagination. In order to get the contours and proportions of the hull just right—the stern is turned slightly toward us—Marschall set up his scale model of the ship outdoors and photographed it from several angles with a telephoto lens.

 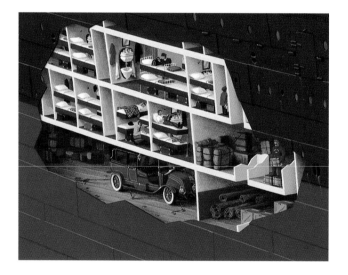

For *Inside the Titanic*, Marschall painted enlarged, close-up sections of the ship's interior in cutaway.
He took young readers into the elegant First-Class suite on B-deck occupied by the Carter family of Philadelphia (above left);
into the depths of the ship where the Carters' Renault (the setting for a passionate scene in James Cameron's *Titanic*)
was stored (above right); and into many of the more interesting public spaces (opposite), including the forward
Grand Staircase, the gymnasium, and the First Class dining saloon.

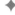

◆

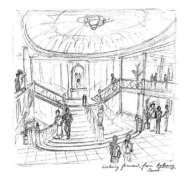 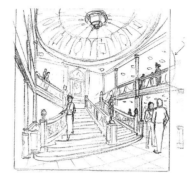 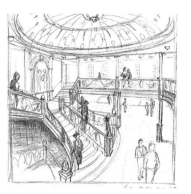

When trying to render the forward Grand Staircase as accurately as possible, Marschall was fortunate to have been given a scale model by one of his oldest friends in the *Titanic* world, Father Roberto Pirrone. He had helped Father Pirrone with reference material for an eighteen-foot cutaway model of the whole ship that Pirrone had worked on for many years. Before beginning the painting, Marschall photographed the model from many angles in order to understand how the spaces worked and how the scene would look from different vantage points. The sketches above show him exploring the space from these varying angles before choosing the one that worked the best.

Marschall unhesitatingly admits that his boyhood friend Rick Parks helped render the people in this painting. Rick realized the figures in the foreground, including the stunning lady in a scarlet gown descending the last few steps. Her dress is a careful replica of an actual "Lucile" creation, designed by Lady Lucile Duff Gordon, one of the *Titanic*'s more notable passengers.

 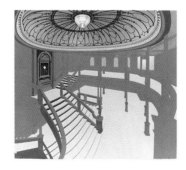 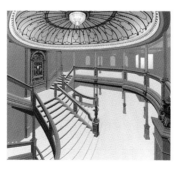 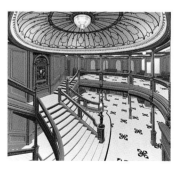

In the four illustrations above, we see the gradual emergence of the Grand Staircase painting. Marschall begins by painting the basic architectural elements, then gradually builds up detail. In the final illustration, the painting is nearly complete, except for the addition of the passengers.

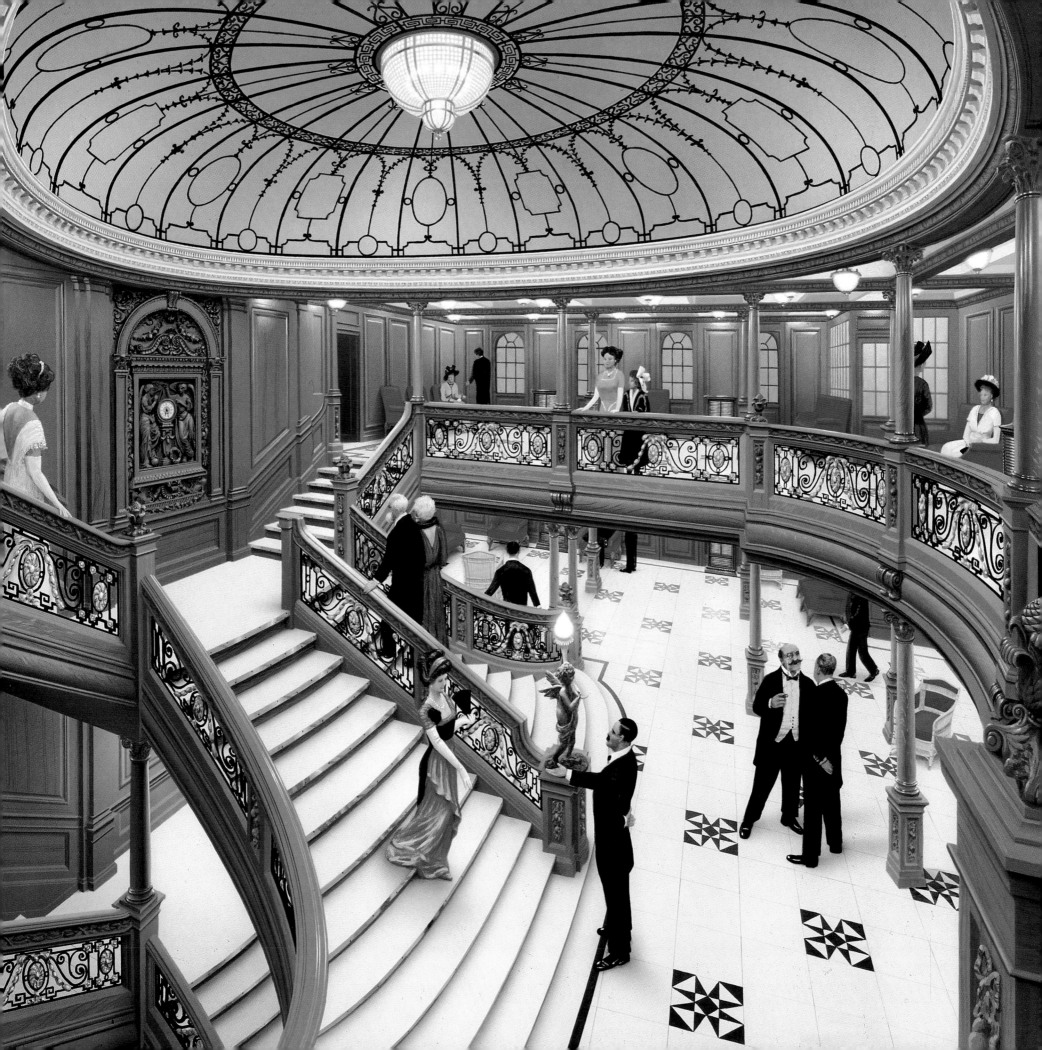

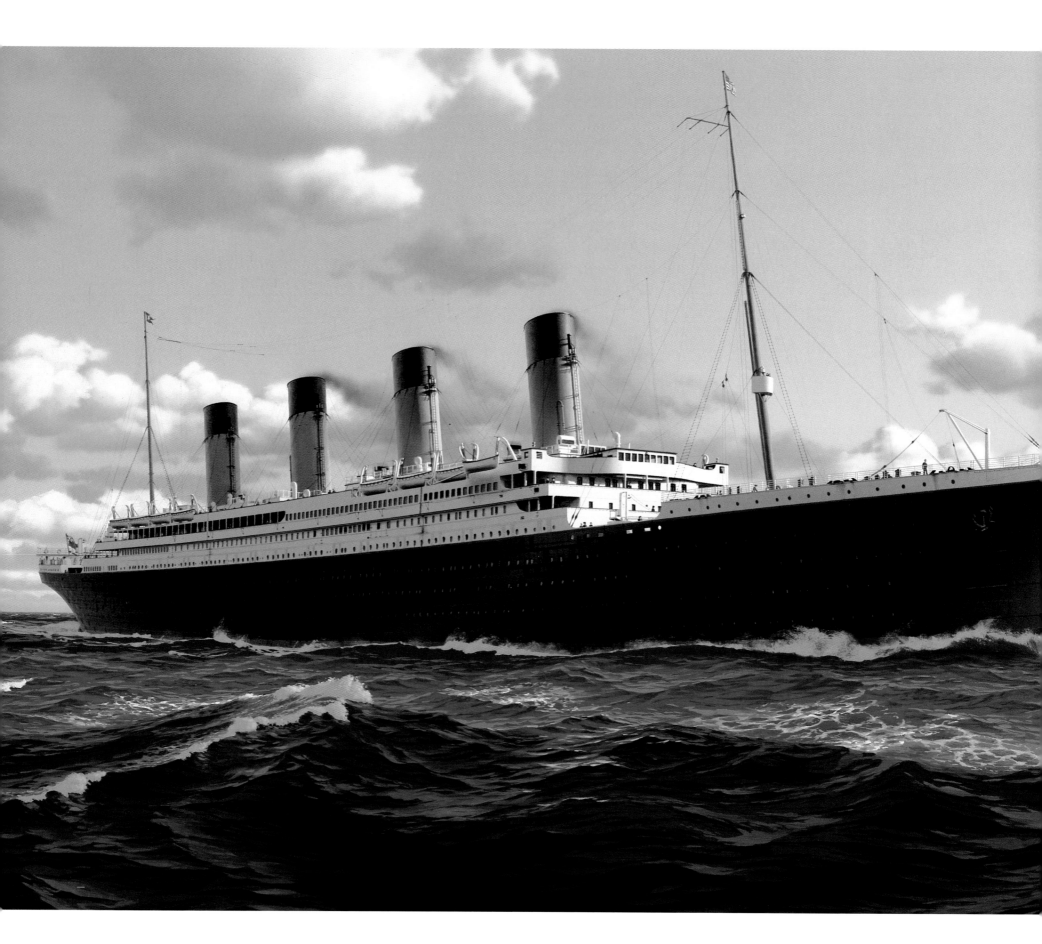

(Left) This view of the liner slicing through the Atlantic swells reveals a detail that some might find incongruous in so new a vessel—rust on her starboard side. Marschall has sometimes been criticized for showing rust on the *Titanic,* but he does so on good authority. While the port side of the ship was touched up at Southampton, the starboard side was not. Careful examination of the photographic record supports this detail. The scene on the early evening of April 14, 1912 (below), shows the dramatic sunset noted by those passengers who braved the chilly air on deck to admire it.

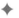

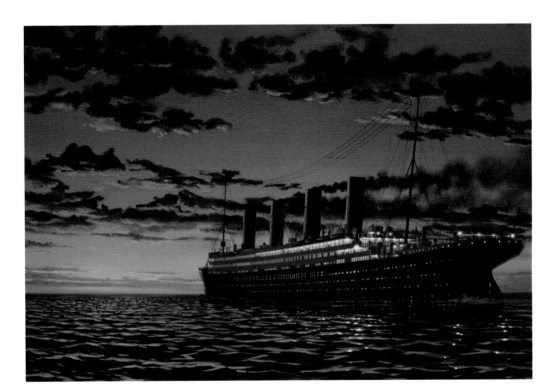

Collision

But for the *Titanic*'s fatal brush with an iceberg, we would know little of its maiden voyage. Because of it, that voyage has become one of history's most famous ocean journeys. And with the "slight, grinding jar" one passenger felt as the hull scraped along the iceberg's edge, the story takes on a sudden urgency. The carefree ocean voyage is over. Less than half an hour later Captain Smith receives the estimate that his ship will sink in barely two hours.

Like other *Titanic* historians, Ken Marschall has carefully studied the events leading up to and following the collision. His understanding of what actually happened that night was greatly enriched by the discovery of the wreck in 1985. From eyewitness accounts, he knew the approximate height of the iceberg above the water: it reached the level of the boat deck and so must have been about sixty feet high. But when it came to imagining the ocean scene as midnight approached, he was very much on his own.

Was the sea studded with giant icebergs and the smaller bergs known as growlers? Or was the deadly berg a lone crag on an empty sea "like glass." The record shows that when the *Titanic* sailed into the sunset on April 14, it sailed toward an empty horizon, in unusually calm conditions. Various wireless messages had reported bergs, growlers and a field of ice directly in the *Titanic*'s path. But the exact setting at the moment of collision is anyone's guess.

A keen amateur astronomer, Ken has researched exactly how the constellations would have appeared in the clear moonless mid-Atlantic sky on the fateful night. He even went to the trouble of placing the stars accurately in his early paintings, a painstaking activity that he now admits was beyond the point. Most important is to create a mood. In the paintings of the ship before the collision, the mood is one of insouciant gaiety contrasted with imminent danger.

With the collision, the *Titanic* story takes on a moment-by-moment immediacy. From now on, it is the story of a disaster. In the pages that follow, Marschall chronicles its most important moments.

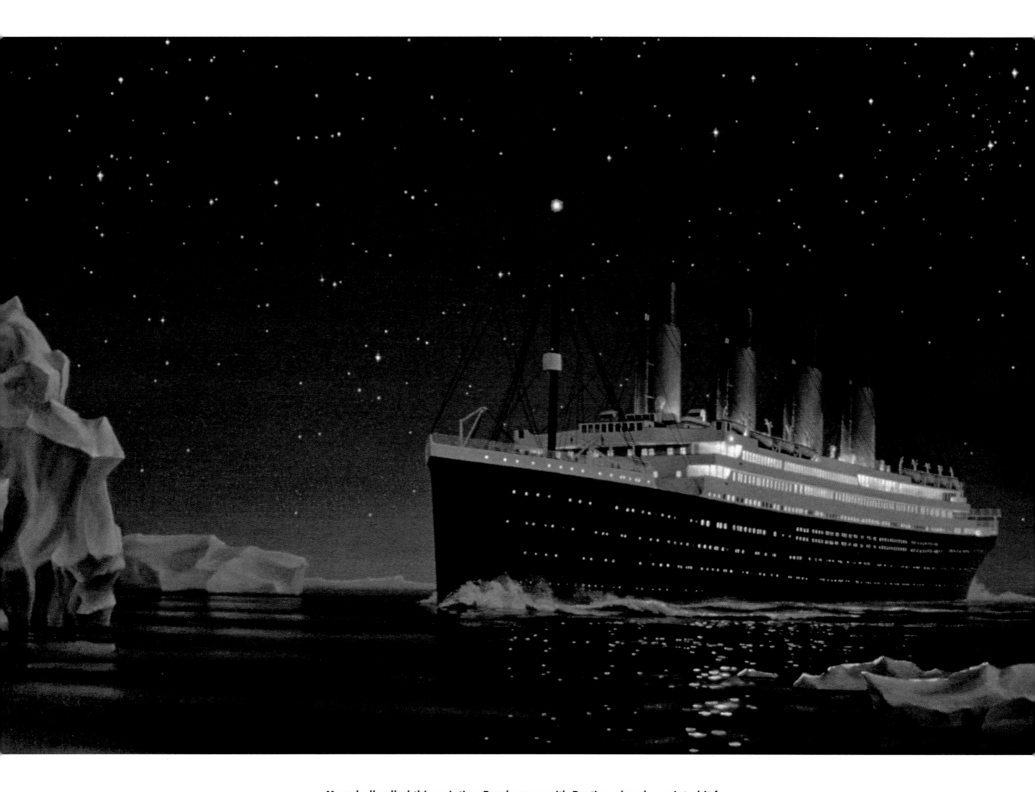

Marschall called this painting *Rendezvous with Destiny* when he painted it for a
record album cover in 1973. The album told the story of the *Titanic* through interviews with survivors
and others connected with the vessel.

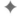

With many of her lights still blazing, R.M.S. *Titanic* sails unwittingly toward disaster. Viewed from a distance as she sails on into the calm starlit night, the scene has a tranquil quality at odds with the catastrophe that is about to take place. Just before 11:40 P.M., lookout Frederick Fleet frantically rings the bridge telephone. "Iceberg right ahead!" he shouts into the mouthpiece when Sixth Officer James Moody finally picks up the receiver. First Officer William Murdoch then orders the wheel "hard 'a starboard," a quaint holdover from the days of sail that actually means the ship will turn to port. But by now it is too late. The iceberg toward which the ship is steaming rises above the ship's deck, taller than the actual iceberg must have been. Artistic license had to be taken here, since from this perspective, the real berg wouldn't have had the dramatic impact the painting needed.

◆

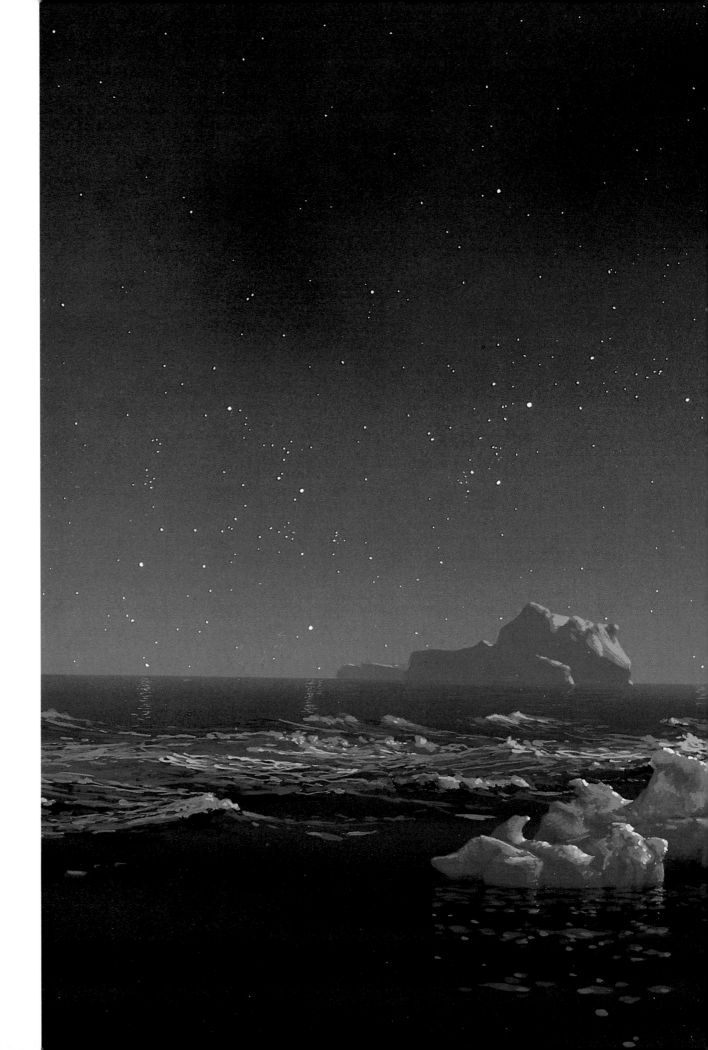

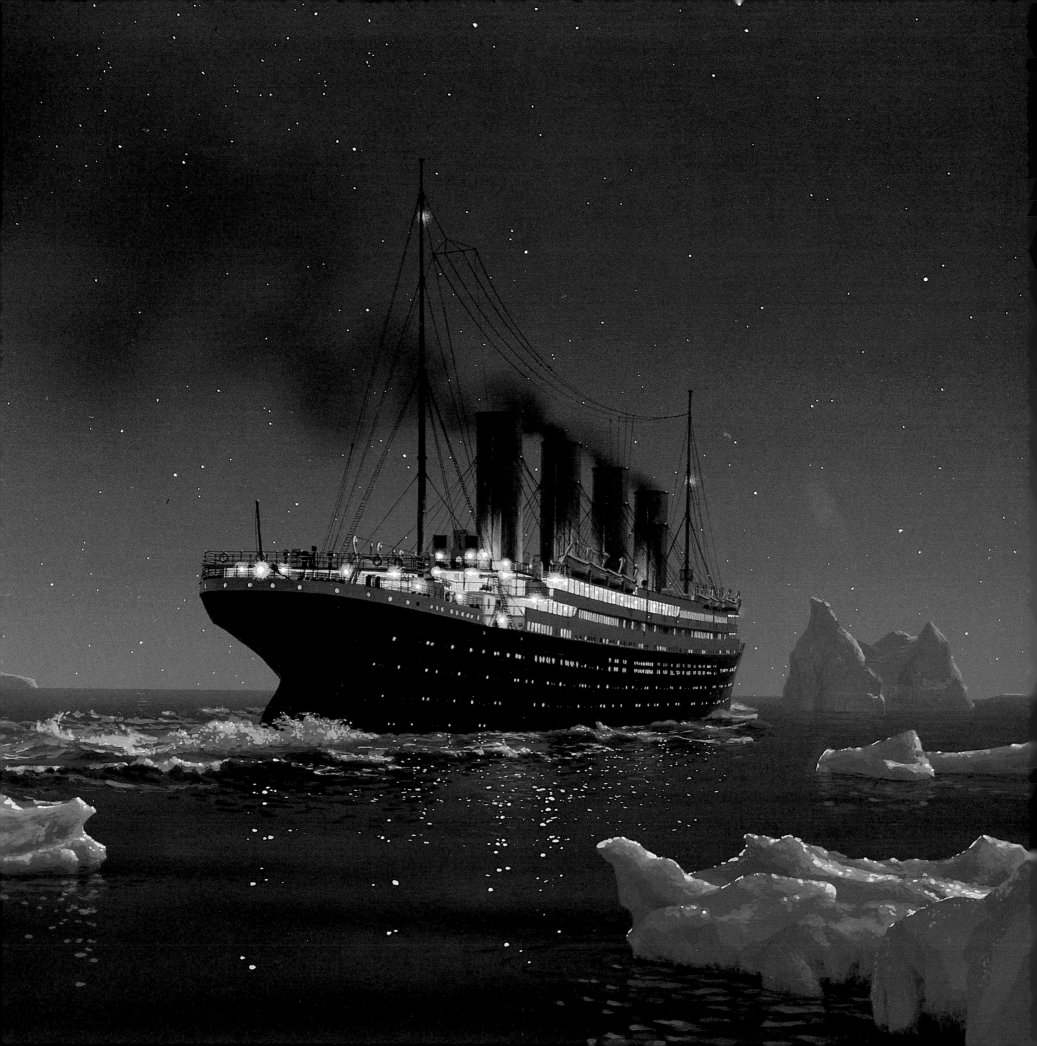

Iceberg Right Ahead

◆

First Officer William Murdoch repeats the alarm "Iceberg right ahead" as he rushes into the wheelhouse, where he orders the wheel turned to port and the engines "full astern" (below). Marschall holds the view, shared by a number of *Titanic* historians, that this combination of orders doomed the ship. With the propellers coming to a stop and then reversing, the slipstream that fed the rudder's turning power eased. As it was, the ship needed only a few more feet to miss the berg. Had Murdoch simply ordered a full turn to port, the *Titanic*, Marschall believes, would certainly have cleared the berg without a scratch.

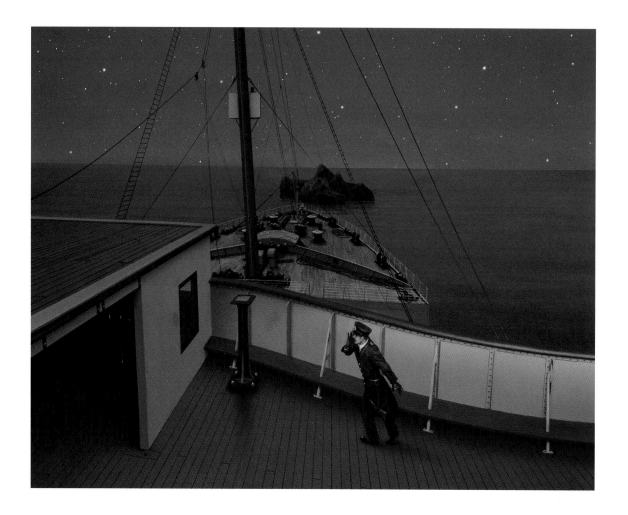

(Opposite page) Marschall cuts away to investigate the scene on the bridge moments before the iceberg is sighted. Quartermaster Robert Hichens is at the wheel, holding the set course. To his left stand Quartermaster Alfred Olliver and Sixth Officer James Moody. First Officer William Murdoch strolls on the starboard bridge wing.

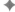

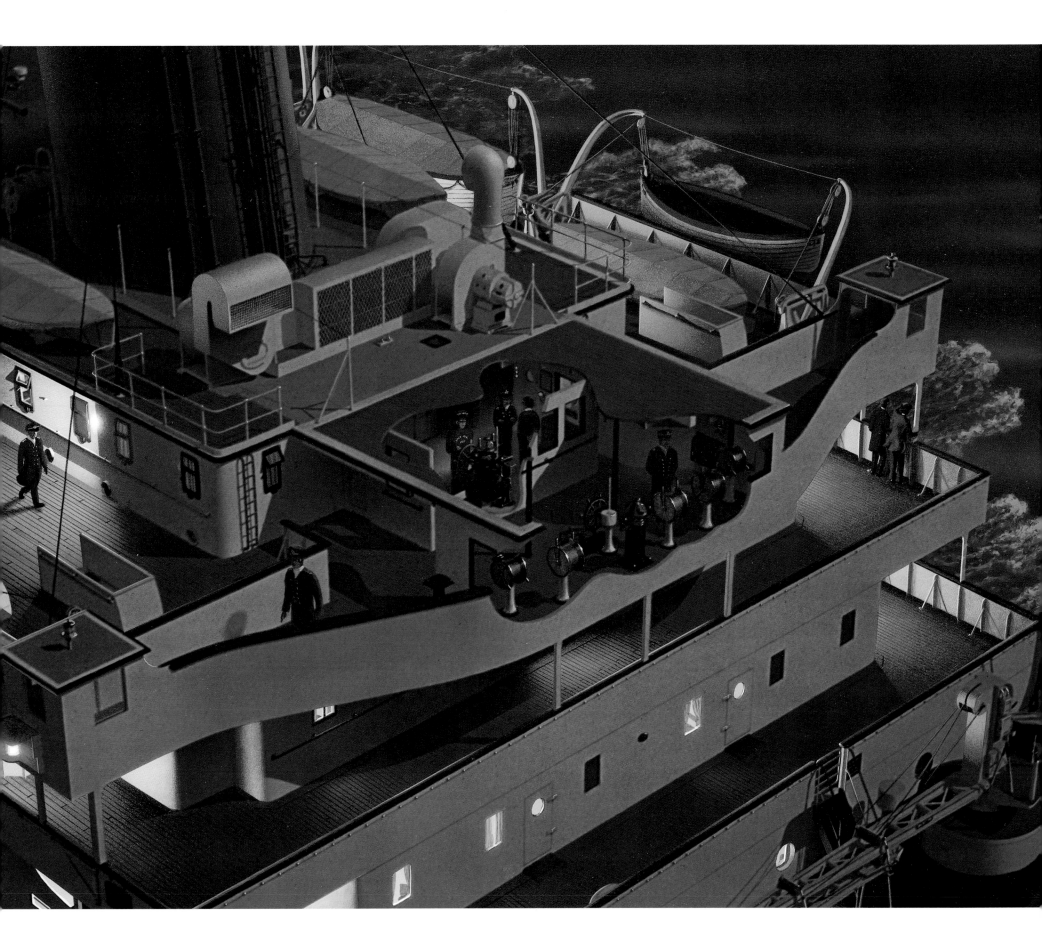

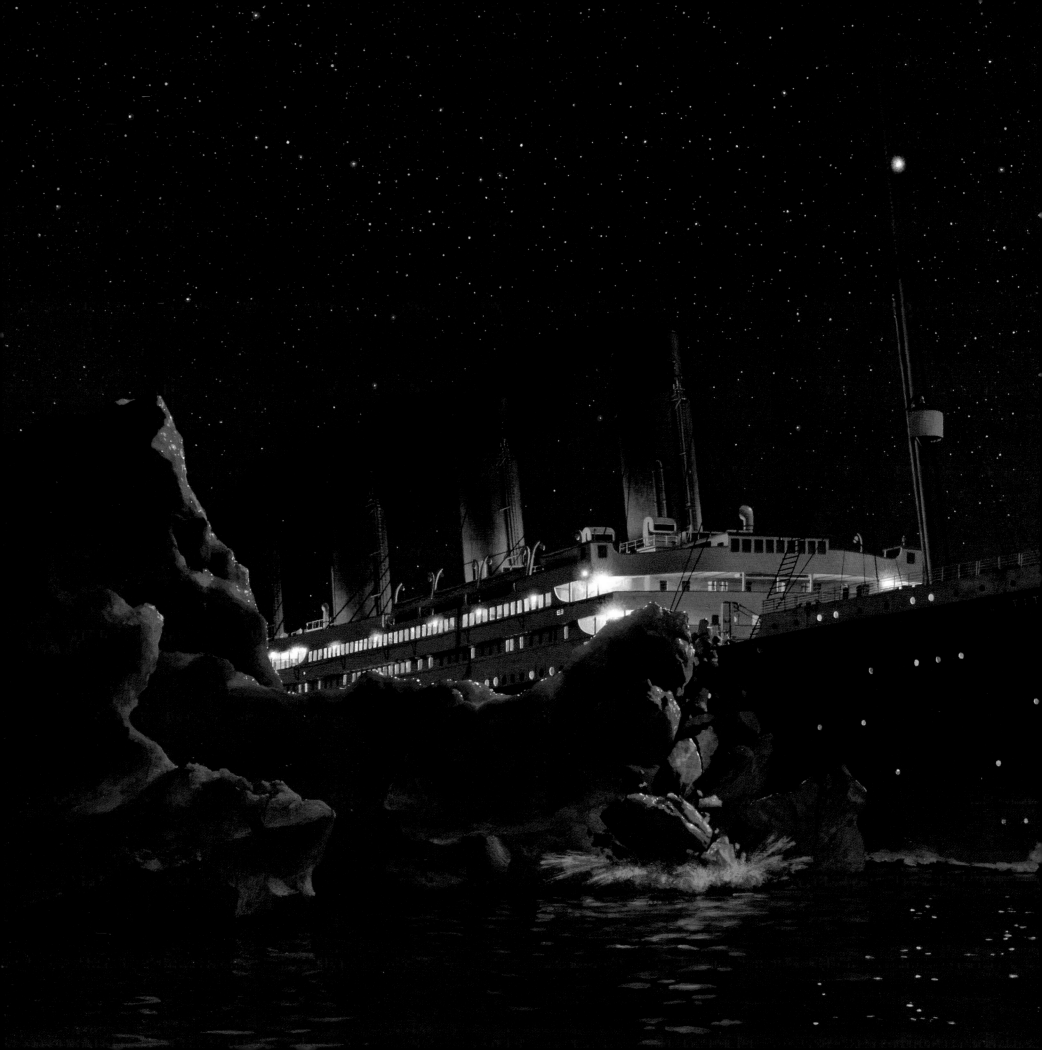

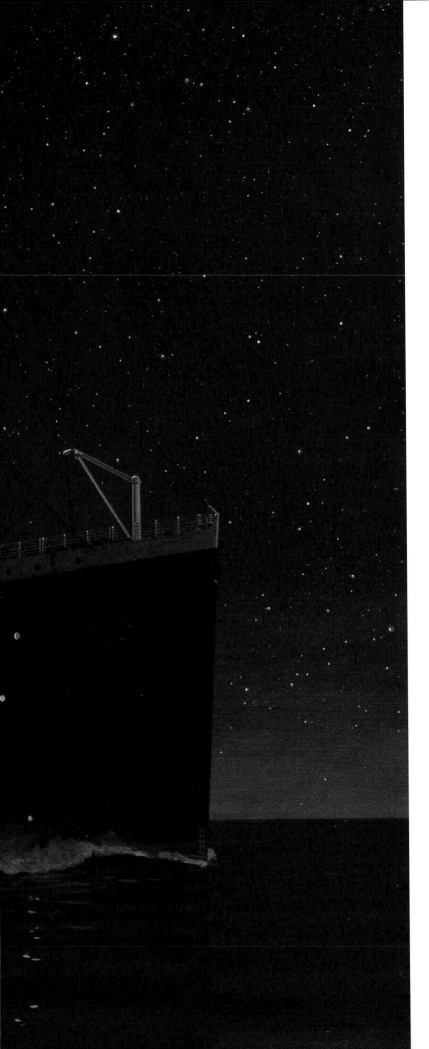

These two views of the collision are as accurate as the artist could make them, given the evidence. The berg that scrapes along the hull (left) is just high enough to topple chunks of ice into the well deck. Third-Class passengers, who don't realize how serious the damage is, will later play with pieces of it. The head-on cutaway view (below) focuses on the part of the ship where the impact is greatest: Boiler Room No. 6 and the forward compartments, where the iceberg opens the ship to the inrushing sea.

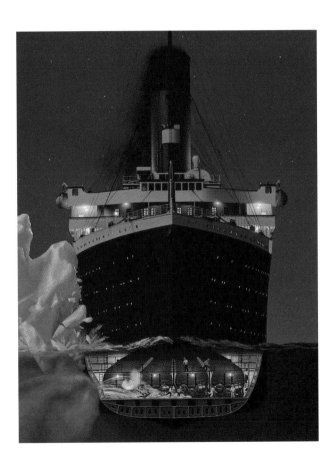

To the Lifeboats

The two and a half hours between the collision with the iceberg and the *Titanic*'s final plunge have inspired more words and pictures—both still and moving—than any other part of the story. No wonder. During that brief stretch of time, more than 2,200 human beings found themselves focused on one of life's ultimate questions: in the face of death, how will I behave?

This same question also connects us to an event that happened more than eighty-six years ago and helps explain the *Titanic*'s staying power. In the remarkable diversity of the ship's passengers and crew each of us can find a counterpart. Each of us can imagine being there.

Many of those who *were* there have left us gripping eyewitness accounts of the night. And thanks to the two official inquiries—one American, one British—held following the disaster, an ample written record exists. This documentation has provided Ken Marschall with many points of inspiration: each of his paintings set during the sinking corresponds to a particular recorded piece of the story. Even in outline, the account makes chilling reading.

Around midnight, only twenty minutes after the collision, Captain Smith turns to Thomas Andrews, the *Titanic*'s chief designer, for an estimate of how long the ship has left.

Andrews and Smith know that the first six compartments have been breached and that water has already risen to the mailroom, twenty-four feet above the keel. Andrews makes some quick calculations then delivers his verdict: "an hour and a half, perhaps two." Both Smith and Andrews know that due to the out-of-date regulations of the British Board of Trade, the ship carries only twenty lifeboats, having a maximum capacity of 1,178. There is little hope for roughly half of the over 2,200 on board unless another ship arrives in time.

The nearest ship to receive the *Titanic*'s distress call, sent out at midnight, is Cunard's *Carpathia*. Although Captain Arthur Rostron immediately turns his ship around and races toward the distress position, Captain Smith realizes rescue cannot reach them in time. So the *Titanic*'s commanding officer faces the unenviable dilemma of trying to evacuate as many people as possible from his ship without creating panic. Because no general alarm is ever raised—either through indecision or by design—the seriousness of the situation dawns only slowly on the passengers, most of whom can't believe that their giant ship could founder and are reluctant to leave its apparently solid decks.

As one of the highlights of the story, Marschall has chosen to paint the firing of the first rocket at around 12:45 A.M.

(page 88), an event that alerts most of the passengers already up on deck that the ship is in serious trouble. By the time the last rocket is fired at 1:20 A.M., most of the lifeboats have departed, many of them less than half full. In Marschall's painting, the stern looms in the foreground, the propellers rising ominously from the water.

As the slope of the deck grows steeper, more passengers willingly leave the ship. But in the general confusion, portside Lifeboat No. 2, the second-last boat away, departs with only twenty-five people on board. It has room for forty. By 2:05 A.M., the last boat leaves and water is about to wash onto the promenade deck. There are still more than 1,500 people on board.

At 2:18 A.M., with the stern jutting upward at perhaps a forty-five-degree angle, a huge roar rises up from inside the ship as all movable objects crash toward the bow. The liner's lights then go out. With a horrible scream of metal and explosion of sparks, the *Titanic*'s huge hull tears apart between the third and fourth funnels, and the bow begins its plunge to the seafloor. The stern seems to right itself briefly, then rises up until it reaches a vertical, where it pauses for a few agonizing moments before dropping slowly straight down, like some huge elevator.

Marschall's paintings of these final moments have clearly inspired the parallel scenes in James Cameron's *Titanic*, as has his portrayal of the water crashing through the dome and invading the forward Grand Staircase.

A little over an hour later, at 3:30 A.M., a distress rocket lights up the cold predawn and the *Carpathia* steams into view. By 4:10 A.M. the first surviving passengers stumble onto its welcoming decks. As the sun rises, it illuminates a scene of chilling beauty: a wind-stippled sea dotted with icebergs. (By some minor miracle, the *Carpathia* has dodged them all.) As of 8:30 A.M., the rescue is complete: only 705 of the *Titanic*'s more than 2,200 passengers and crew have survived.

With the rescue, the *Titanic* story returns to the realm of visual record, in the form of photographs, most of them taken by passengers aboard the *Carpathia*. They are suggestive, but of little help to the artist attempting to imagine what it must have been like when the rescue ship first appeared.

Ken Marschall's chronicle of the *Titanic* tragedy takes us from that awful calm just after the engines have stopped through each stage of the sinking and to the bittersweet redemption that dawn brings to the fortunate few.

Marschall has produced many sketches exploring the most dramatic angles from which to portray the *Titanic*'s final moments.

◆

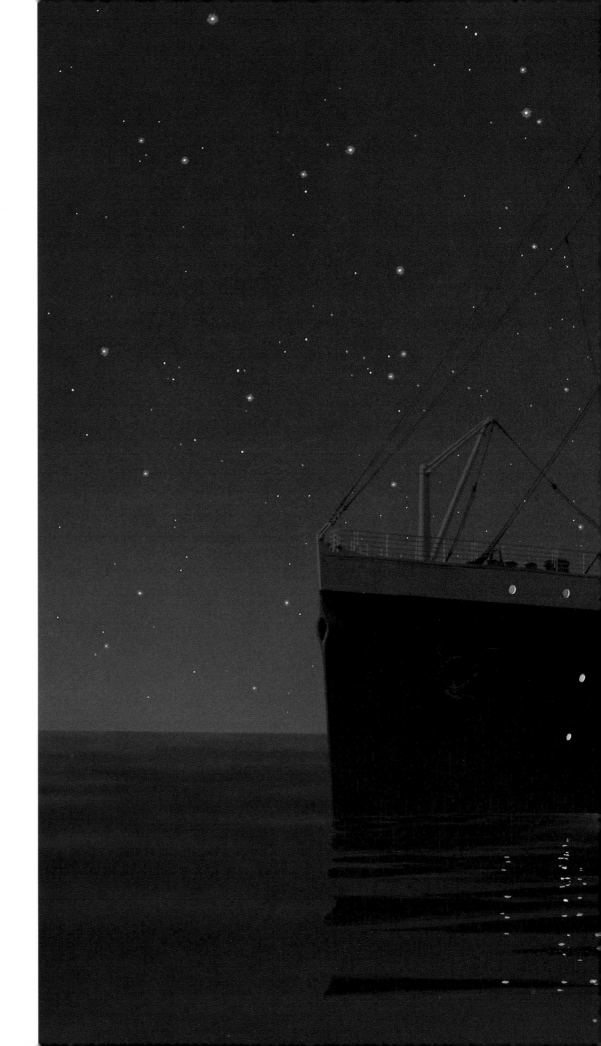

It is a moment of unnatural calm, after the great liner's engines have gone silent and it has drifted to a stop, that Marschall records in his painting of the scene following the collision. The ship is now sufficiently down at the head for observant passengers to understand that something is very wrong. Waste steam is vented into the icy air from the still-hot boilers as all the lifeboats are swung out on their davits.

✦

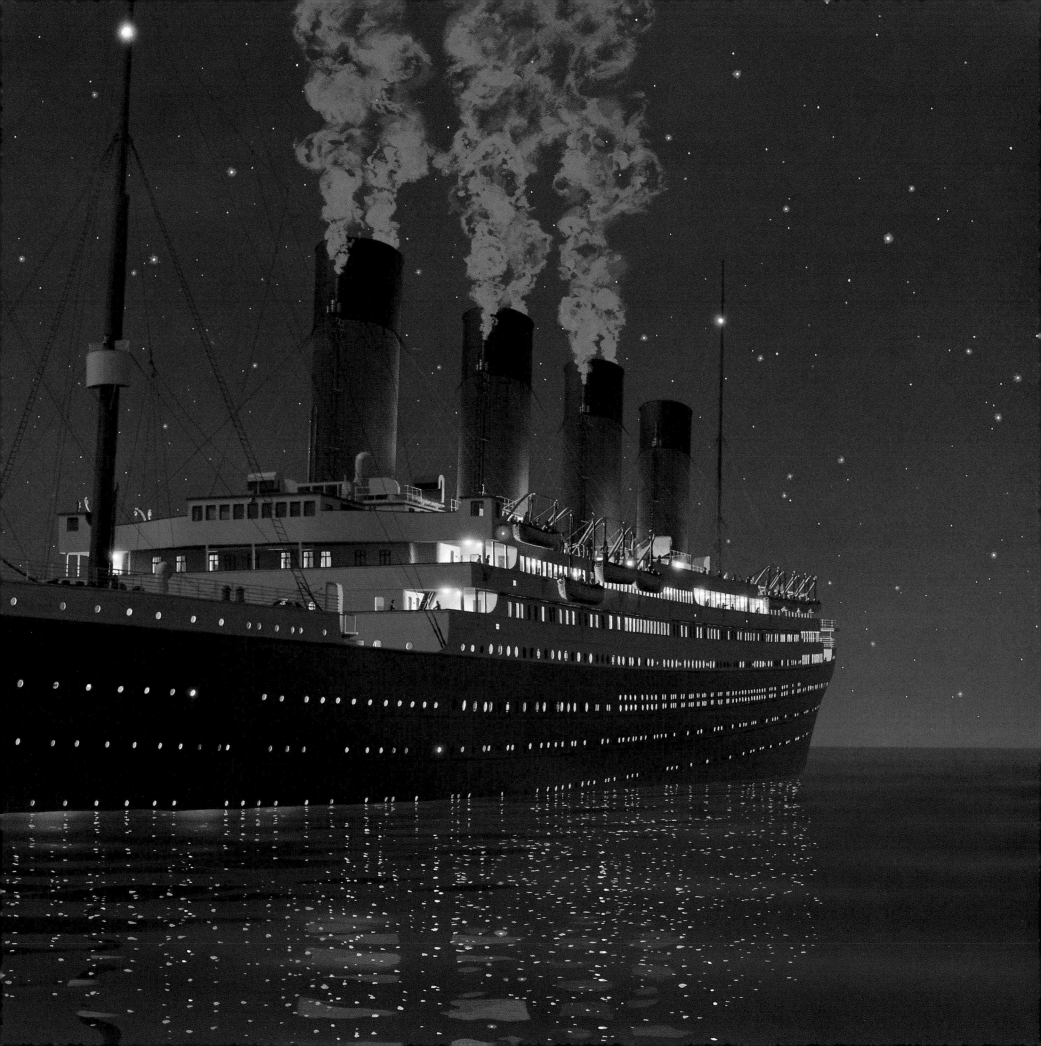

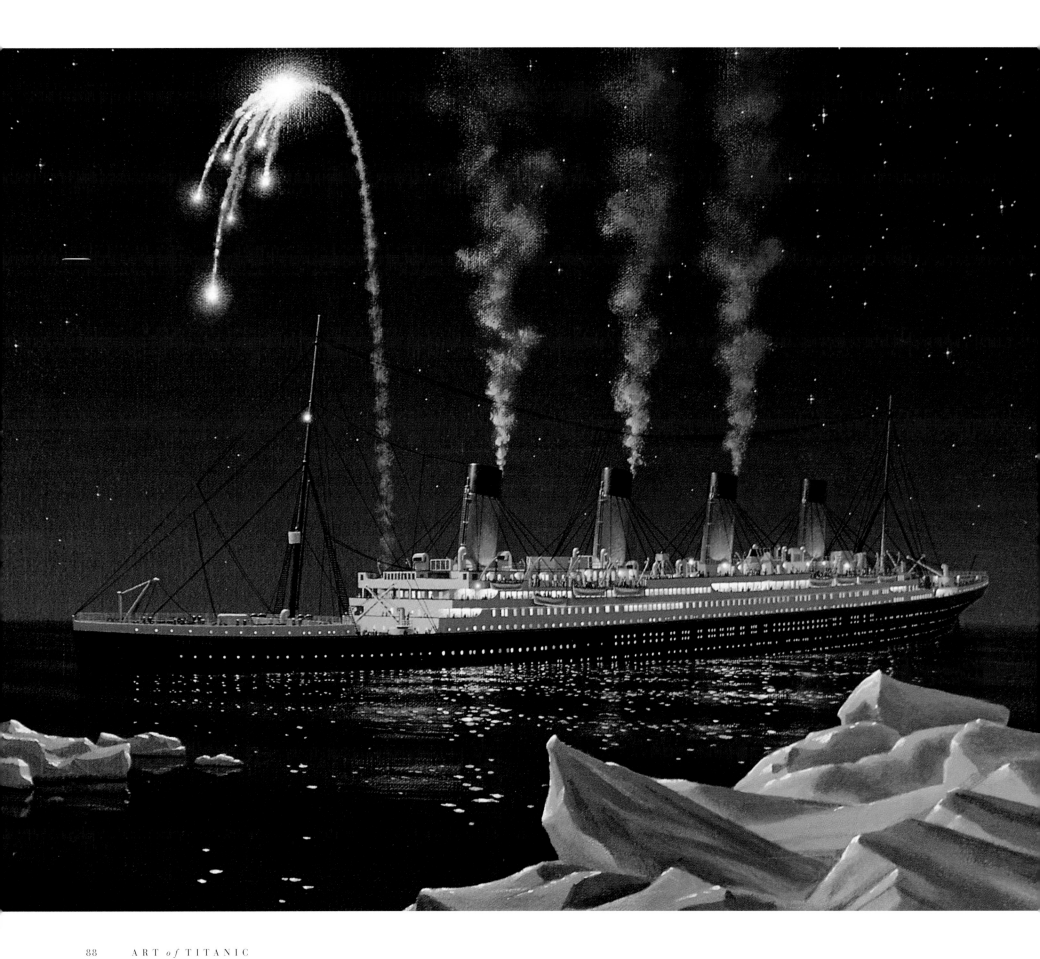

Perhaps the most tantalizing aspect of the *Titanic* sinking is the presence of a mystery ship close enough to have come to the rescue. When Captain Smith orders the first distress rocket to be fired at 12:45 A.M. (left), he can see the lights from this ship quite clearly. The identity of the mystery ship has been the source of much controversy. Some historians believe it was the *Californian*, a ship stopped in the ice nearby, and that its failure to respond to the *Titanic*'s distress signal was an act of criminal negligence. (Right) At about the same time, the first lifeboat, No. 7, is lowered from the starboard boat deck. Only twenty-five passengers have been persuaded to enter a boat capable of handling sixty-five. Above them, Lifeboat No. 5 has already been swung out, and passengers have begun to board.

◆

(Overleaf) In this portside view just before 2:00 A.M., the Titanic's forecastle deck is almost submerged. Passengers board Collapsible D, which now rests in the davits from which Lifeboat No. 2 was lowered fifteen minutes earlier.

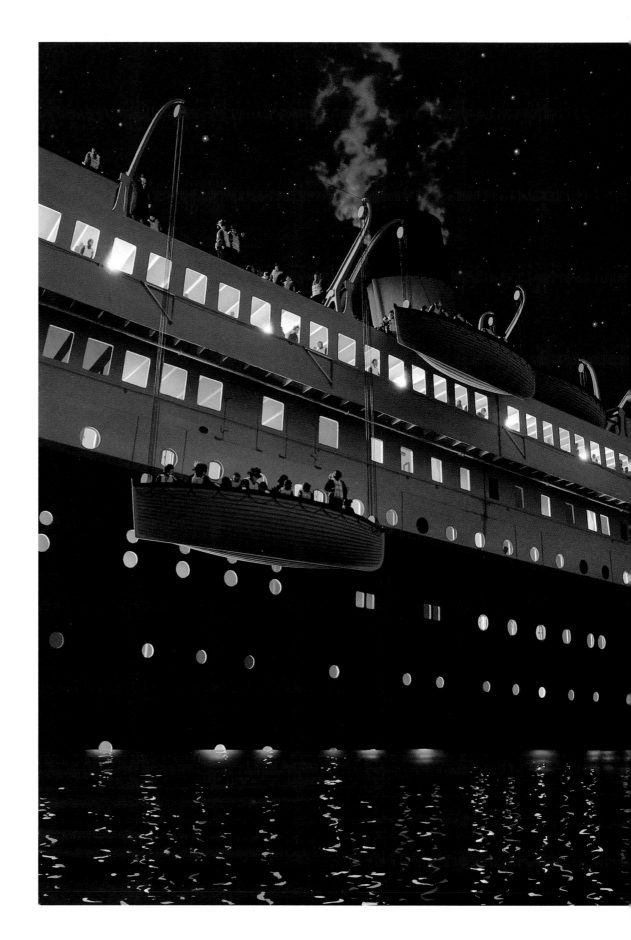

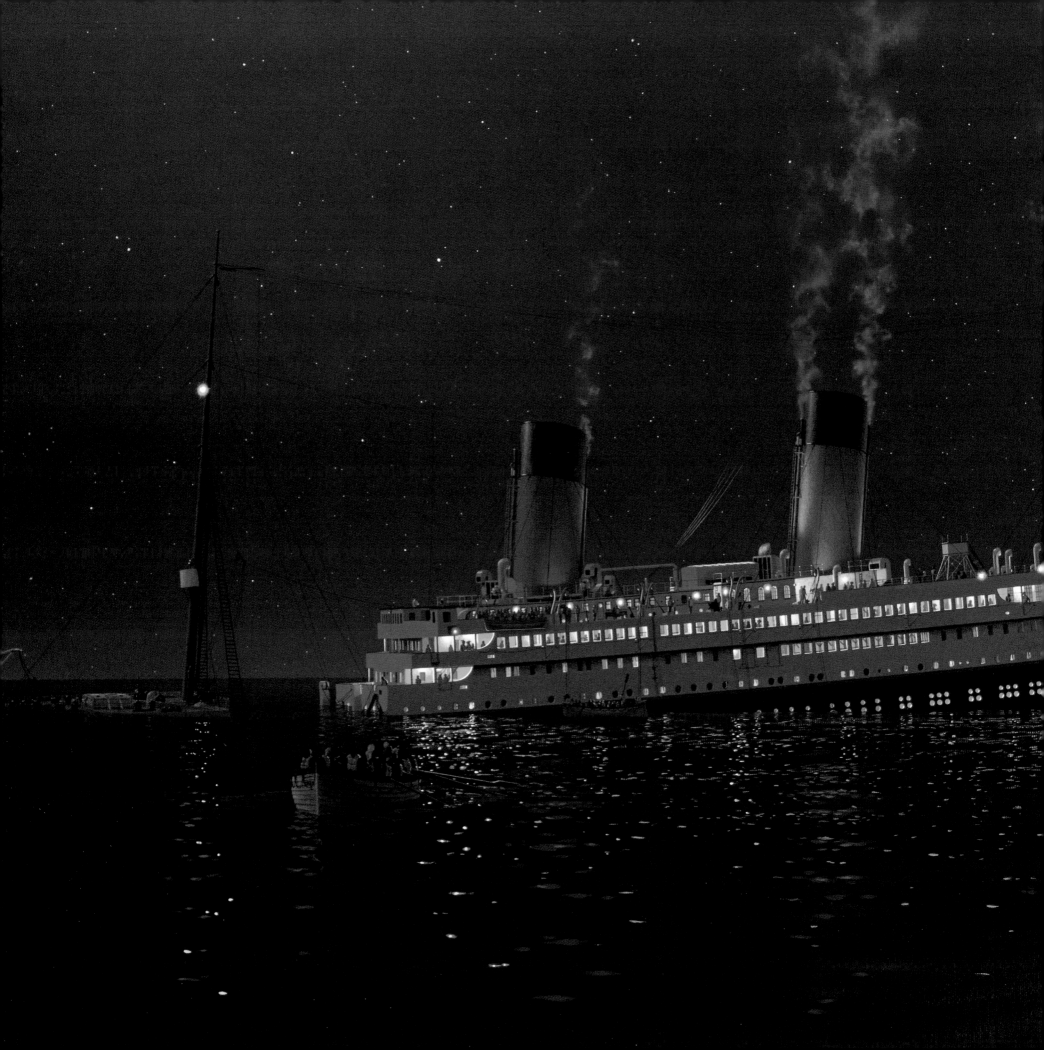

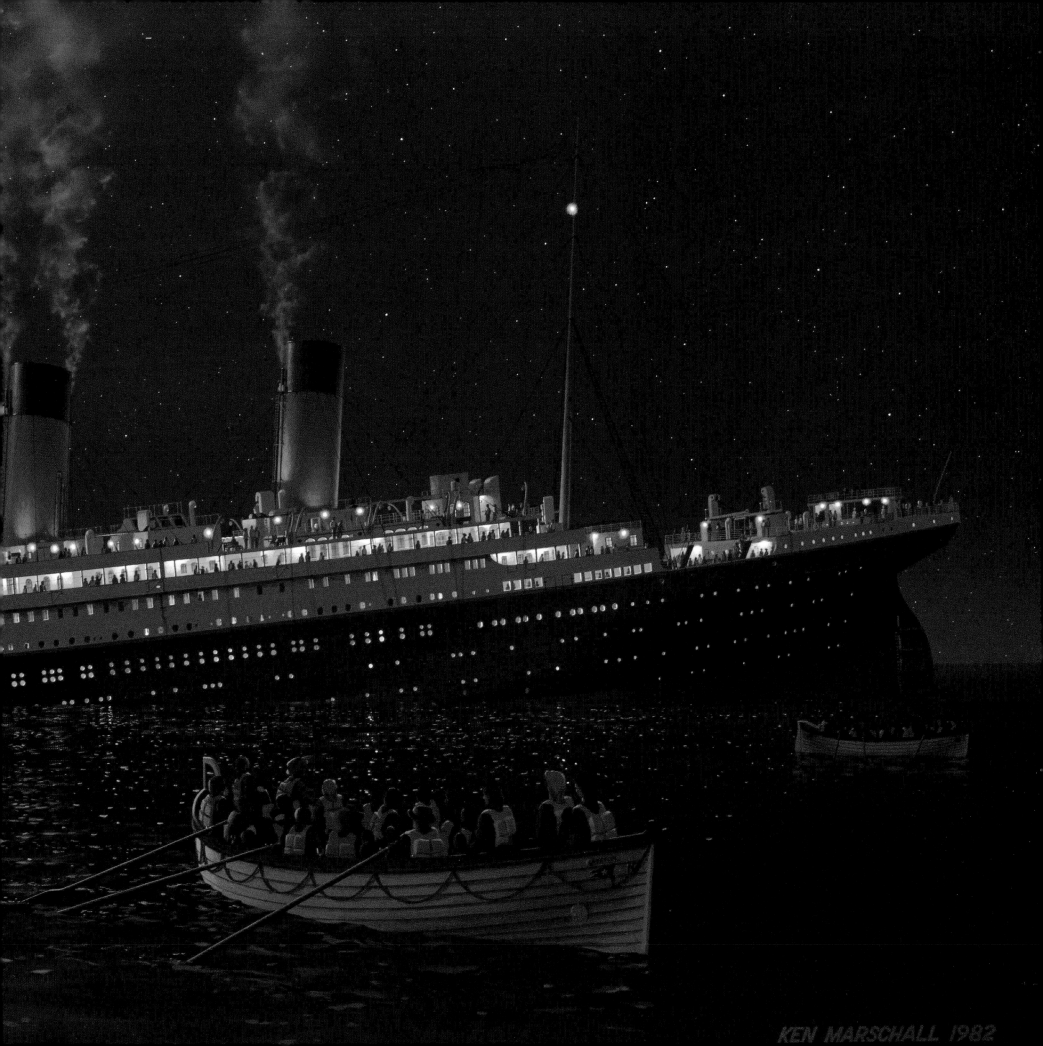

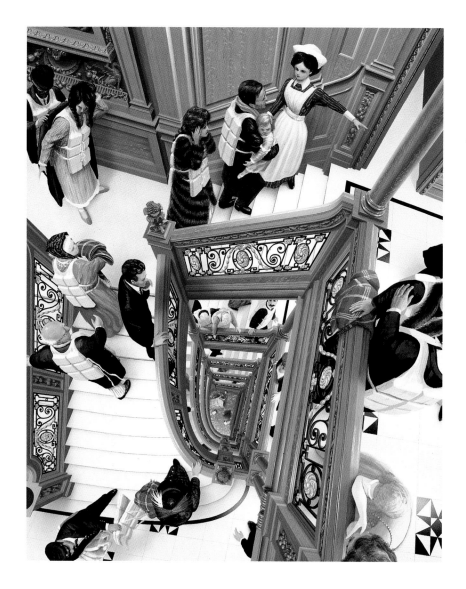

As passengers—among them Hudson Allison, carrying his daughter Loraine, and his wife, Bess (top center)—climb the First-Class staircase on their way to the boat deck, water is flooding E-deck far below. Two-year-old Loraine Allison was the only child from First Class lost with the ship.

Just before 2:00 A.M., Lifeboat No. 4 is loaded from the portside A-deck promenade (opposite). One of the women helped through a promenade window by Second Officer Charles Herbert Lightoller is Madeline Astor, the very young and pregnant wife of the richest man on board. When John Jacob Astor asks to join her, Lightoller—scrupulously observing the age-old dictum "women and children first"—politely but firmly refuses. On the boat deck just above, a crowd gathers at Collapsible D, one of the last boats to leave the ship upright. In the foreground, the occupants of Lifeboat No. 6 can see the water pouring through the open portholes on D-deck.

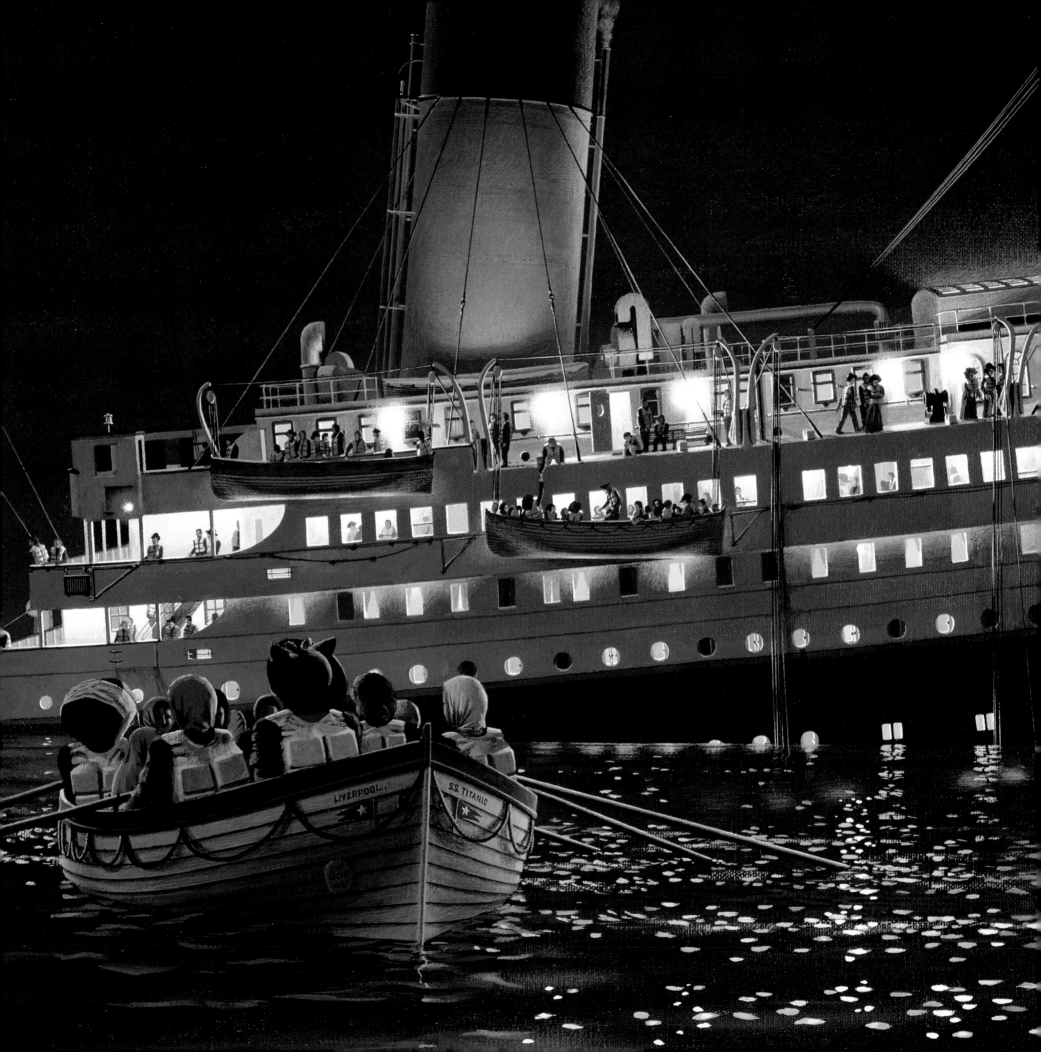

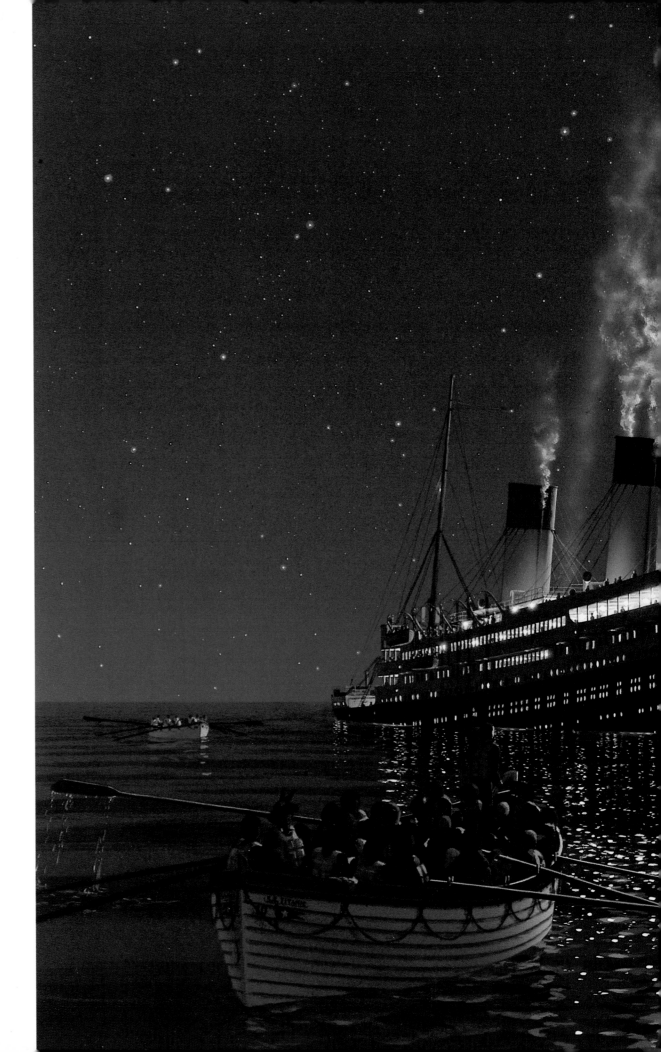

Ken Marschall's painting of the last distress rocket fired from the *Titanic* at about 1:25 A.M. was actually inspired by James Cameron's movie. True to his reputation, Cameron used real rockets to reproduce the most accurate on-screen effect. Showers of sparks backlight the steam venting from the funnels, creating a marvelous cathedral-like arch over the ship.

All of the portside lifeboats are in the picture: No. 10 is in the foreground, No. 8 on the right below the mast, No. 6 in the left background, and No. 12 in the water just below the third funnel. Still being loaded or lowered are No. 2 (the forwardmost boat), No. 14, and No. 16.

◆

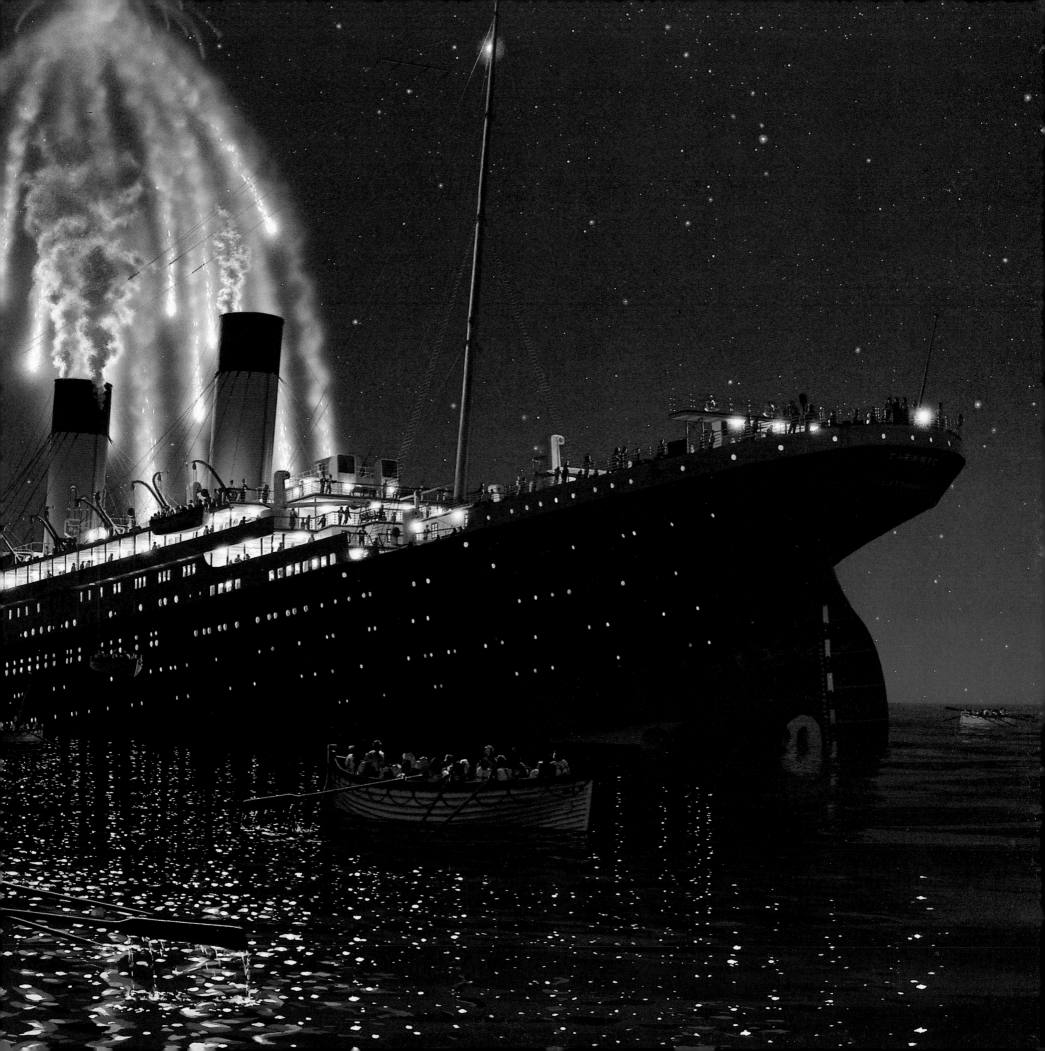

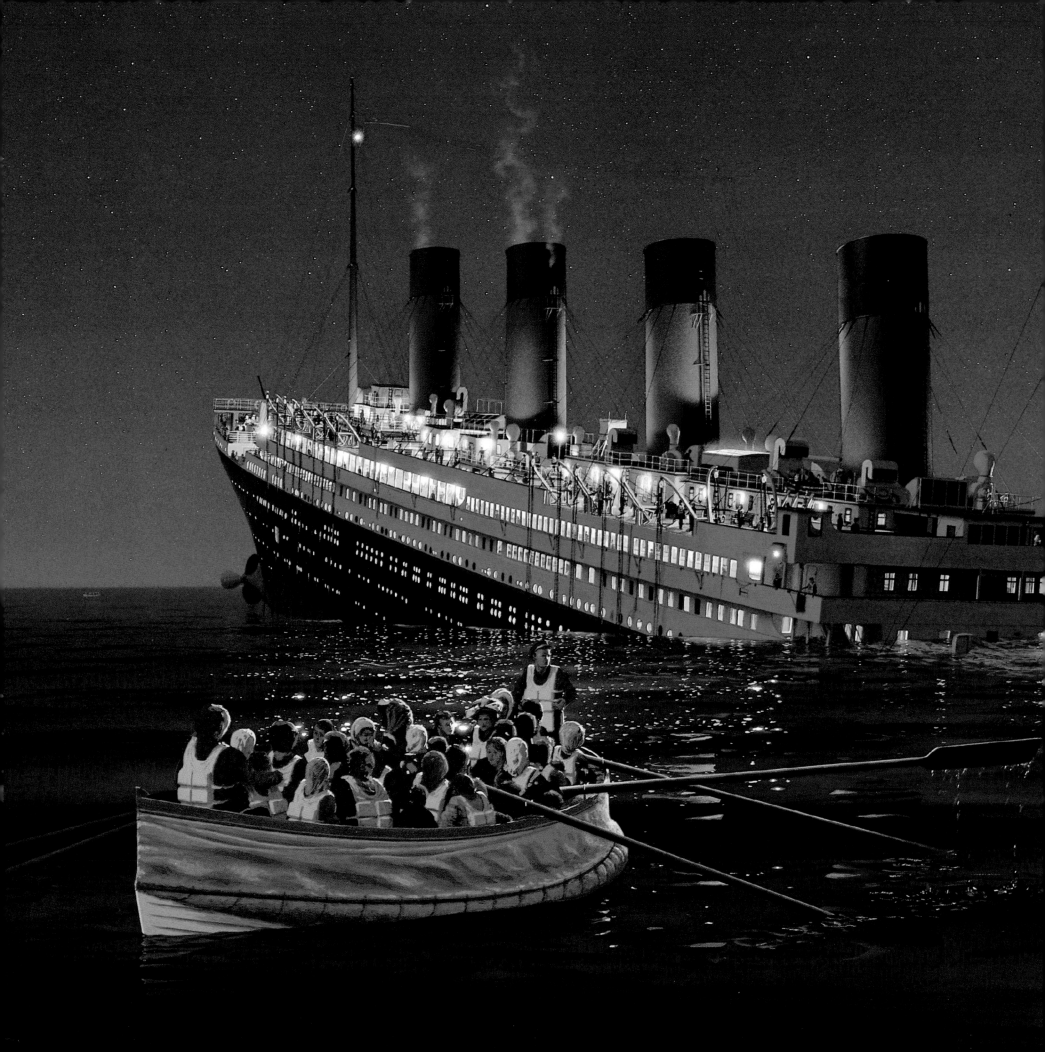

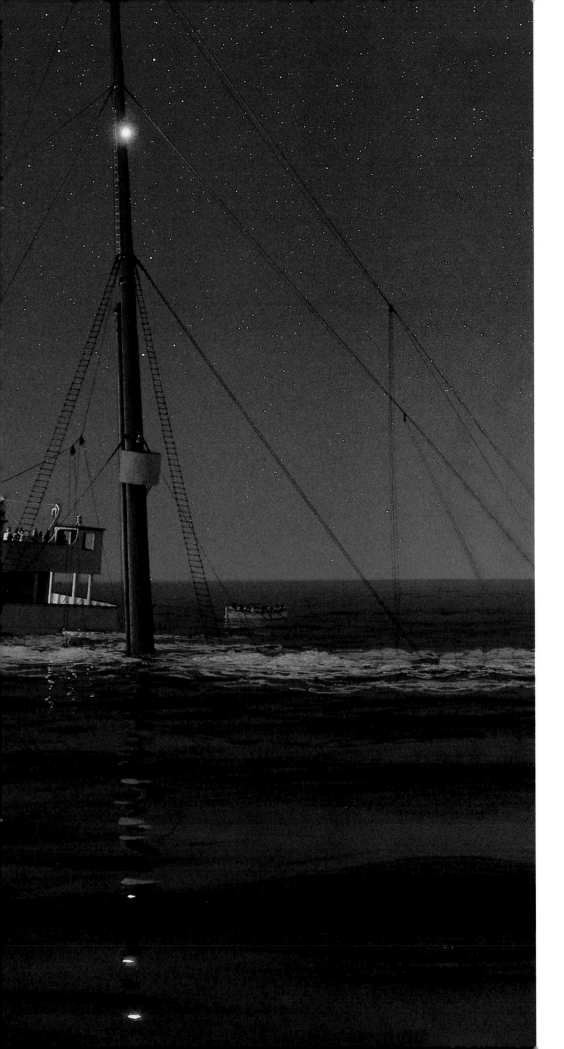

It is around 2:00 A.M. in this starboard view, and the ship has entered the final stages of the sinking. The forward davits on the starboard side are cranked back to receive Collapsible A, which passengers and crew are struggling to free from the roof of the Officers' Quarters. Bubbles break the surface above the sunken bow as air escapes from the now-submerged forward compartments. In the foreground, a well-filled Collapsible C, which counts among its occupants J. Bruce Ismay, the managing director of the White Star Line, rows away from the scene.

✦

The Final Moments

◆

The dramatic sequence of events preceding the sinking brings the *Titanic* story to its climax. Between 2:00 A.M., when the stern rose high enough to expose the huge propellers to those watching in the lifeboats, and 2:20 A.M., when the great ship began its plunge to the seafloor, time compressed. As the paintings here and on the following pages demonstrate, Marschall has chronicled these twenty minutes from several angles, most dramatically with the break-up of the ship just before it sank.

◆

In the painting at the right, occupants of Lifeboat No. 16 watch as No. 14, one of the last to leave, descends toward the water. Given the confusion during these final minutes, the precise order of lowering will never definitely be known.

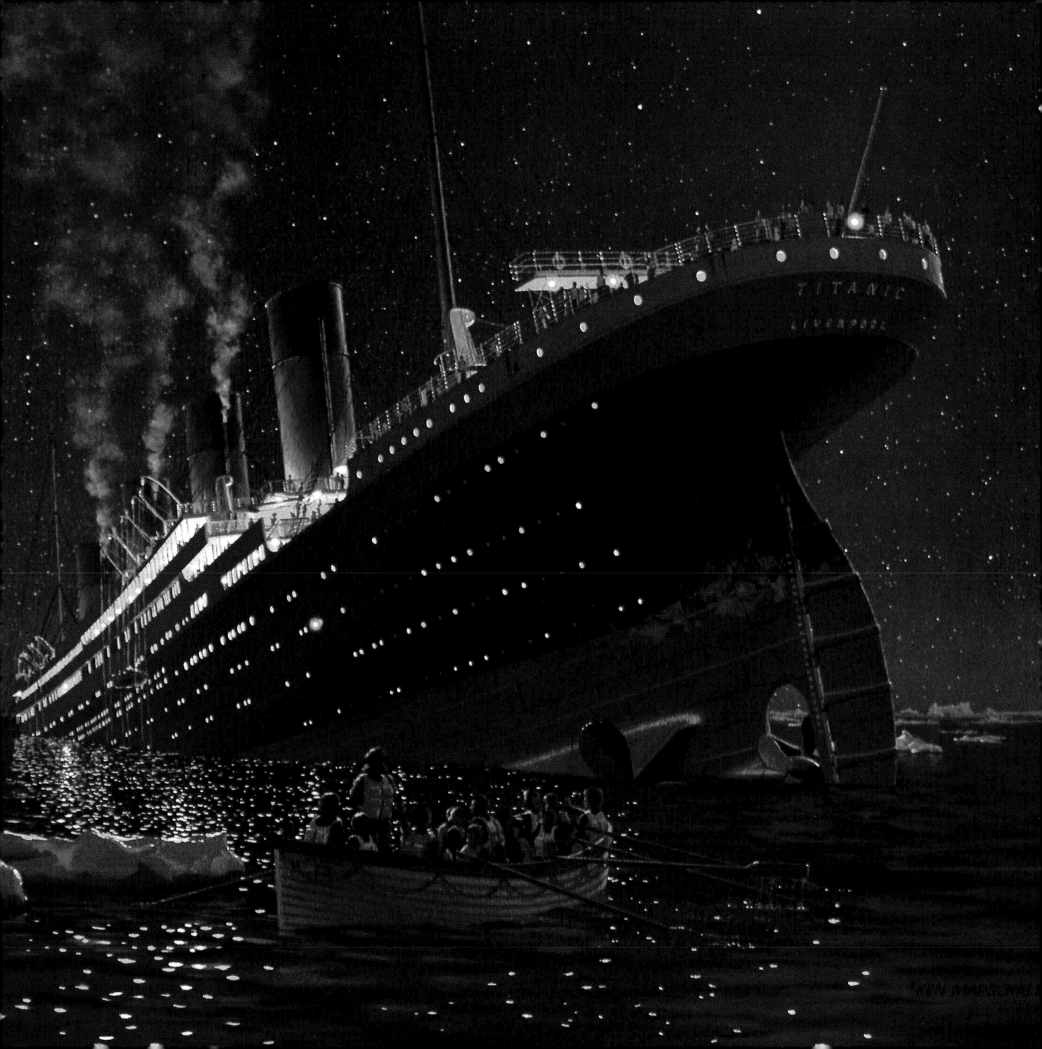

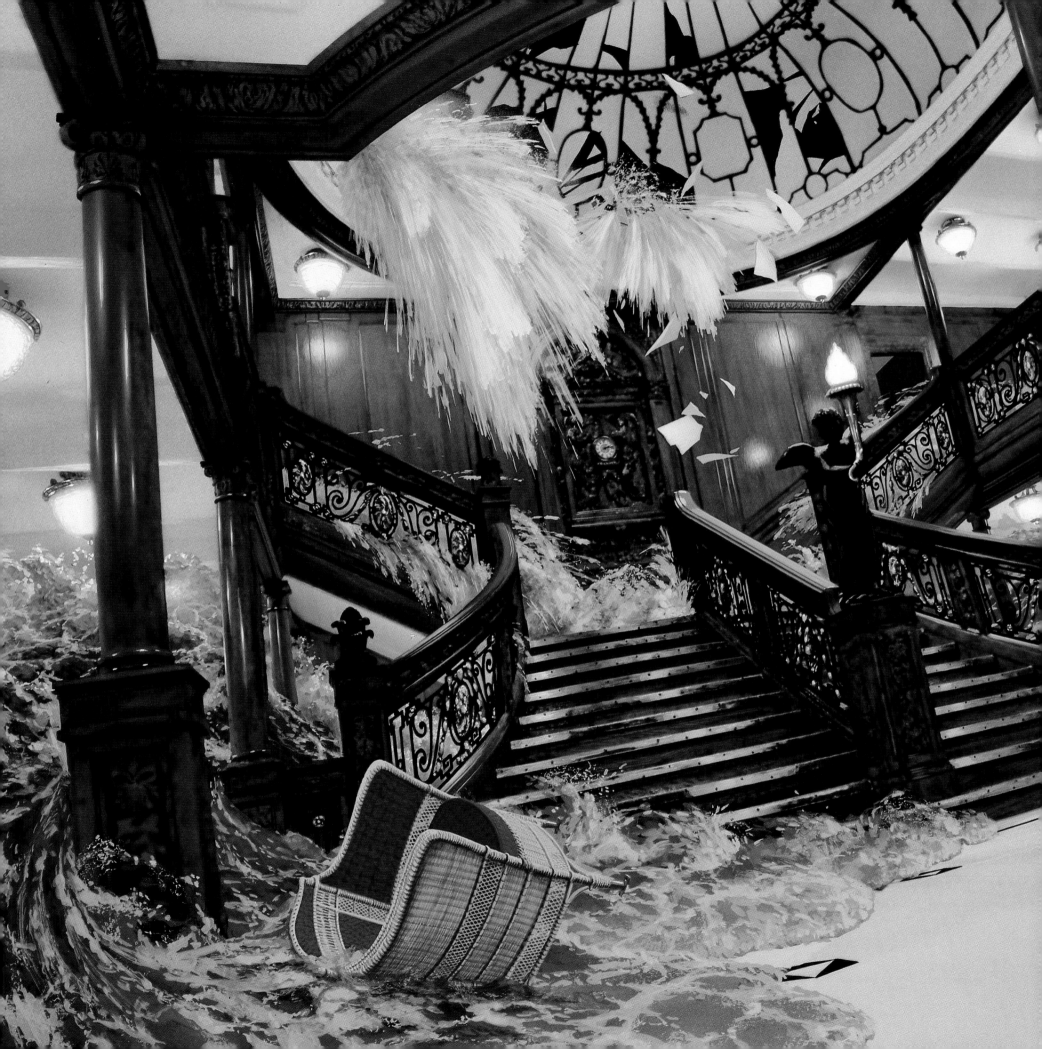

At around 2:15 A.M., the *Titanic* lurches downward, probably as several of the forward compartments implode. A wave rolls aft along the boat deck, washing Collapsible A from the roof of the Officers' Quarters and Collapsible B from the boat deck, from which it floats away, upside down. Here, the artist surmises that this same wave may have crashed through the glass dome of the Grand Staircase. No subject better symbolizes the tragic loss of this great ship than the destruction of its most impressive public space—a scene dramatically recreated by James Cameron for his movie.

◆

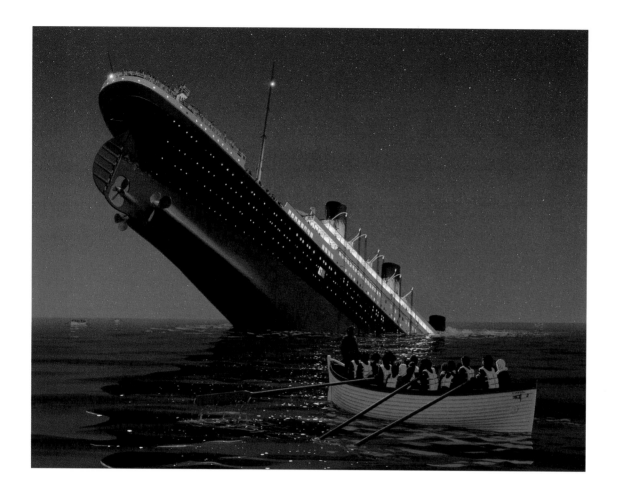

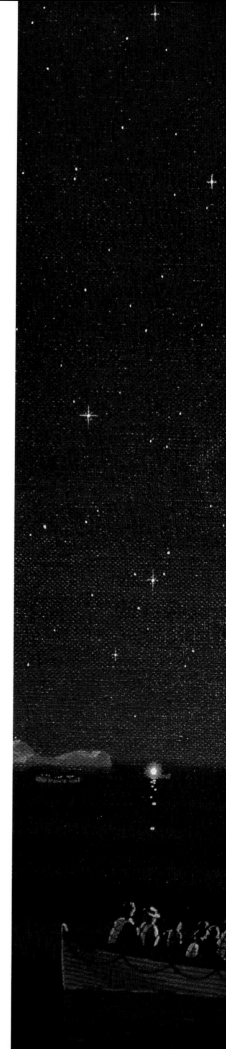

It is approximately 2:18 A.M., only minutes before the end, yet the ship's lights still burn, members of the engineering crew having manned their posts until the last possible moment. Most of the 1,500 passengers remaining on board have climbed toward the stern, where they cling desperately to anything that seems solid. The horrible scene unfolding before those in the lifeboats is accompanied by a growing roar as everything movable inside the ship crashes toward the bow.

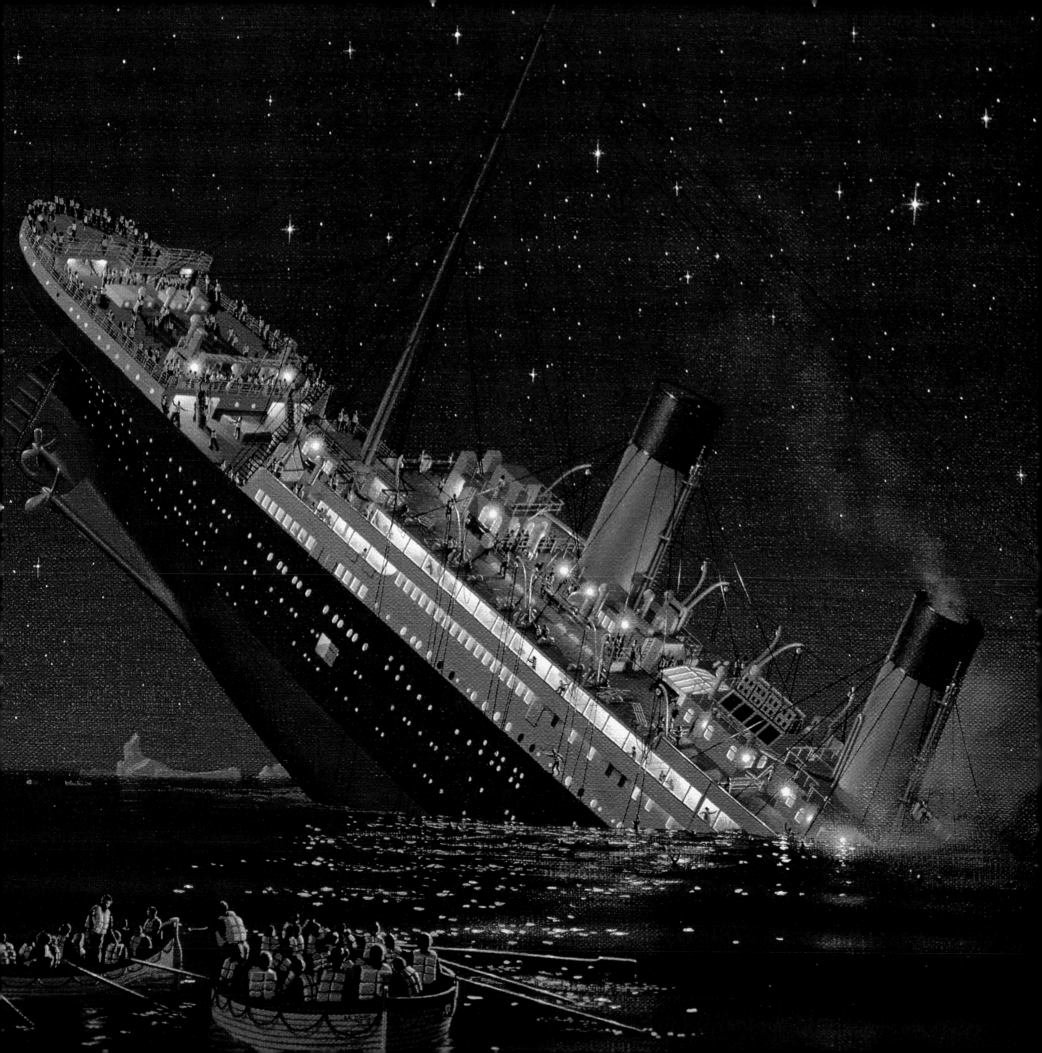

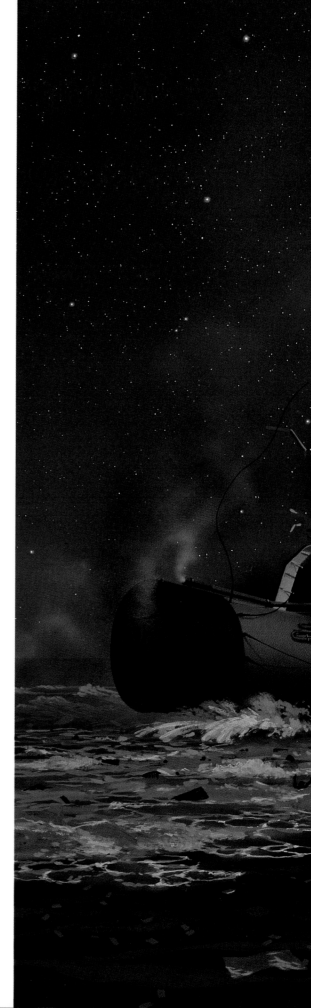

The Break-up

◆

T his view of the *Titanic* tearing in two between the third and fourth funnels could not have been painted before the discovery of the wreck. Many eyewitnesses believed the ship had broken at the surface, but no reliable consensus had emerged, and the official version held that the ship had sunk in one piece. More important, however, only Marschall's meticulous examination of the state of the two sections of the ship as they now lie on the ocean floor could have permitted such a detailed reconstruction of the actual event.

A huge V-shaped section of the hull where it ripped apart now lies scattered in mangled shards on the seabed. In this painting, Marschall shows individual pieces that are now on the bottom as they break away from the hull. Of course, some aspects of this final grisly scene had to be extrapolated. Although no passenger wrote of seeing sparks when the ship tore in two, Ken concluded that the ripping and rubbing of metal against metal must have sent sparks flying—a detail James Cameron agreed with.

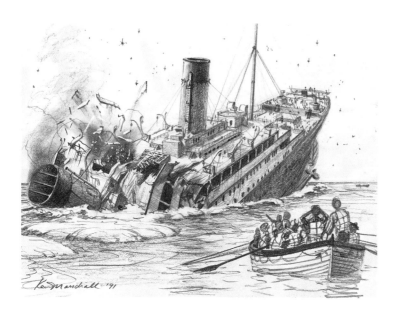

The major difference between this sketch and the finished painting is in the detail the artist brings to the area of the break-up. The final version also shows passengers crowding the stern decks in a desperate attempt to escape the inevitable.

◆

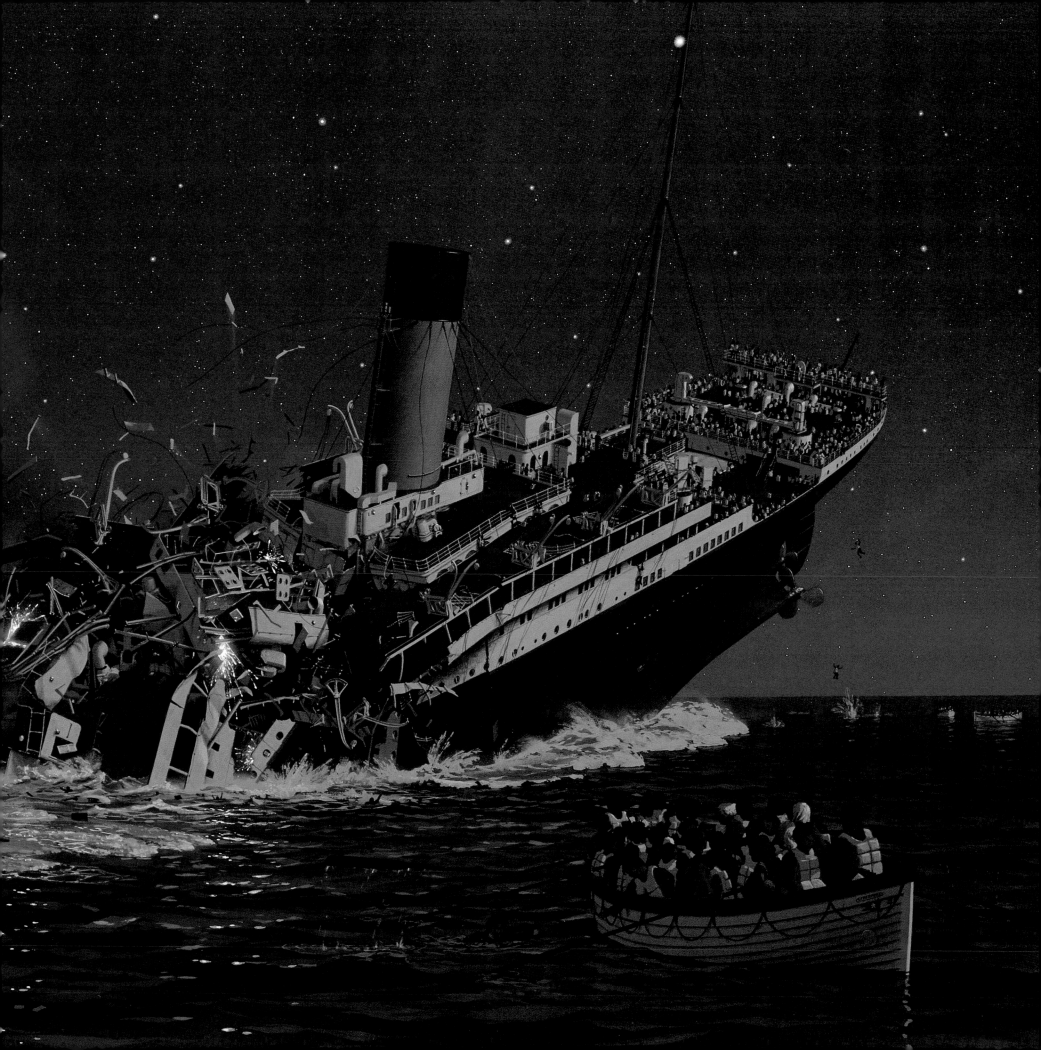

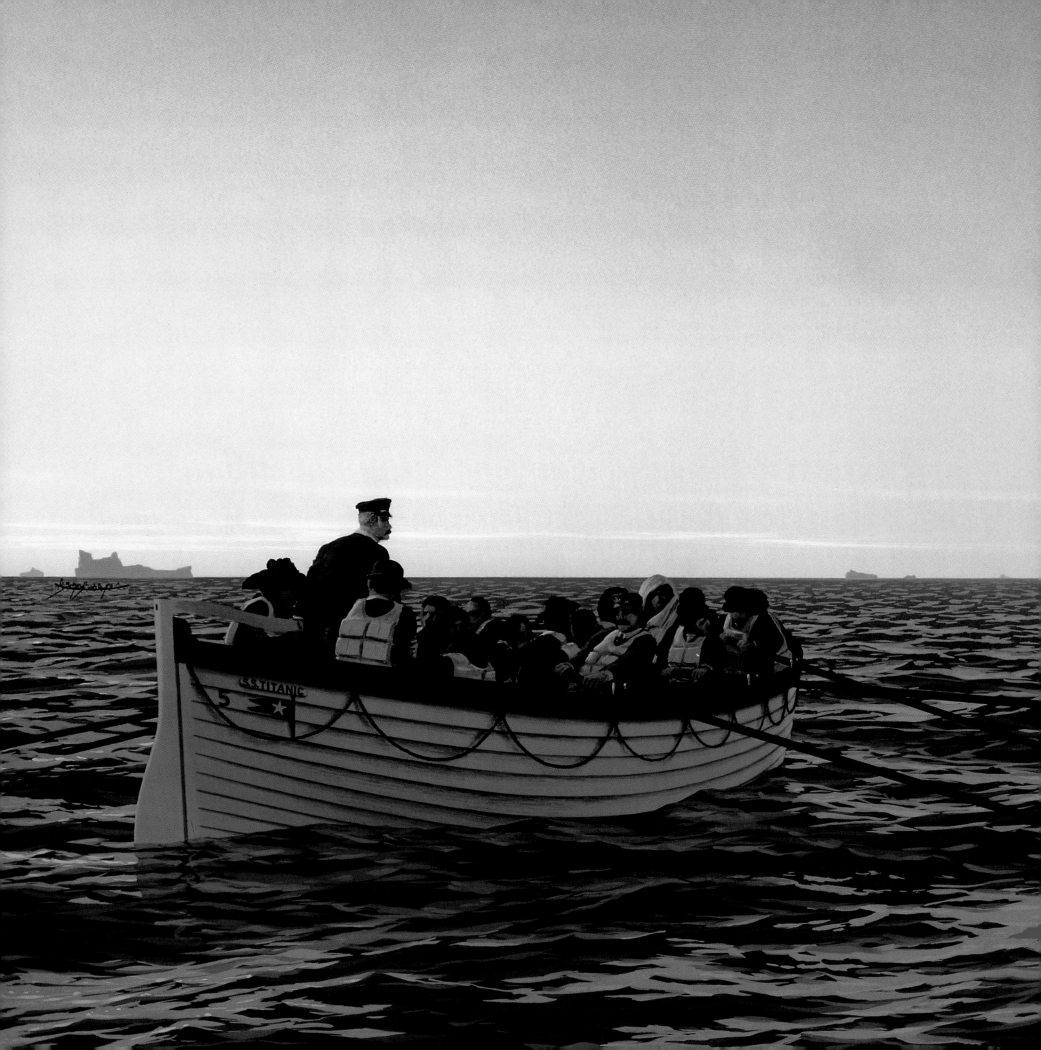

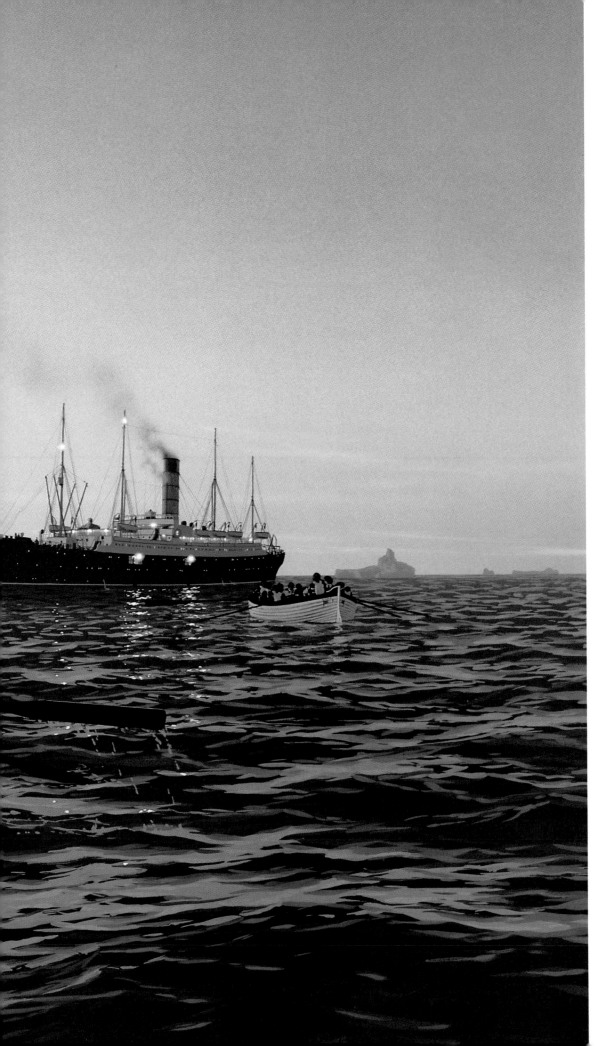

Rescue

◆

Third Officer Herbert Pitman stands at the tiller of Lifeboat No. 5 as his crew of exhausted survivors rows toward the *Carpathia*. Everything about this scene is based on the memories of those who experienced it firsthand, and above all on the meticulous record left by the *Carpathia*'s captain, Arthur Rostron, who directed the rescue. For example, from Rostron's account, Marschall learned that the Cunard captain had ordered all his lifeboats swung out and electric lights placed in each gangway. They are clearly visible in this painting.

Discovery

Robert Ballard's discovery of the wreck of the *Titanic* on September 1, 1985, was only the first of a series of revelations about the ship that continues to this day. Some of these additions to our knowledge have been made by Ken Marschall during endless hours spent examining the photographic record of Ballard's two expeditions. The explorers had noted many single shoes scattered in the debris field, but it was Marschall who first spotted a matching pair of shoes, positioned where a body had once lain. Most important of all, however, Marschall has fashioned our image of what the ship actually looks like in a region of perpetual darkness, two and a half miles beneath the ocean's surface.

A setting where no natural light exists presents an intriguing artistic challenge. Marschall had to invent a source of light, one that would fool the viewer into believing in

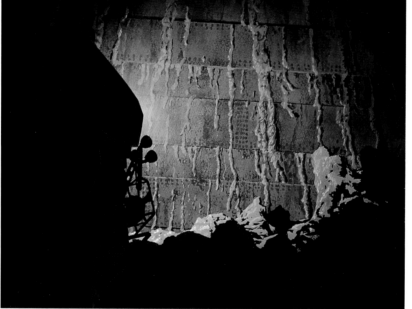

its naturalness, yet he had to try to preserve the sense of distance and mystery. Marschall's approach to this challenge has evolved over time.

In the beginning, for example, with the startling bow image painted for the jacket of *The Discovery of the Titanic* (opposite), the light source is the submersible *Alvin*, resting out of sight on the wreck's forecastle. In other paintings, Marschall almost seems to have created an underwater sun whose rays etch the ship in sharp-edged clarity. Some of these early paintings were so realistic that newspapers were fooled into captioning them as photographs by Ken Marschall. Their lighting, however, was far from photographic.

After *The Discovery of the Titanic* was published, Marschall became dissatisfied with his sharp-shadowed approach. In reality, even the clearest underwater weather gives the wreck a diffuse quality, where edges are softened

◆

(Above) An uncannily photographic recreation in acrylic paint shows *Alvin* approaching the hull of the *Titanic*'s bow as it rises from the deep Atlantic floor.

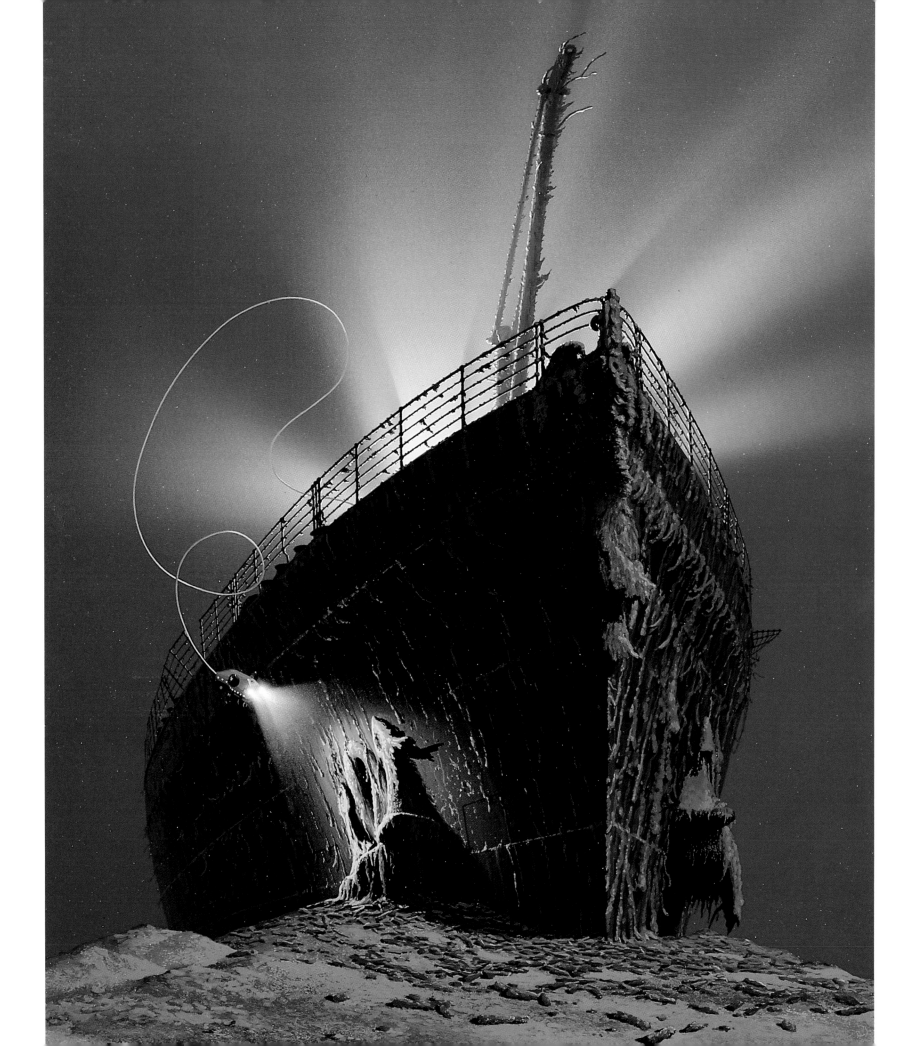

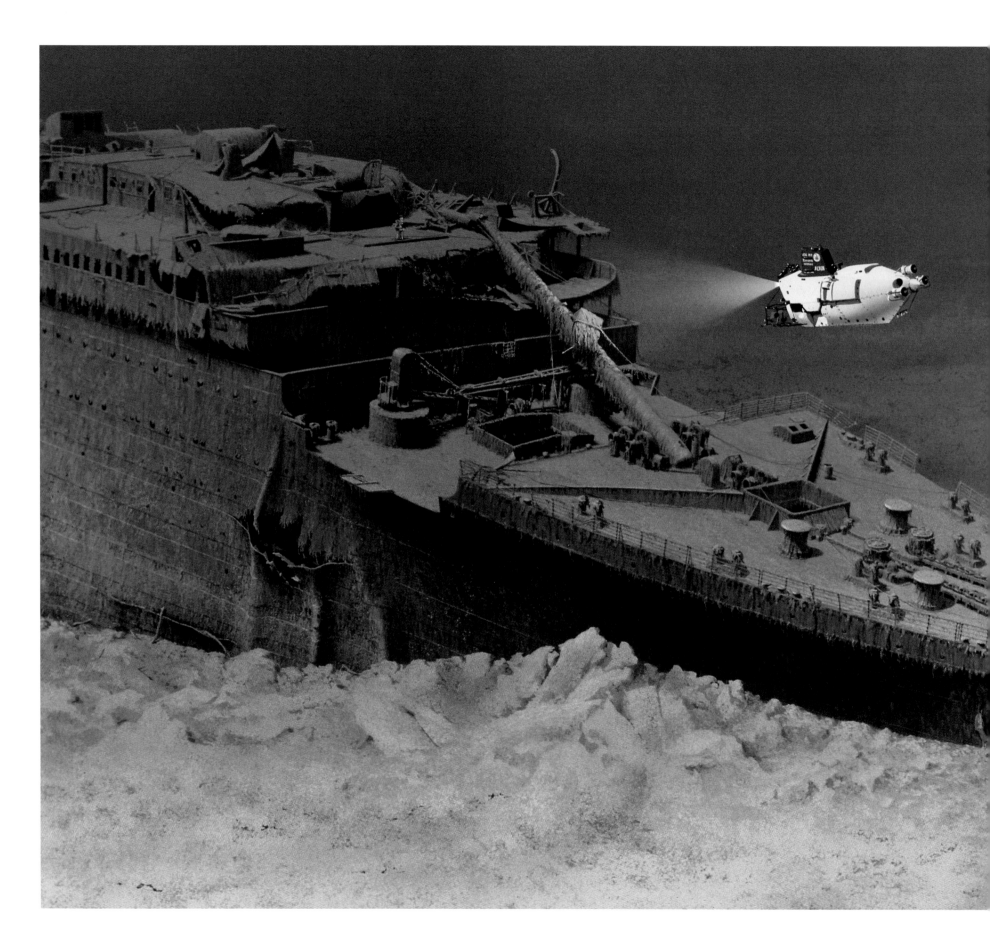

and even a close-up view often blurs. In his later paintings of the wreck of the *Titanic*, as in all his recent paintings of deeply sunken ships, Marschall imagines a diffuse light source that gives the shipwreck a ghostly presence and turns the surrounding water a deep otherworldly blue, far more evocative both of the actual place and of the ship's symbolic presence. Most of these scenes are backlit to heighten their dramatic effect. It is these paintings, more than any of the photographs—even those brought back by the IMAX expedition in 1991—that have formed our image of the fallen *Titanic*.

A second challenge arises from the nature of the photographic record. Neither Ballard's still pictures nor his videotape footage can reveal anything but a scene in tiny fragments lit by the artificial spotlights aimed by his underwater vehicles. Most vexing of all are the still pictures, frame after frame taken in a long "aerial" view from a camera sled as it was towed back and forth at a safe height over the wreck. These pictures have almost no sense of a third dimension.

In the effort to use these still pictures as sources for a painting that captures three dimensions, Marschall has literally gone cross-eyed. First he chooses two of the still images occurring a few seconds apart and showing slightly different views of the same area of the ship. Then he determines which

is the "right-hand" view and which the "left-hand." Finally he places them side by side, with the right-hand view on the left side, and deliberately crosses his eyes so that his right eye is looking at the picture on the left and his left eye is looking at the right. It's an age-old technique, and the result is a startling 3-D image.

In order to paint the wreck of the *Titanic*, Ken Marschall has conceived an imaginary underwater world. In it, the only hard light and sharp shadow are cast when a beam of artificial light strikes the wreck. Elsewhere, a massive and often gnarled hulk looms out of a sort of mist as, for example, in his wonderful painting of the tethered robot *Jason Junior* descending the Grand Staircase (page 123). It is this eerie "look" that James Cameron's special effects experts were able to reproduce at the beginning of the movie. In this way, the movie *Titanic* has virtually institutionalized Marschall's own artistic view.

One of Ken Marschall's few regrets is that he has never seen the real ship up close. He didn't connect with Robert Ballard in time for the 1986 exploration expedition, and the explorer's subsequent plans to revisit the ship have not yet materialized. But Marschall really doesn't have to see it. He has walked its broken decks many times in his imagination. And he knows the lost ship better than anyone.

Ken Marschall has painted many
pictures of the *Titanic*'s broken bow,
beginning with his 1986 cover illustration
for *Time*, but none has more power and
presence than this one. The point of view is
low, almost at seafloor level, and the huge
bow in the enormous furrow of sediment it
plowed really does seem to be in motion,
just as Robert Ballard imagined it.
Pointedly, Marschall has *Alvin* inspecting
the forwardmost starboard davit—the only
one still standing on that side of the ship—
a vivid reminder of the great liner's fatal
flaw. It still stands cranked back inboard to
receive Collapsible A. Off in the distance,
like some ruined Mayan temple, looms the
stern. No photograph, even one taken with
more powerful underwater lights than have
yet been developed, could come close to
capturing this scene.

◆

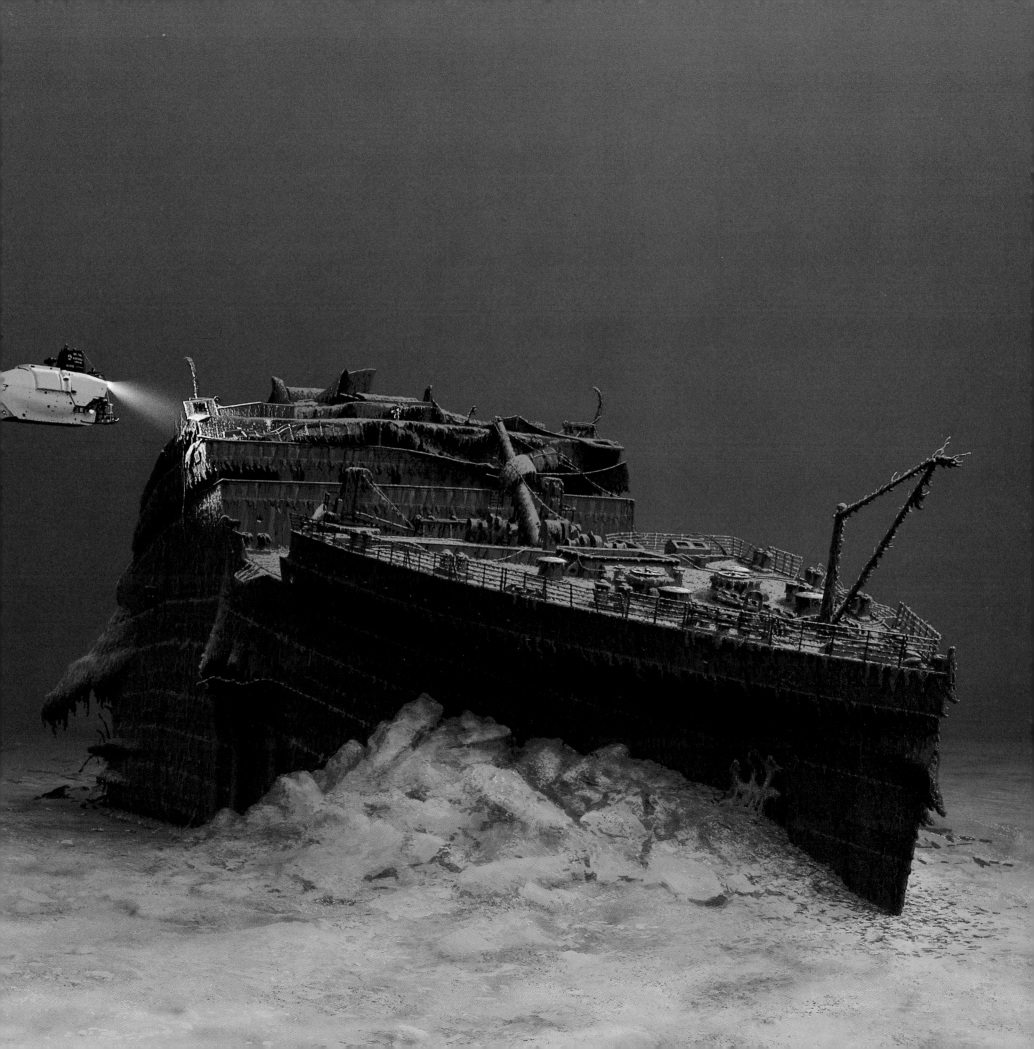

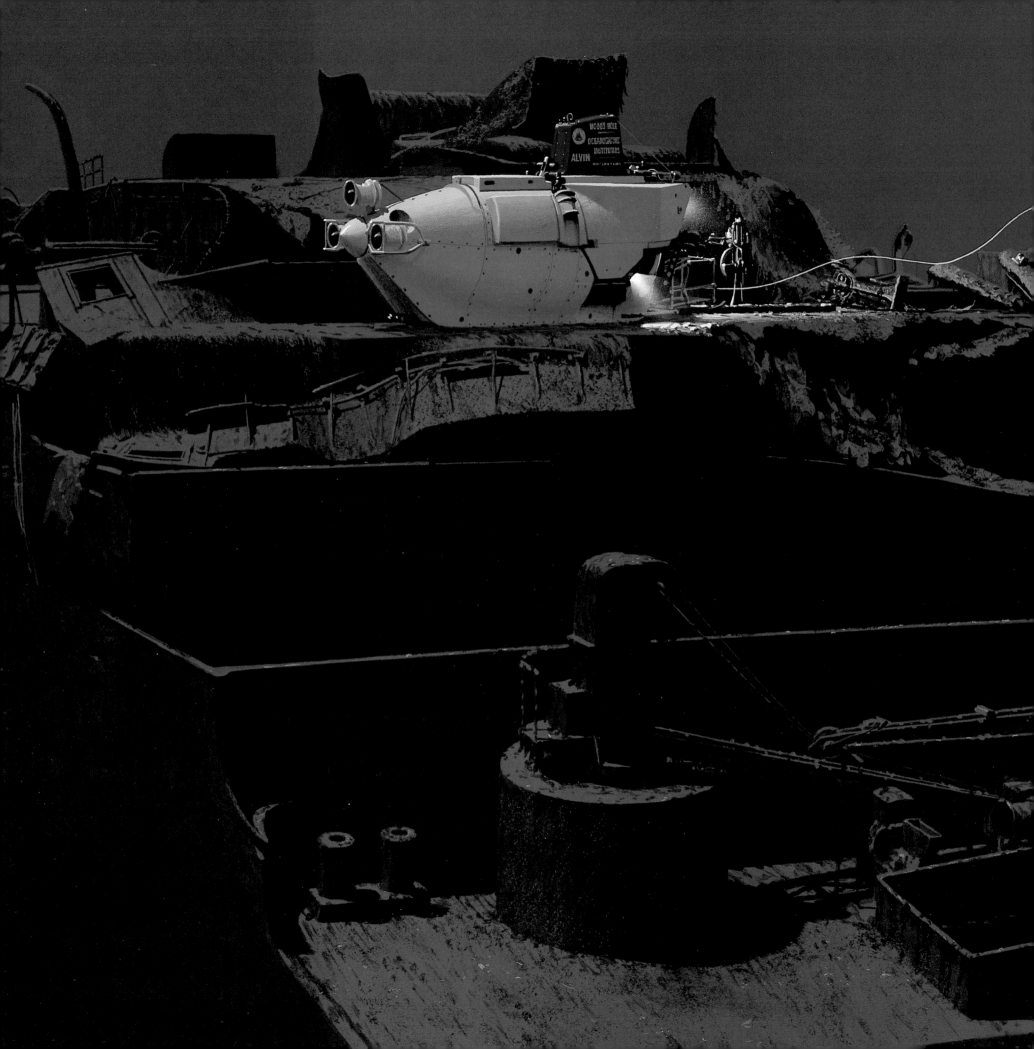

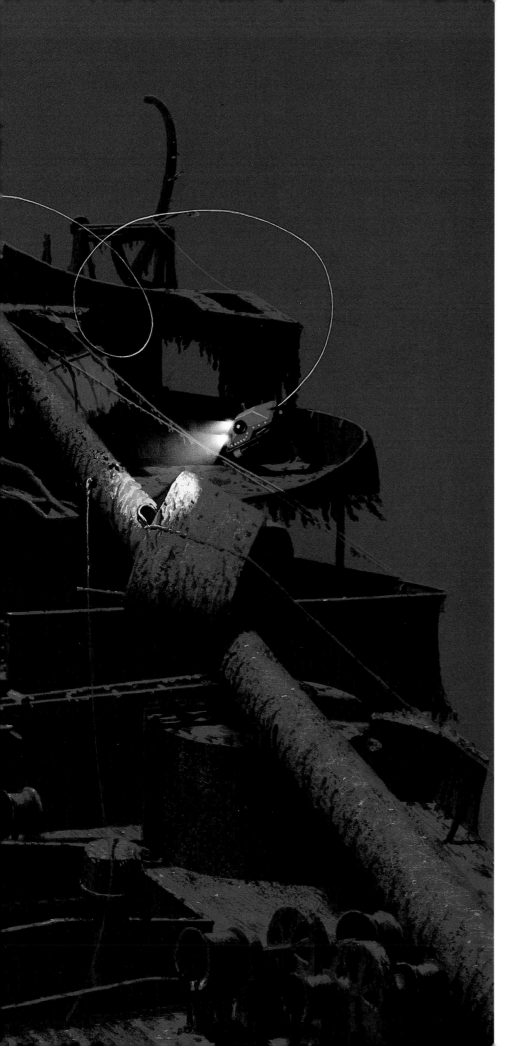

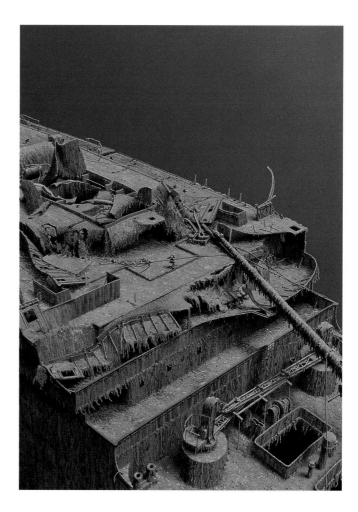

Alvin sits on what was once the enclosed bridge area, next to the telemotor control that supported the ship's wheel, while the tethered robot *Jason Junior* gets in close to the crow's nest (left). The decks fall toward us into the foreground, so that we seem to be standing in the well deck beside the base of the ruined cargo crane. A gate in the bulkhead dividing the First-Class precincts of B-deck from the Third-Class well deck remains closed. For the painting above, Marschall painstakingly researched the bridge area and forward well deck to produce a revealing overhead view.

◆

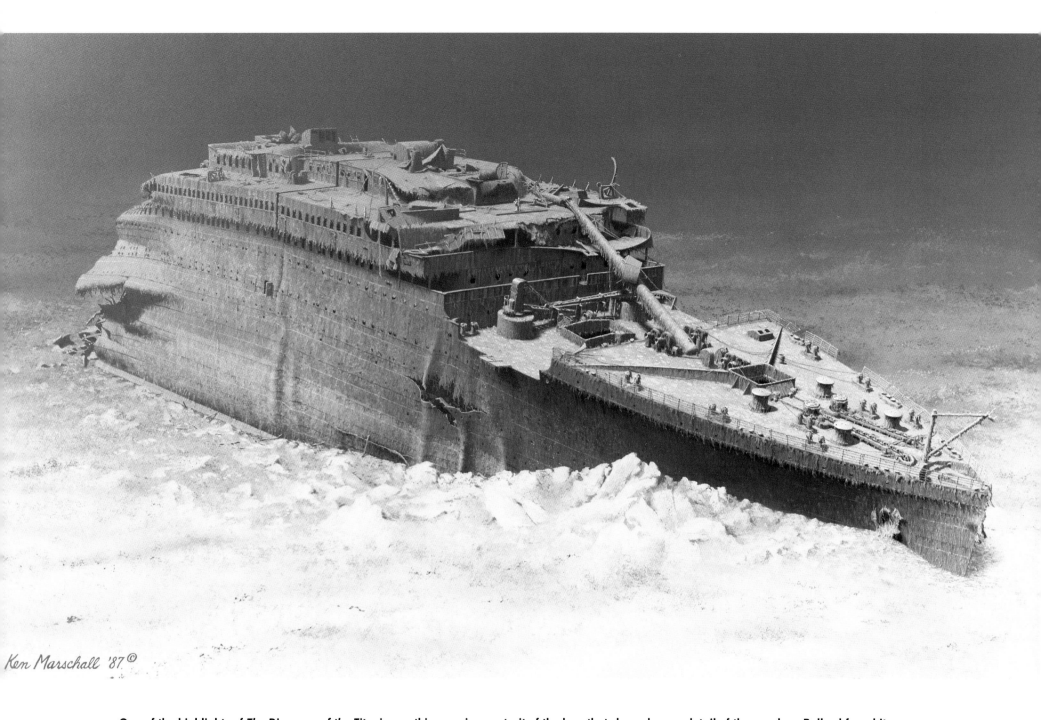

Ken Marschall '87©

One of the highlights of *The Discovery of the Titanic* was this overview portrait of the bow that showed every detail of the wreck as Ballard found it. Apart from the buckling of the hull at a structurally weak point just in front of the bridge, the bow section is in remarkably good condition. The starboard anchor is still in place, as are the anchor chains that lie on the forward deck. They and the huge capstans and bollards that punctuate the deck are undamaged. After over a decade and many visits from other explorers, the underwater scene is now somewhat different. The crow's nest, for example, has fallen away, and the mast itself has collapsed several feet farther down.

✦

Alvin has settled on the boat deck just aft of the forwardmost portside davit, still in the outboard position just as it was left after launching Collapsible D, while robot *JJ* explores the forward promenade deck two decks below.

✦

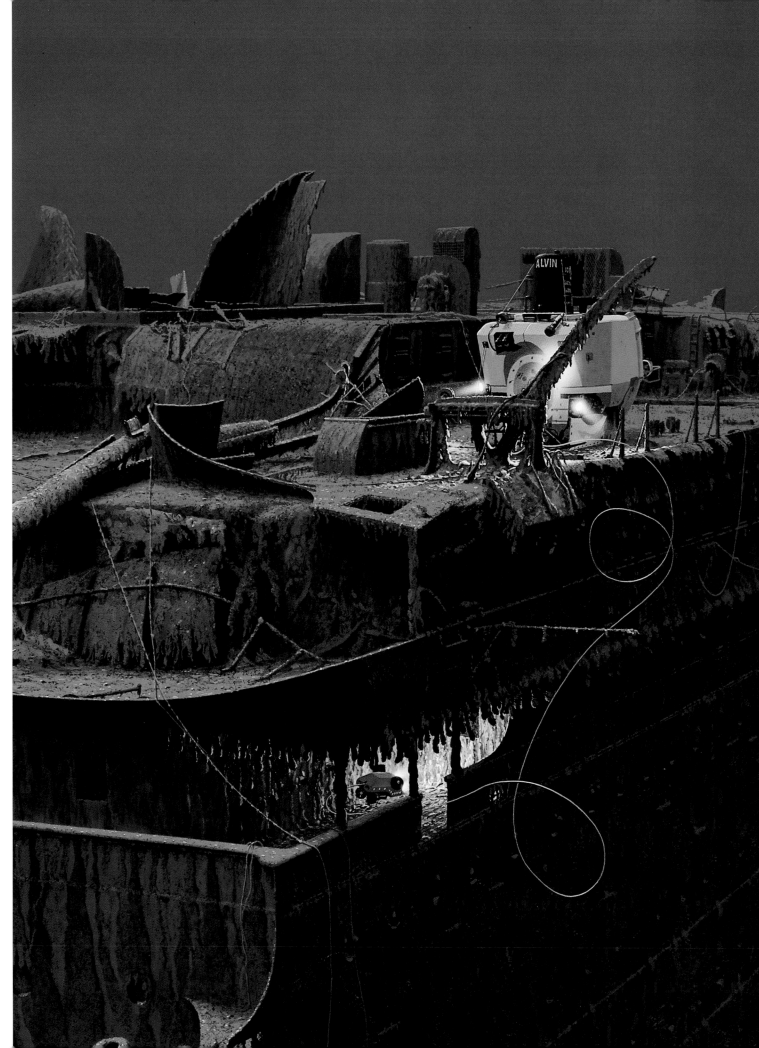

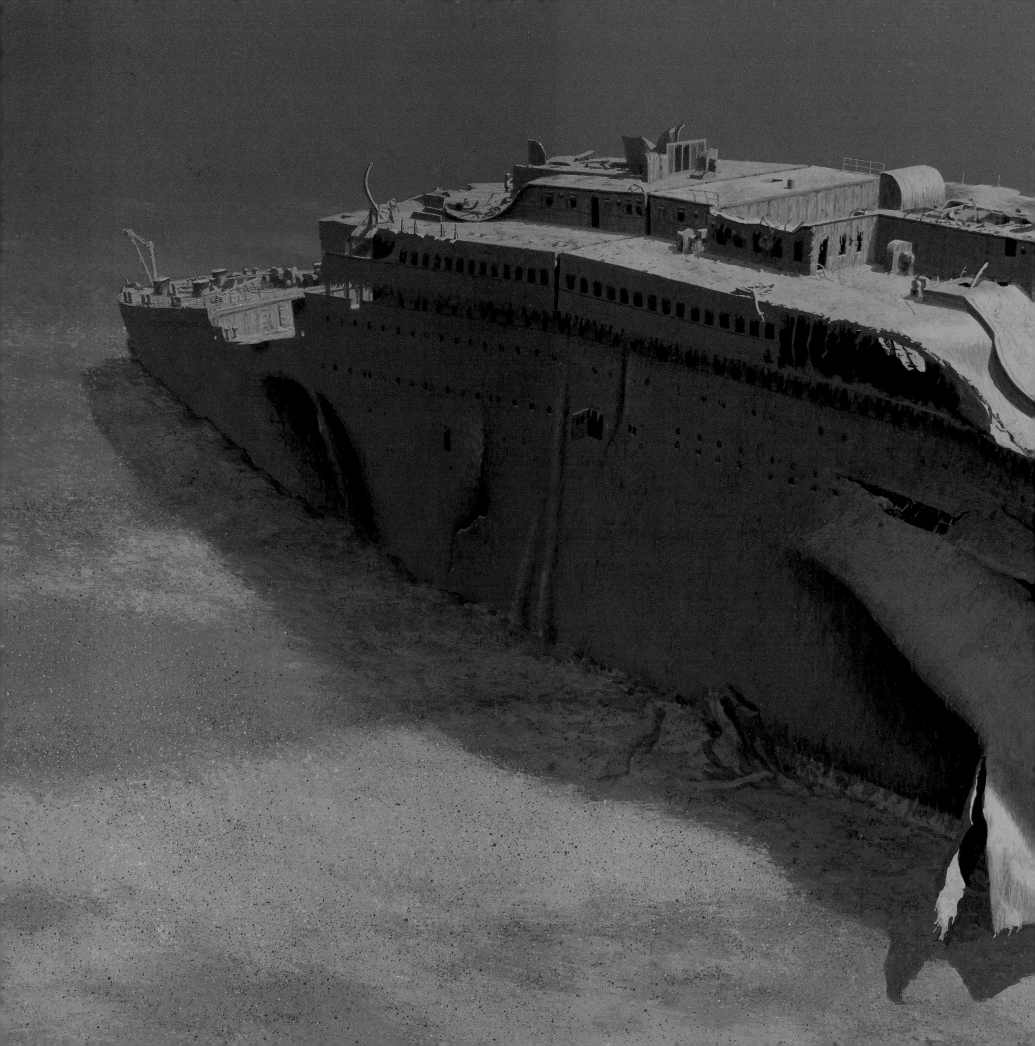

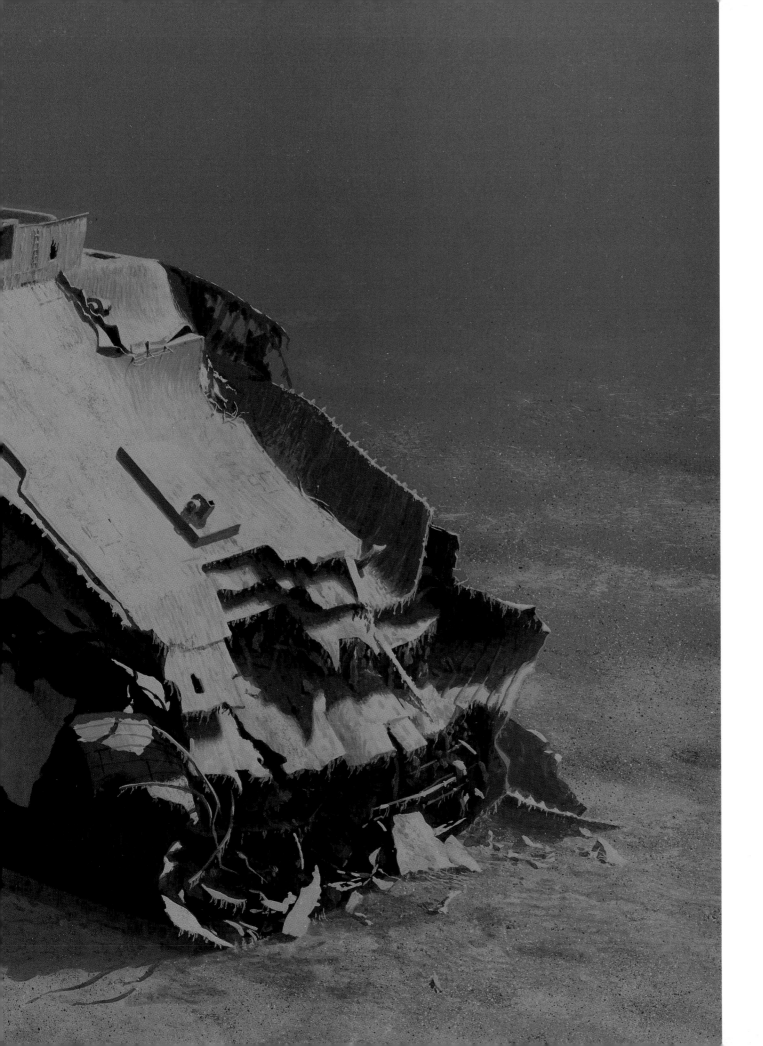

Marschall has painted but one aft view of the bow looking forward. From this angle, he must contemplate—and attempt to portray—the melancholy disorder where the ship tore apart. Since Ballard spent little time investigating this area by submarine, the artist relied on the high-altitude video and still footage, combined with the evidence in the debris field, to portray the torn plating and collapsed decks of what was once the ship's midsection.

◆

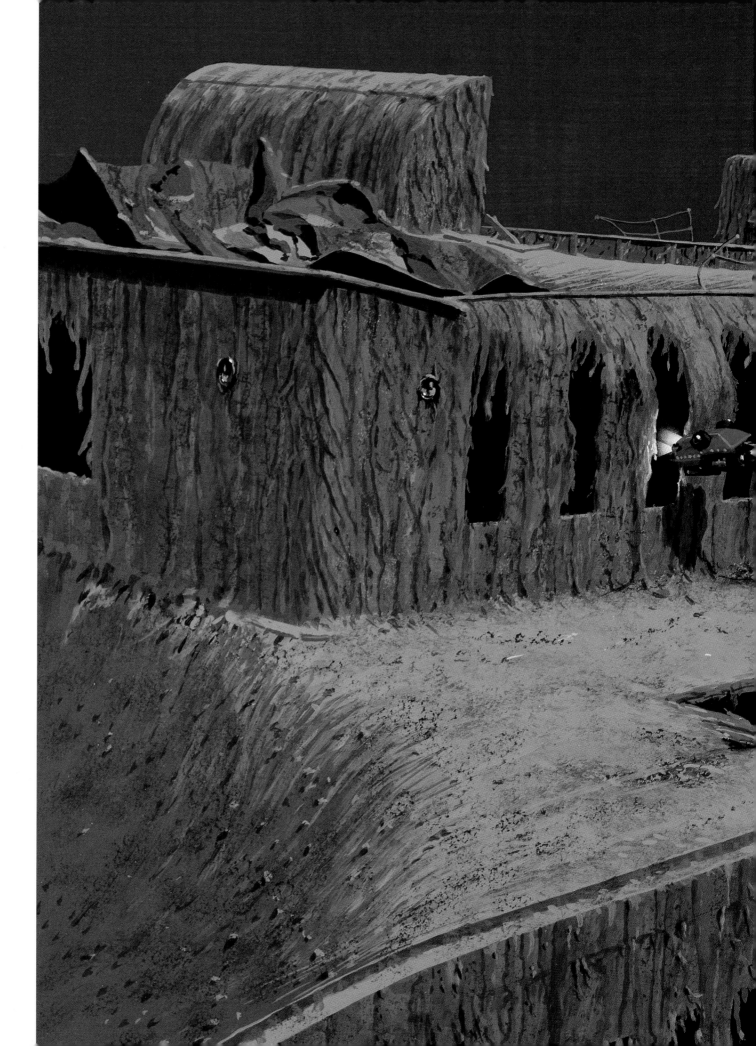

With *Alvin* perched on the starboard boat deck, *Jason Junior* goes for a stroll. Here the remotely controlled robot, which Ballard nicknamed his swimming eyeball, peers into a gymnasium window. As Ballard described it in *The Discovery of the Titanic*, little remained of the fancy exercise equipment that had so impressed passengers such as Archibald Gracie, who wrote one of the most detailed eyewitness accounts of the sinking. JJ spotted a piece of metal grillwork, a few wheel shapes, and a control handle. The rest was rust-enshrouded and in ruins.

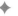

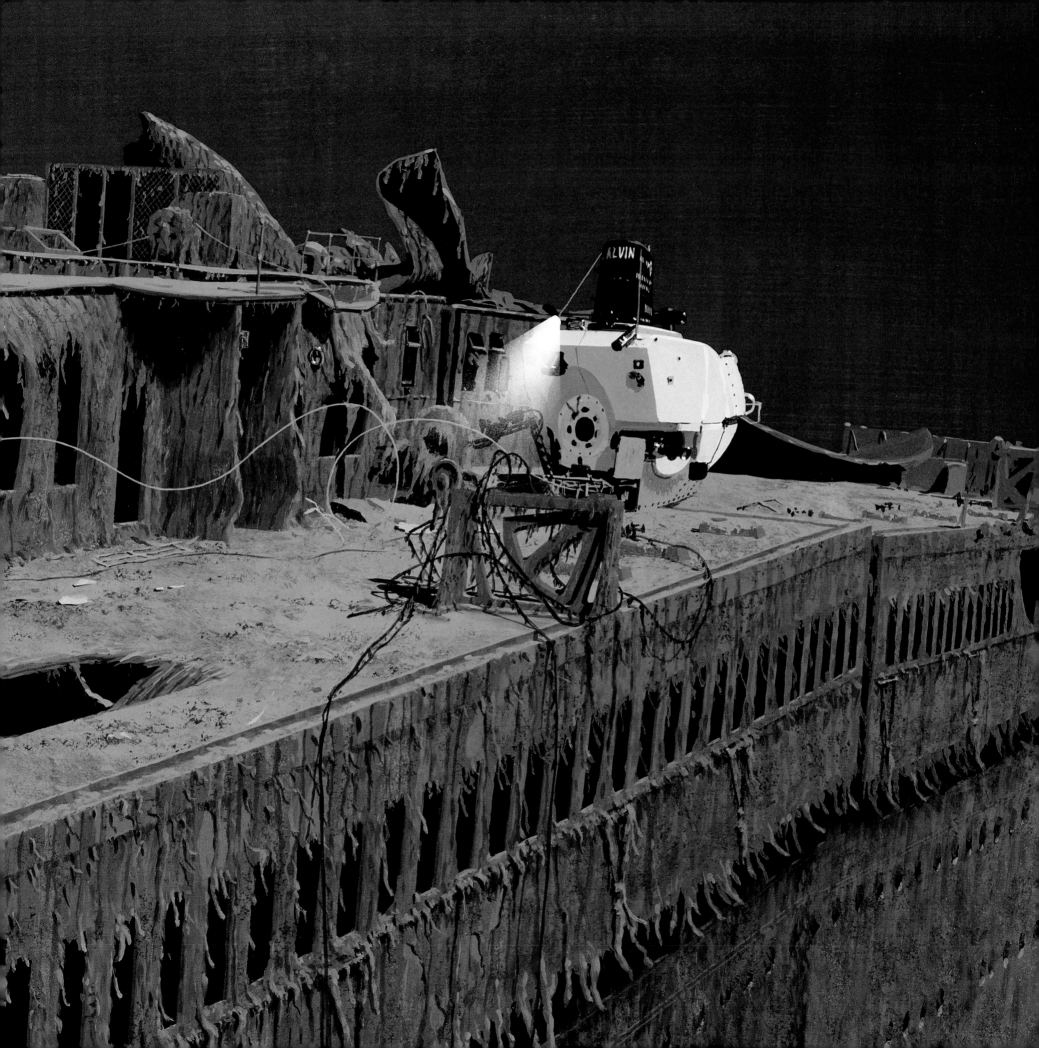

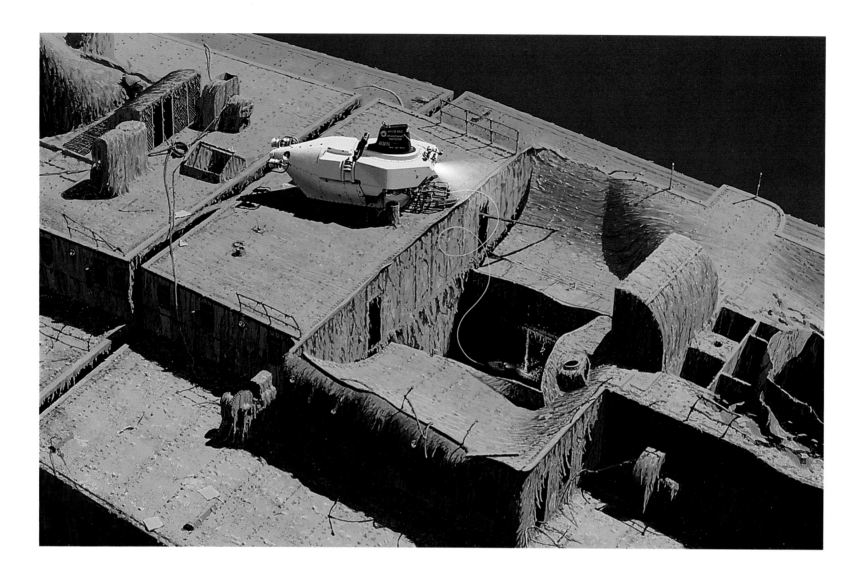

Perhaps the most dramatic episode during Robert Ballard's 1986 exploration of the wreck occurred when he sent *Jason Junior* down the open shaft that once held the forward Grand Staircase (above). It was *JJ*'s first real test and the expedition's only excursion into the deep interior of the ship. An unseen overhang or snagging wire could have ended the foray at any moment and meant the loss of this costly robot vehicle. On the first descent, the robot's pilot, Martin Bowen, steered it down along the forward wall of the staircase opening. In the painting at the right, *JJ* is about to discover the famous "chandelier," one of the light fixtures still dangling from a length of electrical wiring. This painting also amply demonstrates Marschall's "mature" style of wreck depiction with its diffuse light and otherworldly atmosphere.

◆

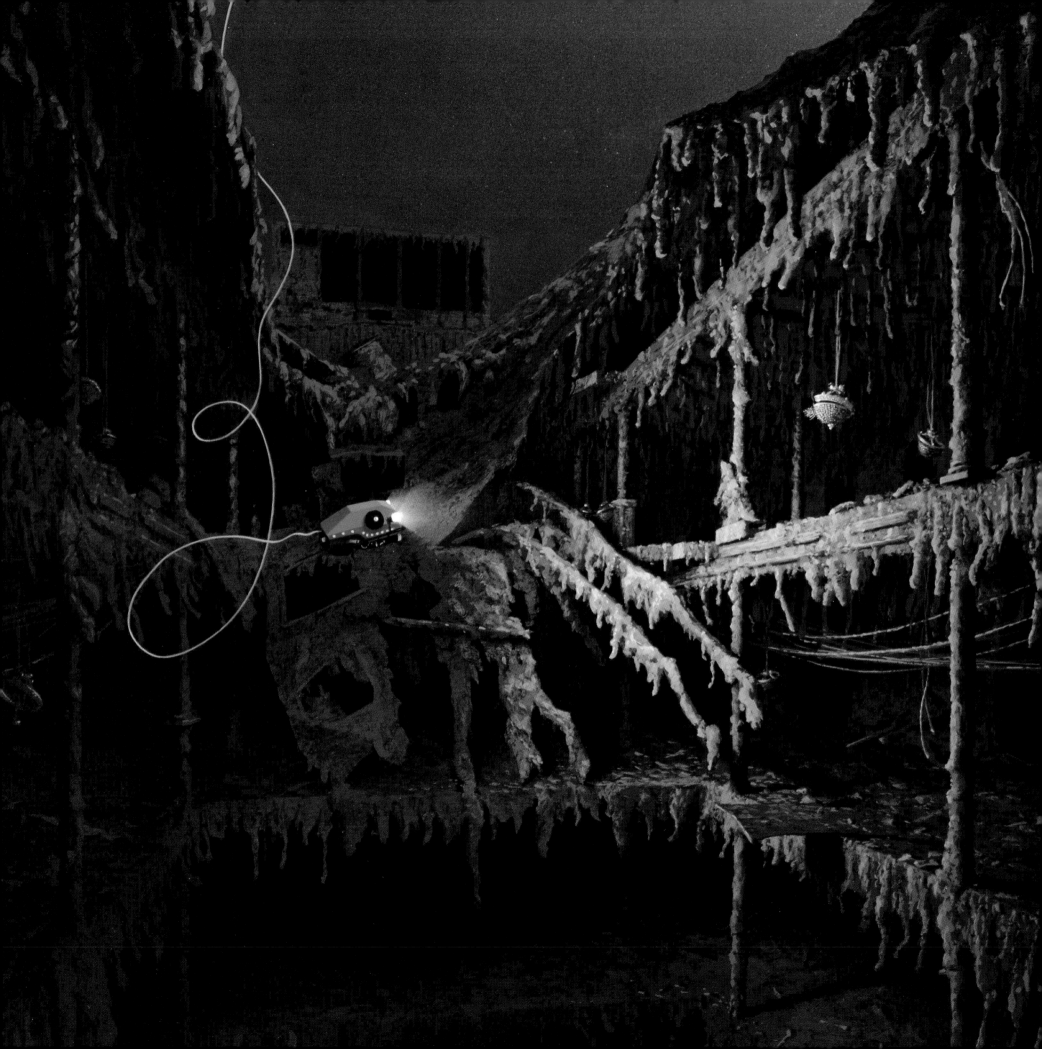

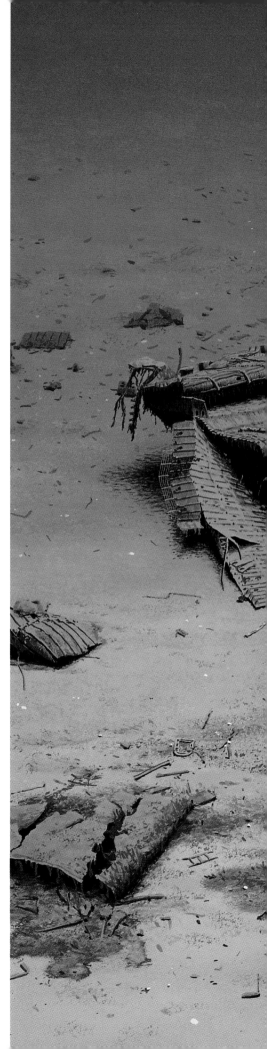

Only Ken Marschall would have had the patience to decipher and chronicle the contorted confusion of the starboard side of the *Titanic*'s stern section. Each piece of mangled wreckage in the surrounding debris field held a clue about the stern's sad state. Each still shot added a piece to the puzzle of the stern itself, which apparently collapsed like an accordion upon hitting the bottom. Yet the huge reciprocating engines are still sitting upright in their places. And at least two of the propellers remain affixed to their shafts. But there will always be places the artist simply can't be sure of. We, however, can be certain that this scene of devastation is likely to be as close as anyone will ever come to the whole truth.

◆

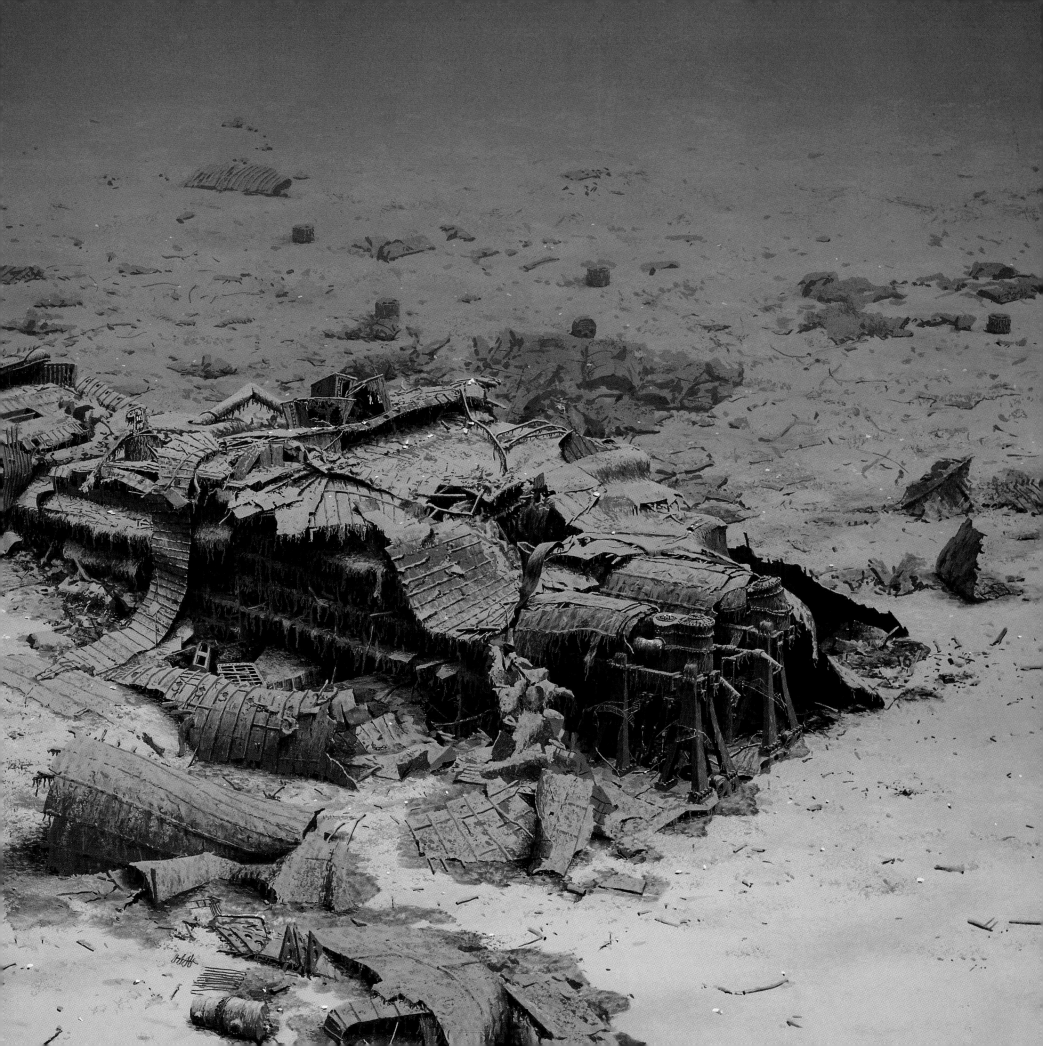

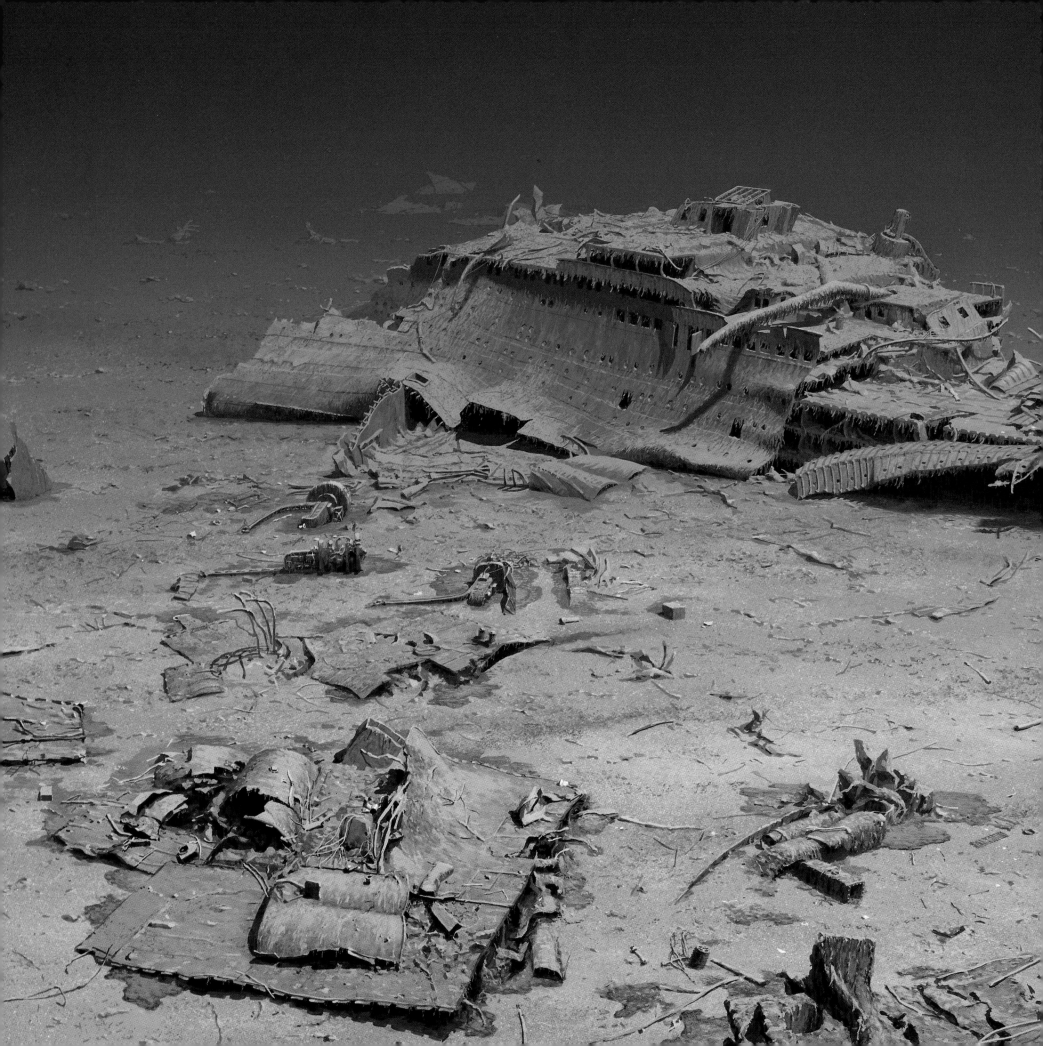

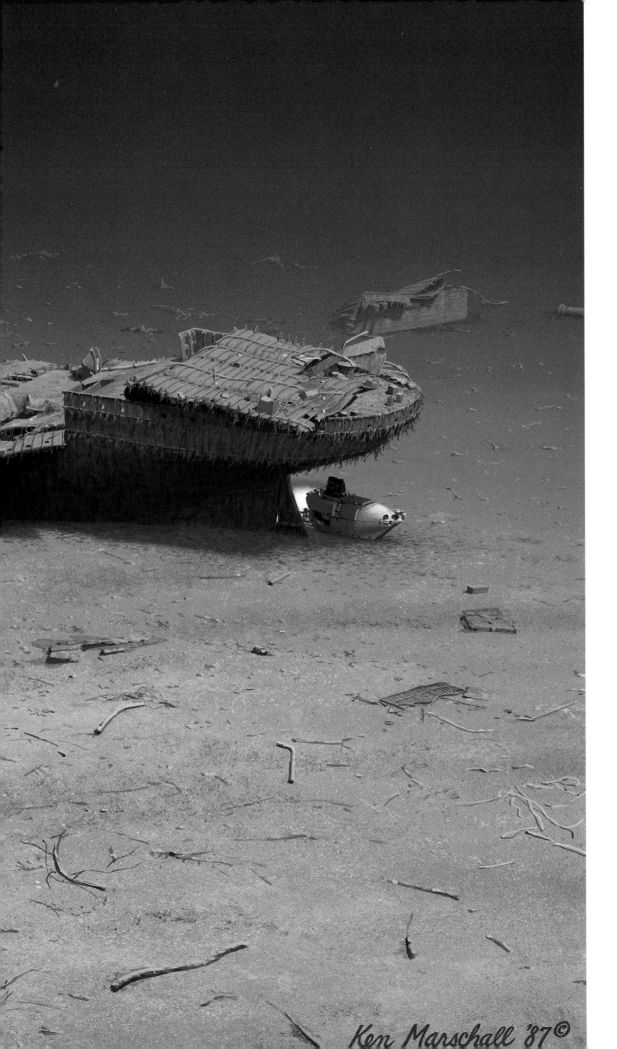

Ken Marschall '87©

When Ballard investigated the stern in 1986, he saw none of the ship's three propellers. Subsequent expeditions discovered the two wing propellers wrenched upward upon impact with the seafloor. That the explorer could be so close and not actually see such huge objects illustrates just how challenging deep-sea exploration can be.

Here Marschall depicts the stern as Ballard thought he found it, but deftly blurs the verdict by leaving the area beneath the very back of the stern in concealing shadow. The debris in the foreground has been meticulously placed and painted according to the photographic record.

◆

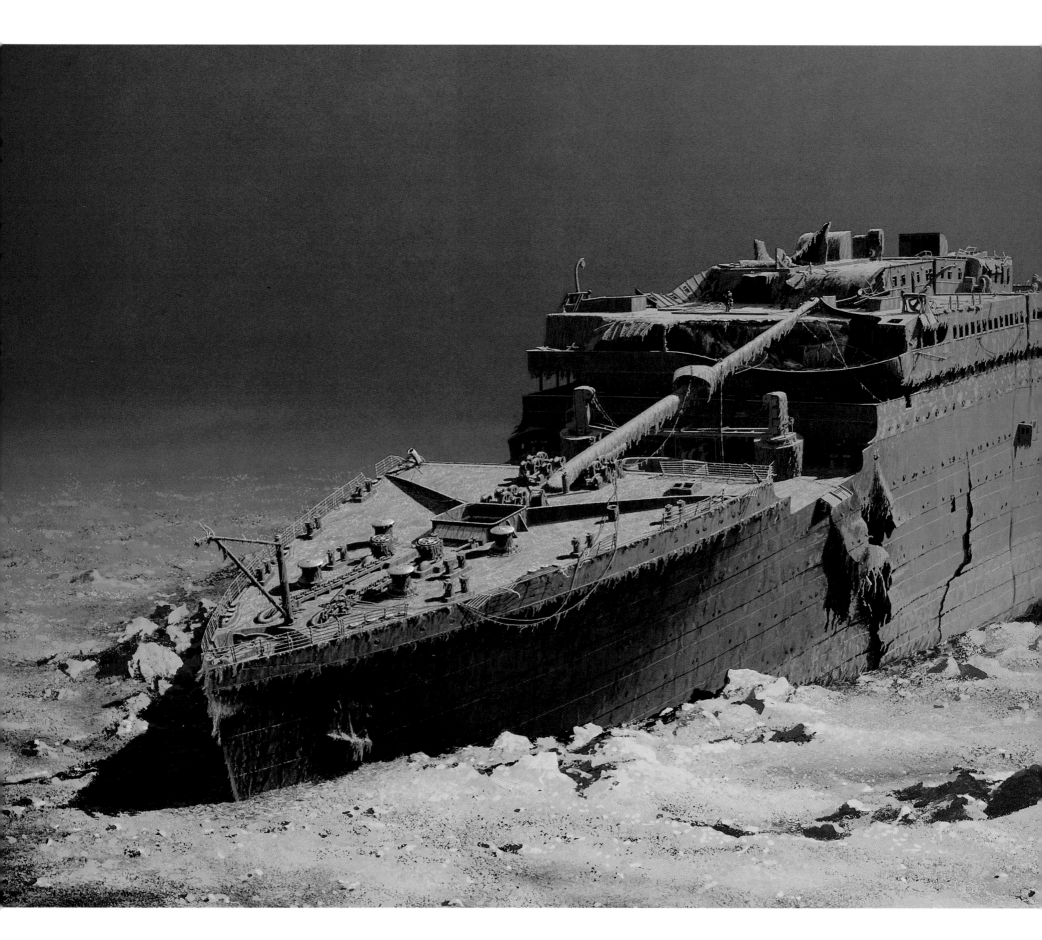

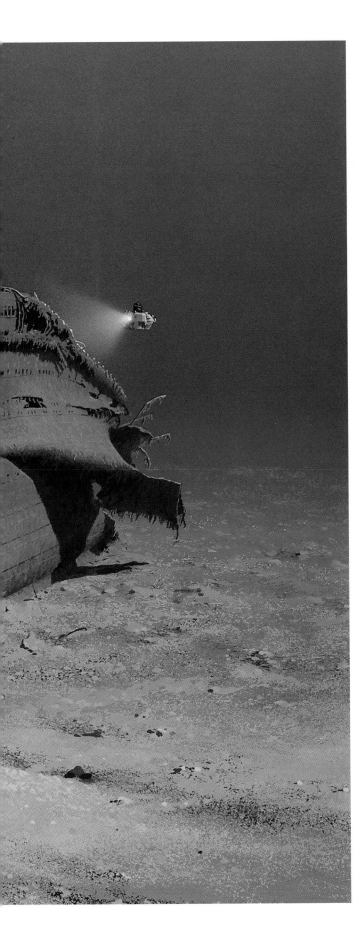

(Left) This painting of the sunken bow, commissioned for the 1988 Reader's Digest book *Great Disasters*, remains Marschall's favorite rendering of the wreck. Robert Ballard so admires this version that he has more than once tried to persuade the artist to part with it. It remains in Marschall's private collection.

(Above) This diagram created for the revised edition of *The Discovery of the Titanic* drew on all the available data to reveal an overview of the entire wreck site as Ballard found it. It shows the gently sloping abyssal plain where the *Titanic* came to rest and the bow and stern sections, which lie 1,970 feet apart and face in opposite directions. Around the bow, which sank first and planed away as it descended, there is relatively little debris. Around the stern, which up-ended before plunging straight to the bottom, lie scattered coal, shattered shell plating, and thousands of other items from the ship.

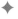

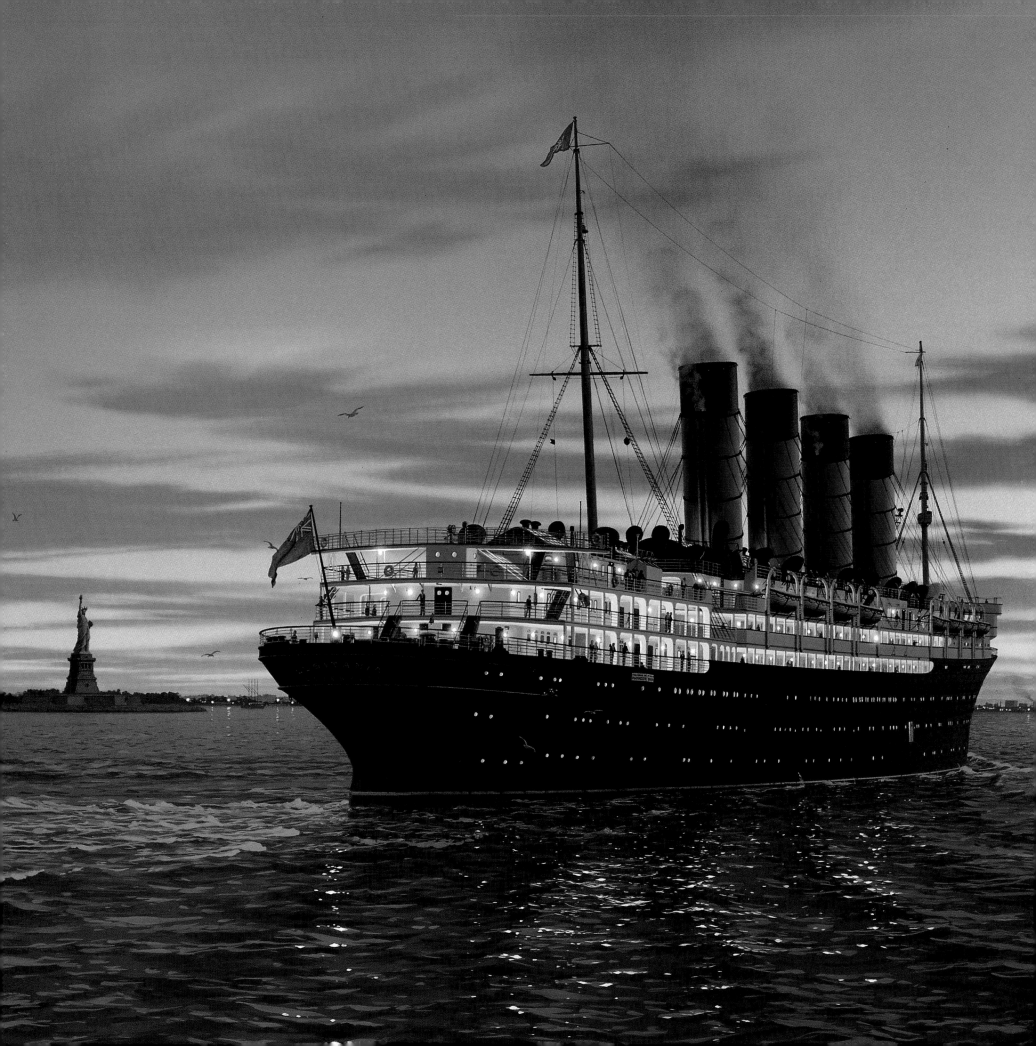

The Maritime Artist

As a researcher and collector, Ken Marschall focuses on the *Titanic* and her two sisters, the *Olympic* and the *Britannic*. As a marine artist of increasing prominence, however, he paints many famous vessels: ocean liners, ancient Roman wrecks, and ships of war. A good number of these commissions have been for books, including several collaborations with Robert Ballard. The most recent of these, *Lost Liners*, narrated an illustrated history of the great trans-Atlantic passenger ships, while highlighting the famous shipwrecks explored by Ballard. Arguably, some of Marschall's non-*Titanic* paintings rank among his best. Consider, for example, his dramatic portrayal of the sinking of R.M.S. *Lusitania* or his tragic portraits of the ship's devastated wreck.

Whenever Marschall paints one of the *Titanic*'s sisters, he brings something special to his work. The two White Star giants led very different lives. The older sister, *Olympic*, which entered service the year before the *Titanic*'s maiden voyage, enjoyed a long and successful career on the Atlantic run, retiring in 1935. The younger sister, *Britannic*, launched in February of 1914, just months before the onset of the First World War, was converted into a cavernous hospital ship ferrying wounded soldiers from the eastern Mediterranean back to England. On one of her outbound voyages, the *Britannic* struck a German mine and sank in only fifty-five minutes, less than

◆

The *Lusitania* approaches New York Harbor at the end of another Atlantic crossing.

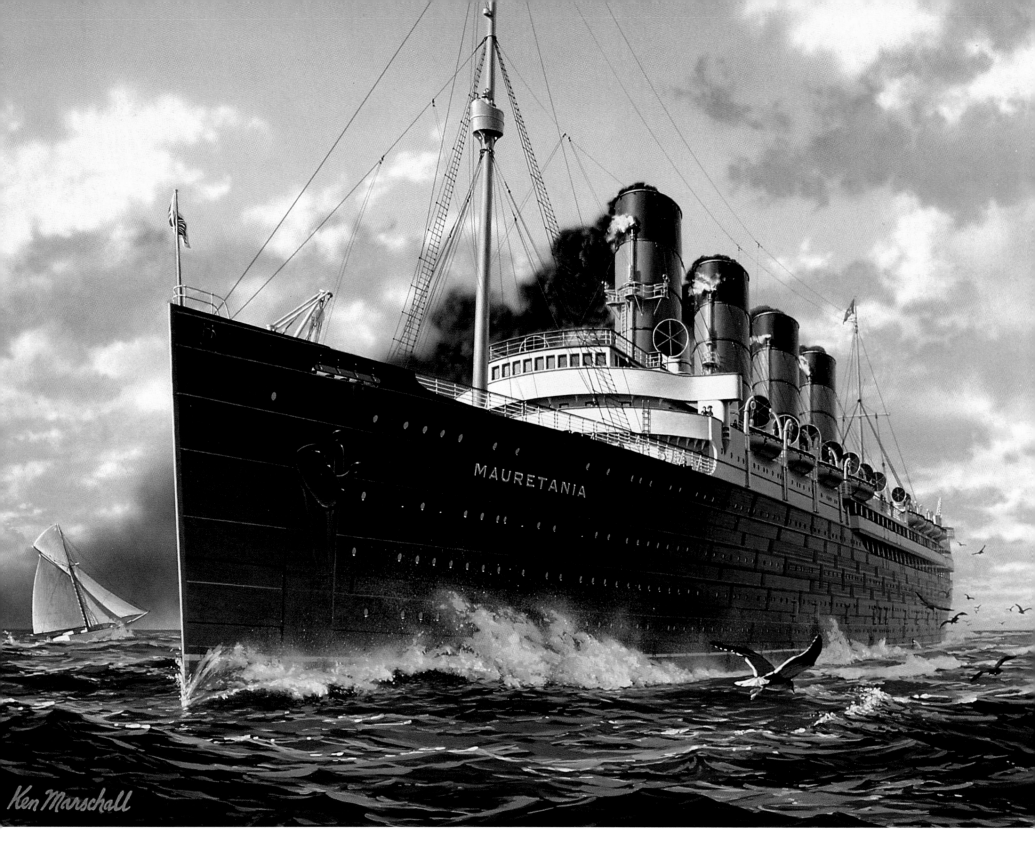

Ken Marschall

One of the most successful ocean liners in history, the *Mauretania* entered service in November 1907 and,

including a stint as a troop ship during the First World War, served passengers until September 1934.

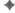

half the time it took the *Titanic* to founder.

In the last few years, Marschall has come to know this youngest of the three sisters quite intimately. In 1995, he accompanied Ballard on an expedition to explore the *Britannic* wreck, which lies in shallow water in the Aegean near the Greek isle of Kea. Marschall acted as the expedition's visual historian. He also spent forty-eight hours in the U.S. Navy's nuclear submarine *NR-1* getting a close-up look at the wreck. Unlike the *Titanic*, the *Britannic* is virtually in one piece and in an amazing state of preservation. According to Ken, "*Britannic* is a Walt Disney dream ship-wreck—just this huge ocean liner looking way too good to be anything but a Hollywood creation." Because the *Britannic* is identical in many respects to her more famous sister, Marschall was deeply moved by the experience of actually visiting the wreck.

After the *Titanic*, *Olympic,* and *Britannic*, Marschall is most knowledgeable about their two great Cunard contemporaries, the *Mauretania* and *Lusitania*. Eric Sauder, one of his closest friends, is an authority on these two ships. Sauder and Marschall accompanied Ballard on his 1993 expedition to the *Lusitania* wreck off the southern coast of Ireland. They were saddened by the deteriorated state of the wreck, but thrilled to visit it aboard the small submersible *Delta*.

Ken has painted both the *Lusitania* and her long-lived sister, the *Mauretania,* in their heydays, capturing the dramatic style of these famous speed-record holders often referred to as ocean greyhounds.

Whether Ken Marschall is painting an ocean liner in full trans-Atlantic flight or a wreck lying inert in a gloomy underwater grave, he manages to express its individuality. His paintings combine carefully researched historical accuracy with something much more difficult to master. He shows us that each of these ships has a soul.

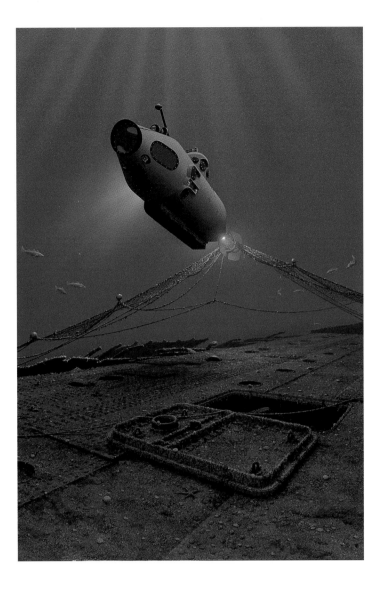

During a dive over the *Lusitania* wreck in August 1993, expedition historian Eric Sauder and Ken Marschall experienced some tense moments when the tiny submarine, *Delta*, snagged on some fishing nets. After struggling unsuccessfully to free the sub, the pilot decided to jettison its tail section to allow the rest of the sub to rise to the surface. Sauder remembers feeling as if the "sub would shoot out of the water like a missile." Marschall's painting captures their predicament before this happy ending. Fortunately, the expedition had brought along an extra tail section. The jettisoned section was later recovered.

◆

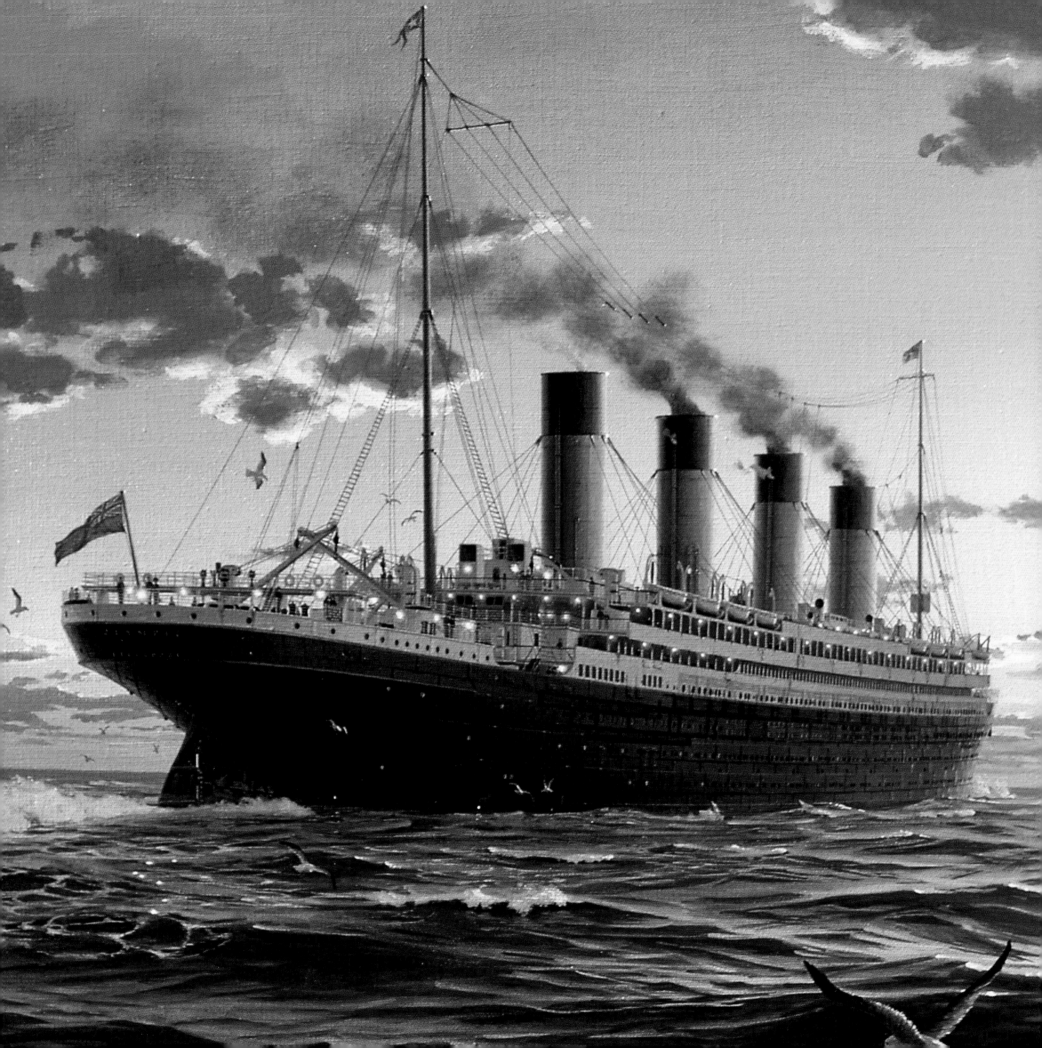

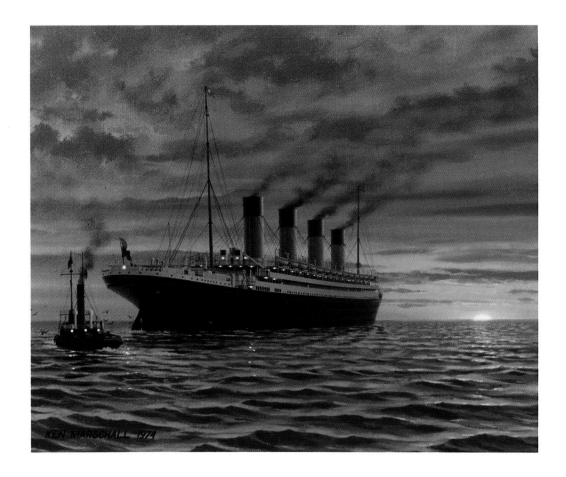

Olympic

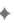

T he R.M.S. *Olympic*'s maiden voyage in June 1911 inaugurated one of the most illustrious careers in trans-Atlantic history, lasting twenty-four years. Her first arrival in New York was a triumph that inspired J. Bruce Ismay, the White Star Line's managing director, to exult, "*Olympic* is a marvel, and has given unbounded satisfaction." In the painting at the left Marschall communicates a sense of promise as the ship sails proudly into the setting sun on her first Atlantic crossing. In the rendering above, owned by Ed Kamuda of the Titanic Historical Society, Marschall shows a similar view at the end of the ship's career, as she sails into her last setting sun on her way to the breaker's yards in 1935, the same year the *Mauretania* met a similar fate. This painting reflects the changes wrought by time and experience—most notably, the addition of many lifeboats after the loss of the *Titanic*.

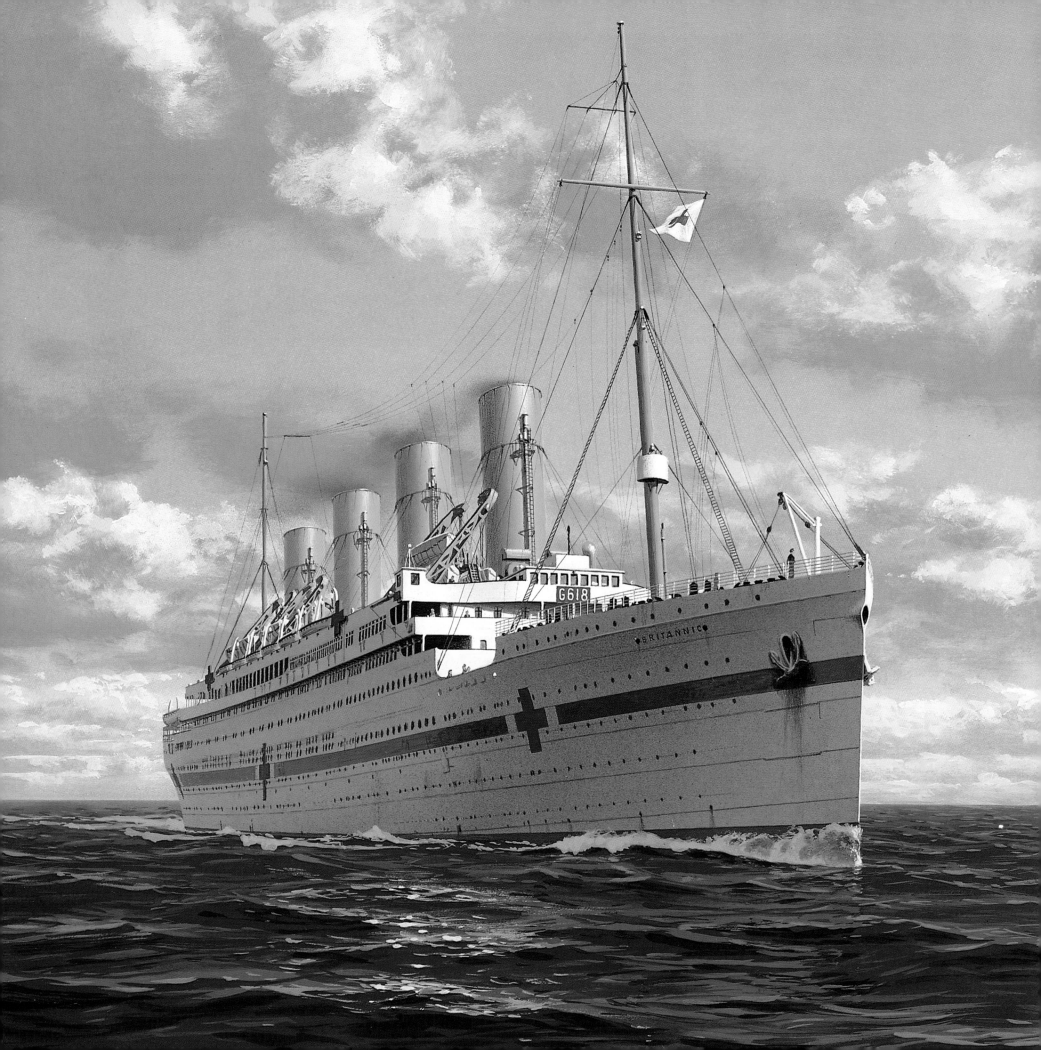

Britannic

✦

In theory, His Majesty's Hospital Ship *Britannic* was immune to enemy attack. Under the Geneva Convention any vessel painted white and bearing red crosses qualified as neutral. Dressed in white, with flashes of red, a green stripe, and mustard-yellow funnels, the *Britannic* cut quite a dashing figure. And her profile was somewhat different from the *Titanic*'s. The most notable contrast is on the boat deck, in the form of five towering gantry davits, each capable of launching six lifeboats. All told, she possessed lifeboat capacity more than sufficient to rescue a full complement of passengers and crew.

White Star also lavished considerable attention on less visible safety features intended to make the *Britannic* withstand an accident like the one that sank the *Titanic*. A watertight inner skin protected her engines and boiler rooms, five of her seventeen watertight bulkheads extended to B-deck, forty feet above the waterline, and each compartment possessed its own pumping system. As a consequence of the fitful communication between the bridge and the wireless operators that had contributed to the *Titanic* tragedy, the two were now linked by pneumatic tube that permitted wireless operators to send relevant messages to the bridge immediately. In theory, neither a single mine nor a single torpedo could sink this ship.

How could a single mine have sunk a ship built to be even stronger and more secure than the *Titanic*? The probable answer appears in the form of the open portholes visible in Marschall's painting of the scene. Leaving portholes open in a combat zone was strictly against operating instructions. But these were orders easy to ignore on a beautiful Mediterranean morning in a ship marked as a noncombatant.

After the mine blasted a hole in the starboard bow, water began pouring into the forward compartments. As a result of the failure of one of the watertight doors, six of these compartments began to flood—in theory the maximum number that could be filled before the ship would sink. But as the bow dips into the water, the open portholes provide new points of entry into the ship, sealing her fate. She sank in less than an hour.

✦

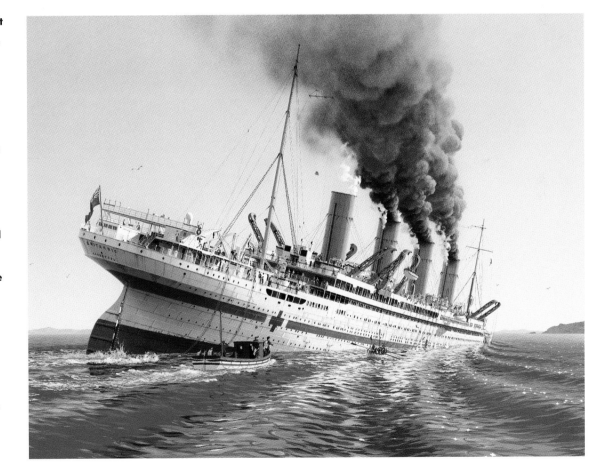

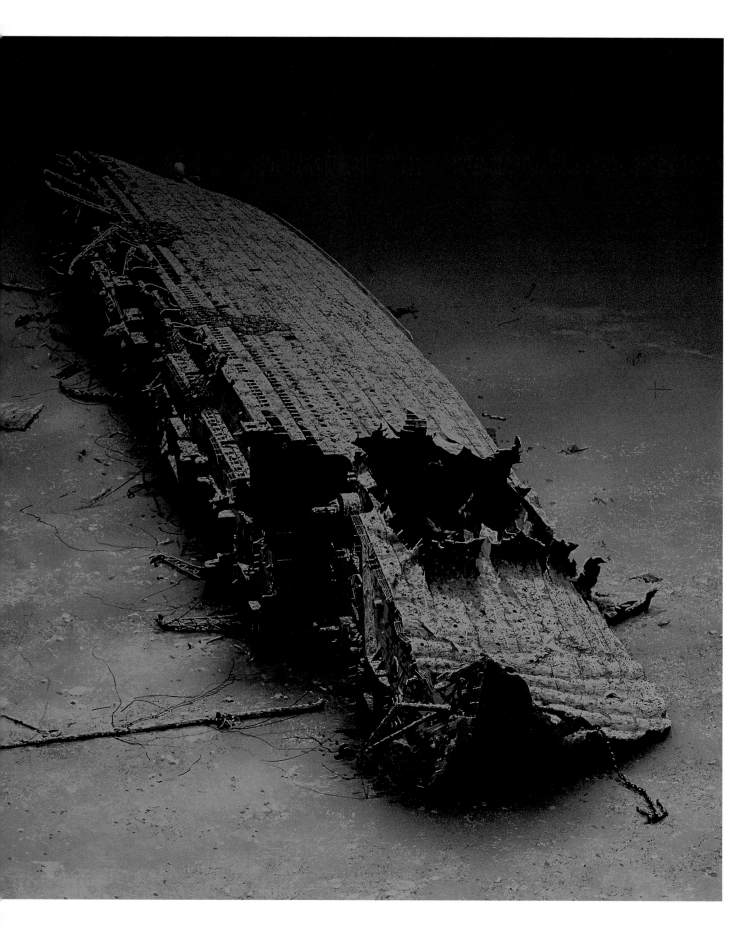

Ken Marschall based his original painting of the wreck of H.M.H.S. *Britannic* (left) on the sketchy evidence brought back from Jacques Cousteau's exploration in the late 1970s. Once Marschall had visited the wreck himself with Robert Ballard's 1995 expedition and studied the many images from it, he revised the painting (right). Among the numerous differences, the hole in the starboard hull is the most obvious. What Cousteau believed was a huge blast hole turned out to be a tear caused when the ship hit the bottom. And the funnel Cousteau found was more accurately repositioned just to the left of the bridge area. The later painting also reflects Marschall's mature approach to lighting undersea scenes. The light is more diffuse, the edges blurred, the mood ghostly.

◆

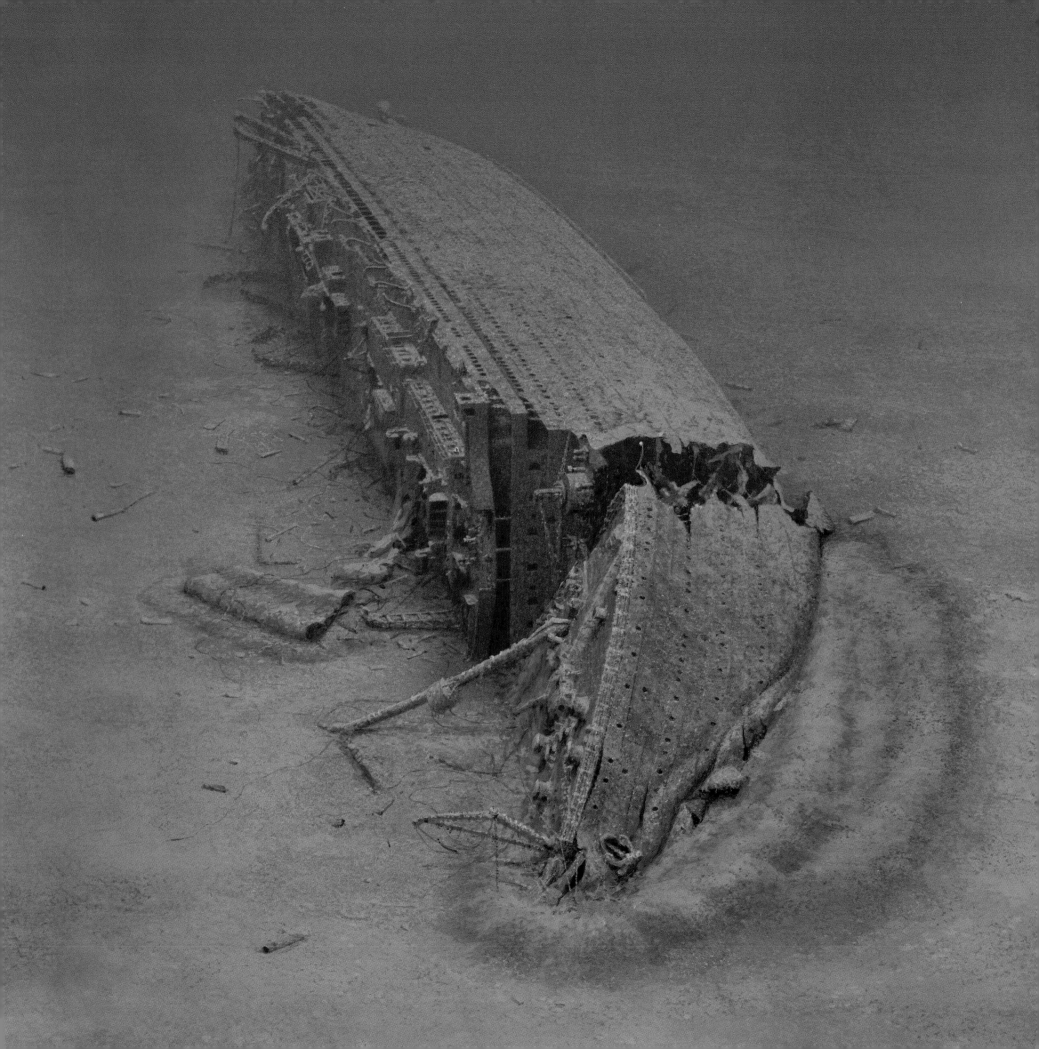

Lusitania

✦

On May 1, 1915, as tugs help the *Lusitania* away from the Cunard pier in New York, her passengers seemingly feel little anxiety at crossing an ocean infested with German submarines. Even with six of her boilers unlit so as to conserve fuel, she can still make twenty-one knots, in theory more than enough to outmaneuver a torpedo. Yet on May 7, she will prove an easy target for a German U-boat, thanks to some questionable decisions by her captain. Almost two-thirds of her passengers and crew will perish after the ship sinks in a mere eighteen minutes. Among the lost are more than a hundred Americans, whose deaths help speed America's entry into the First World War.

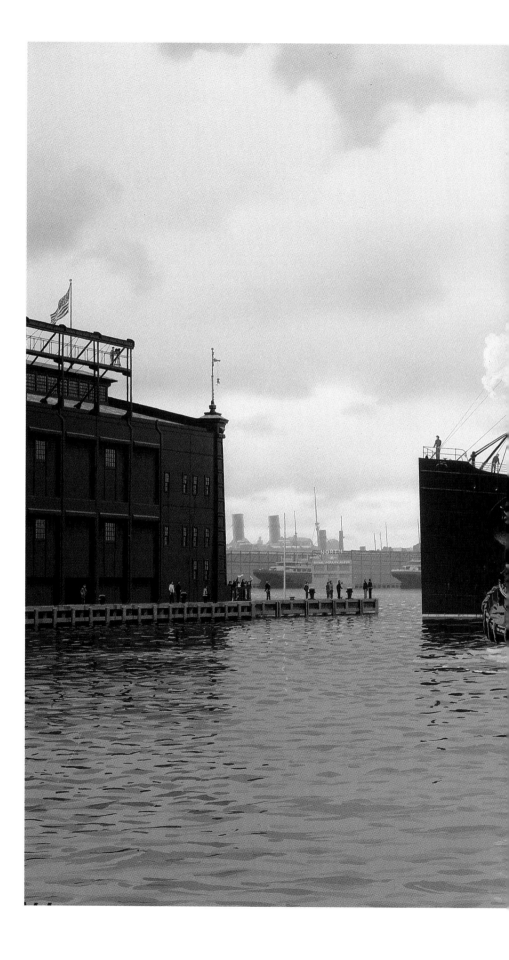

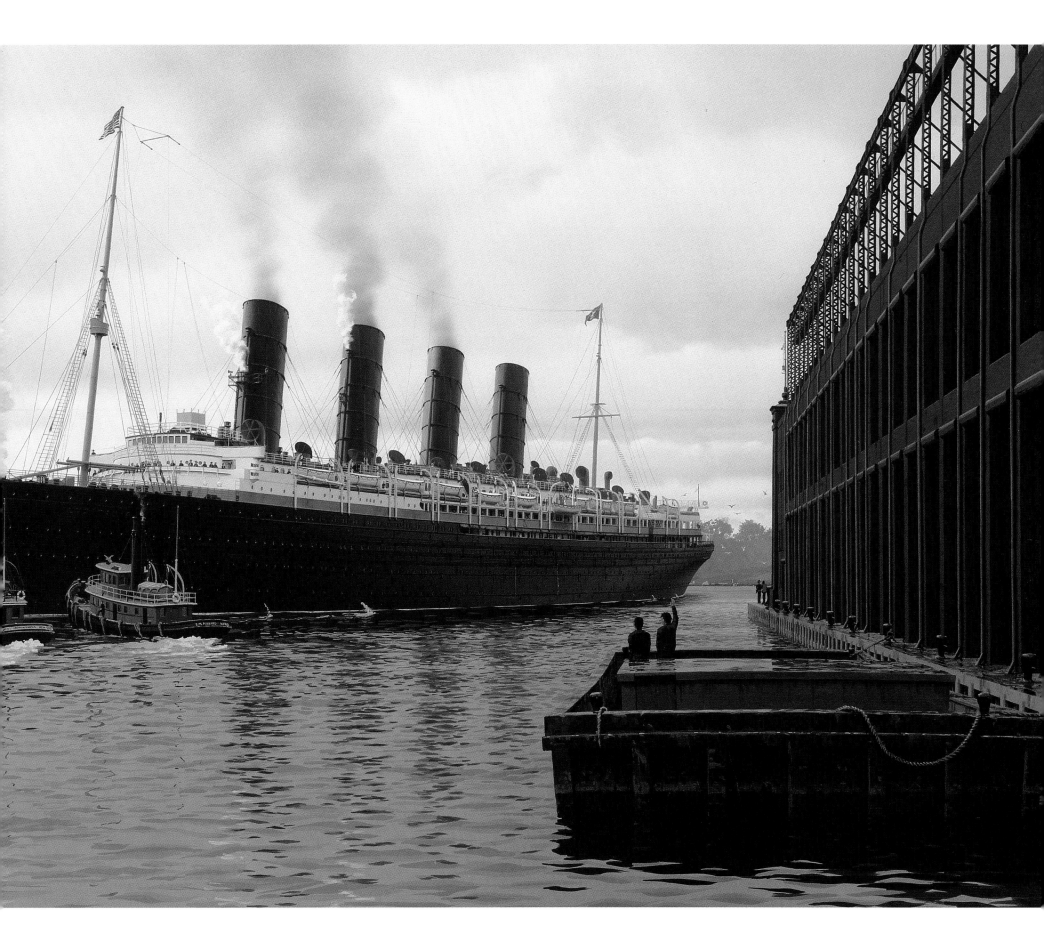

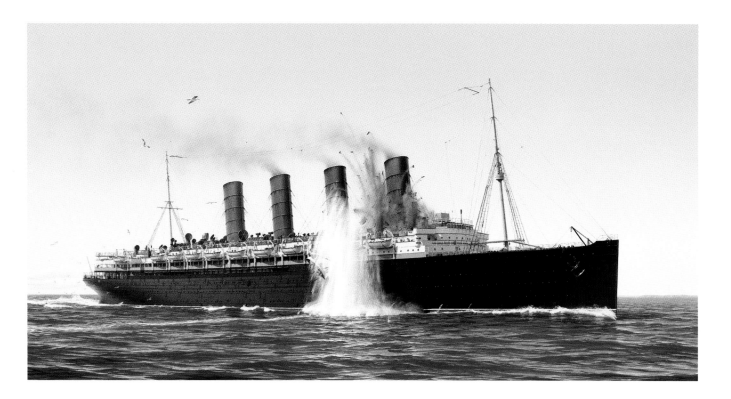

The *Lusitania* was just rounding the southern coast of Ireland near the end of her early May 1915 voyage from New York when disaster struck. The single torpedo hit was quickly followed by a second explosion, possibly caused by the ignition of a volatile mixture of oxygen and coal dust in the nearly empty bunkers. The ship listed sharply and sank so fast that only a handful of the starboard lifeboats could be launched. In fewer than twenty minutes she was gone, taking with her 1,195 passengers and crew.

◆

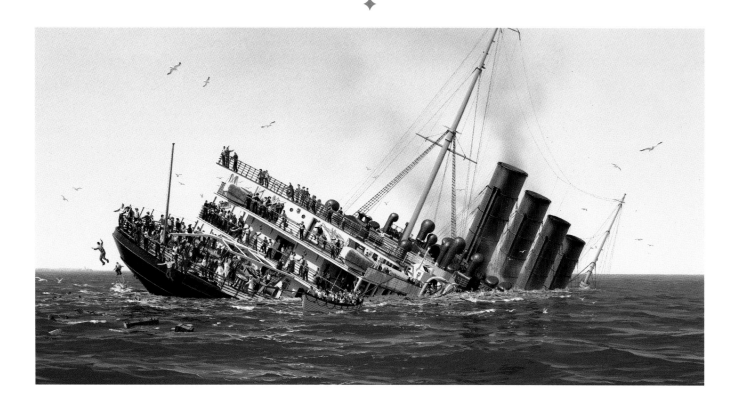

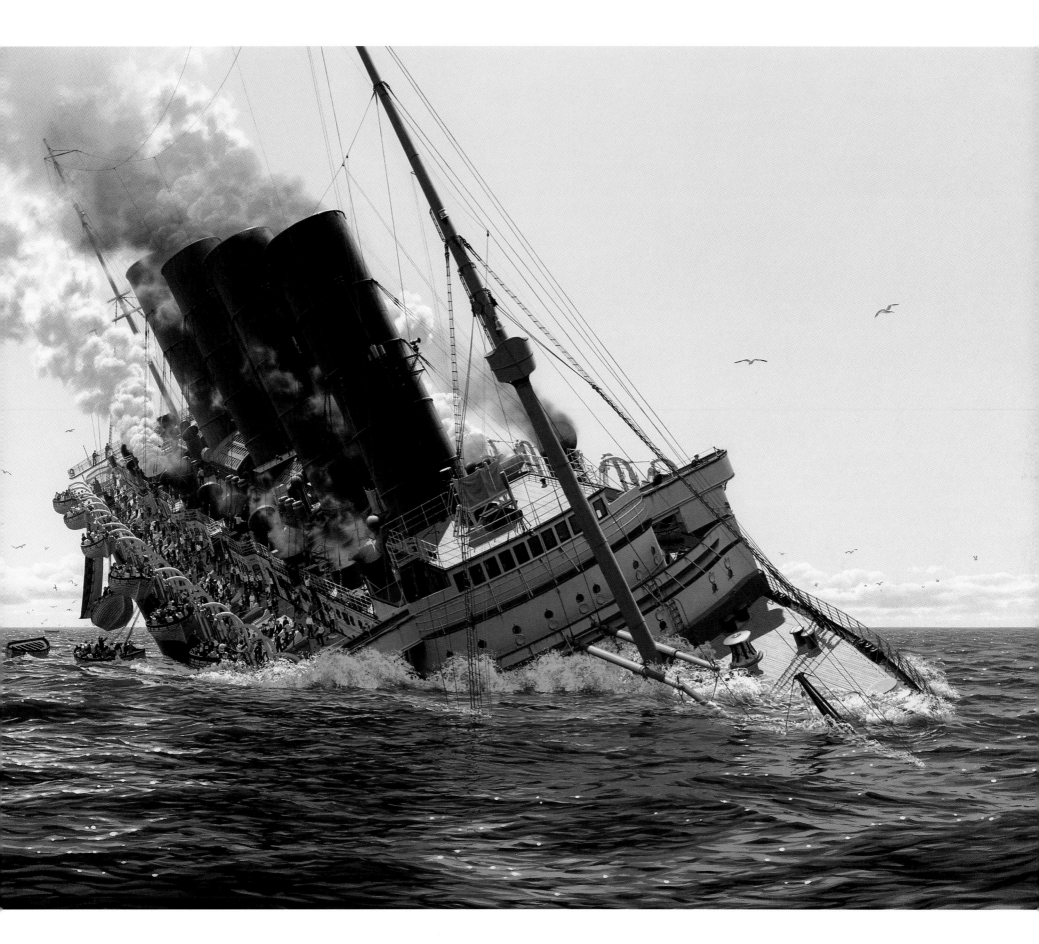

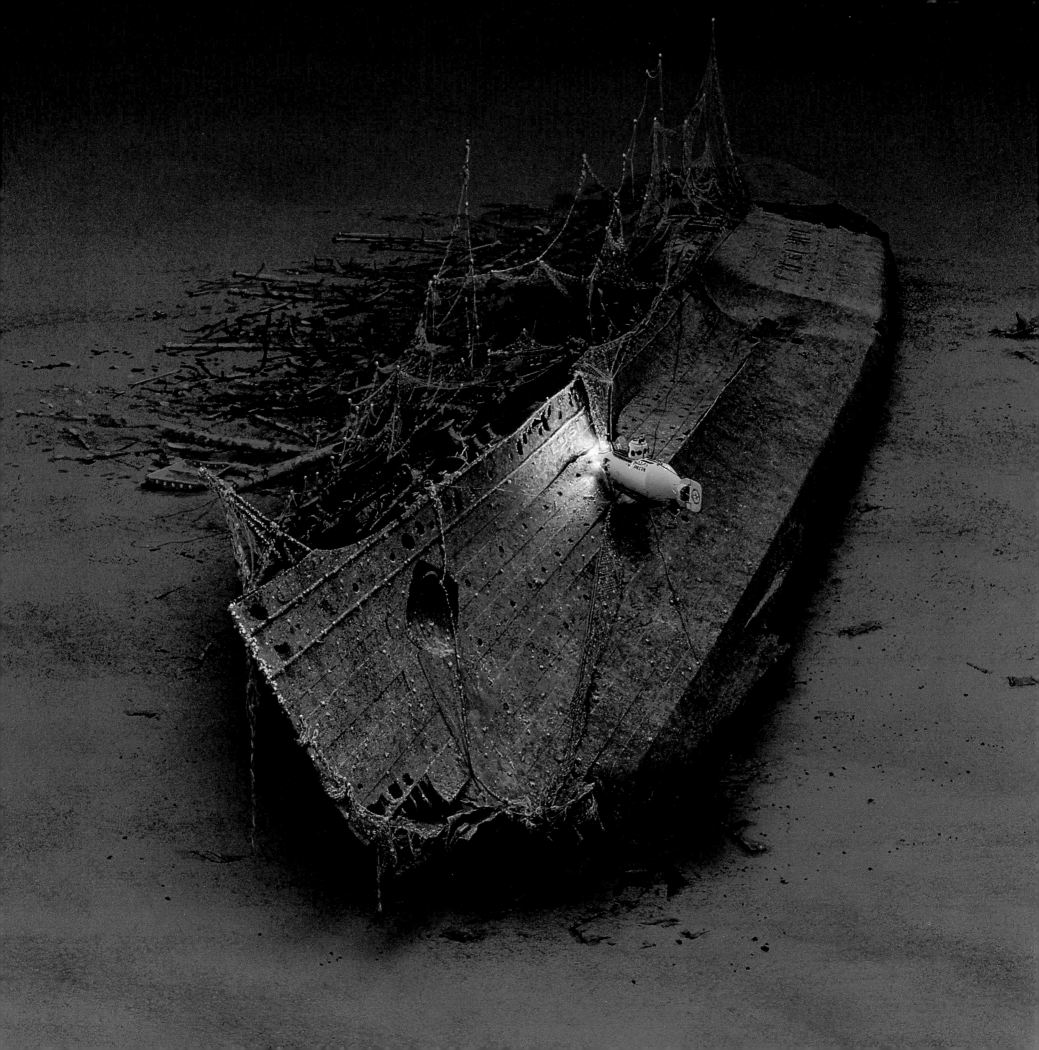

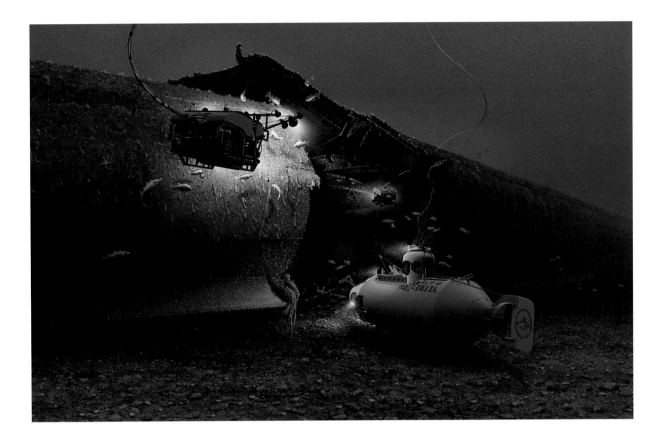

Ken Marschall's paintings of *Delta* exploring the ravaged wreck of the *Lusitania* are among his most haunting. At the left, *Delta*'s headlights illuminate the ship's name on the bow. On the upper right, *Delta,* the remotely operated vehicle *Jason*, the full-scale version of the *Jason Junior* prototype tested on the *Titanic*, and a smaller underwater probe investigate the great tear in the ship's side. On the lower right, *Delta* gets close to the starboard anchor still hanging from the bow.

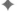

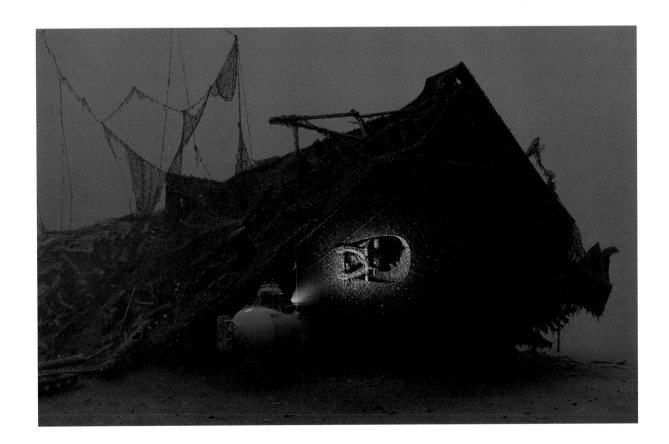

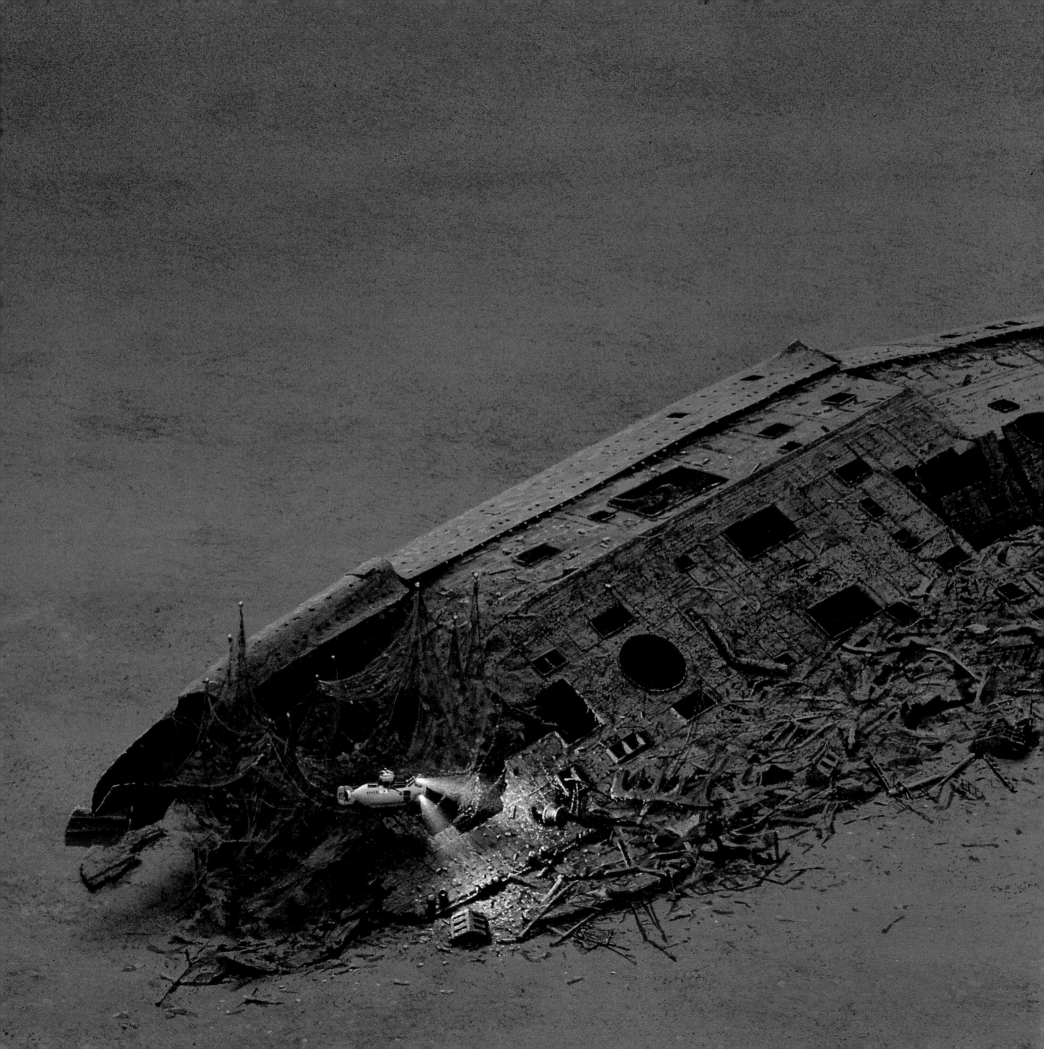

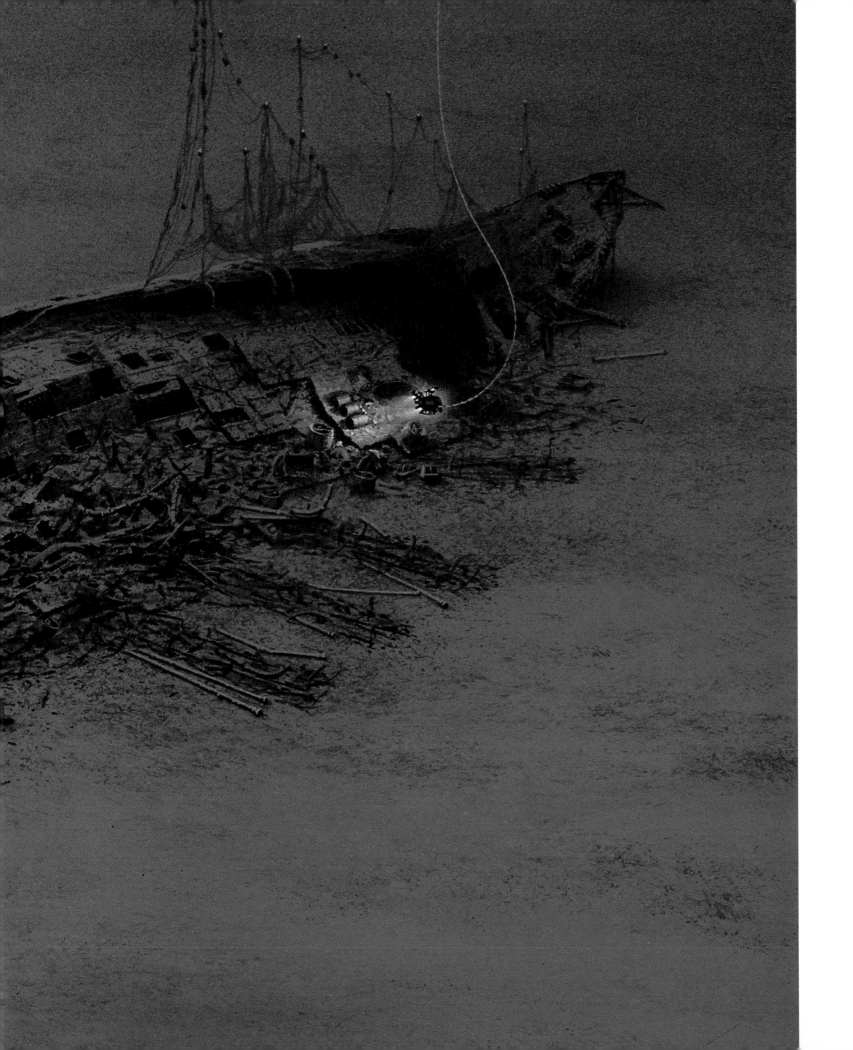

Marschall's full-length portrait of the *Lusitania* wreck, viewed from a wide angle that captures the full extent of her desolation, was one of the highlights of the book *Exploring the Lusitania,* on which he collaborated with Robert Ballard.

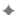

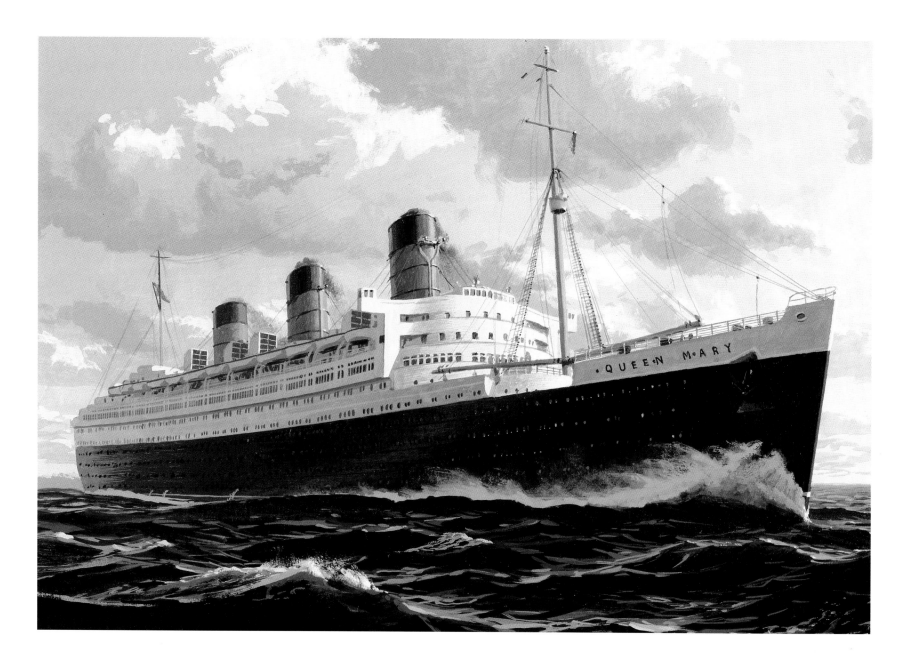

Queen Mary

◆

The *Queen Mary*, commissioned in 1936, may have been the biggest and fastest ship of her day, but in design and interior appointments, she hearkened back to an earlier era. She was far closer in demeanor to the *Mauretania*, the *Lusitania*, and the *Aquitania*, the great Cunard trio from before the First World War. Her straight-edged bow and upright funnels seem to speak of probity and tradition. Yet despite her faults, which included a sickeningly long slow roll in heavy seas, the *Queen Mary* quickly became the most popular ship on the trans-Atlantic run. During the Second World War she contributed distinguished service as a troop ship. From war's end until 1967, the *Queen Mary* continued her peacetime career and now resides at Long Beach, California, as a dockside hotel.

Normandie

◆

The French Line's *Normandie* seems the antithesis of the *Queen Mary*. Everything about her is stylish and forward looking, even her rakish bow and streamlined profile. From her maiden voyage in 1935 until a fire sank her at her wartime berth in New York Harbor, she represented the epitome of trans-Atlantic glamor. If boarding the *Queen Mary* reminded one of arriving at a comfortable English country house, entering the *Normandie* seemed like walking inside a vast art deco movie set. Her grand salon, with its giant murals and fountains of light, and her spectacular three-hundred-foot-long dining salon, to which one descended by means of a long staircase, was built, above all, for show. Not surprisingly, movie stars and entertainers, including the immortal Marlene Dietrich, favored the French ship over the English one.

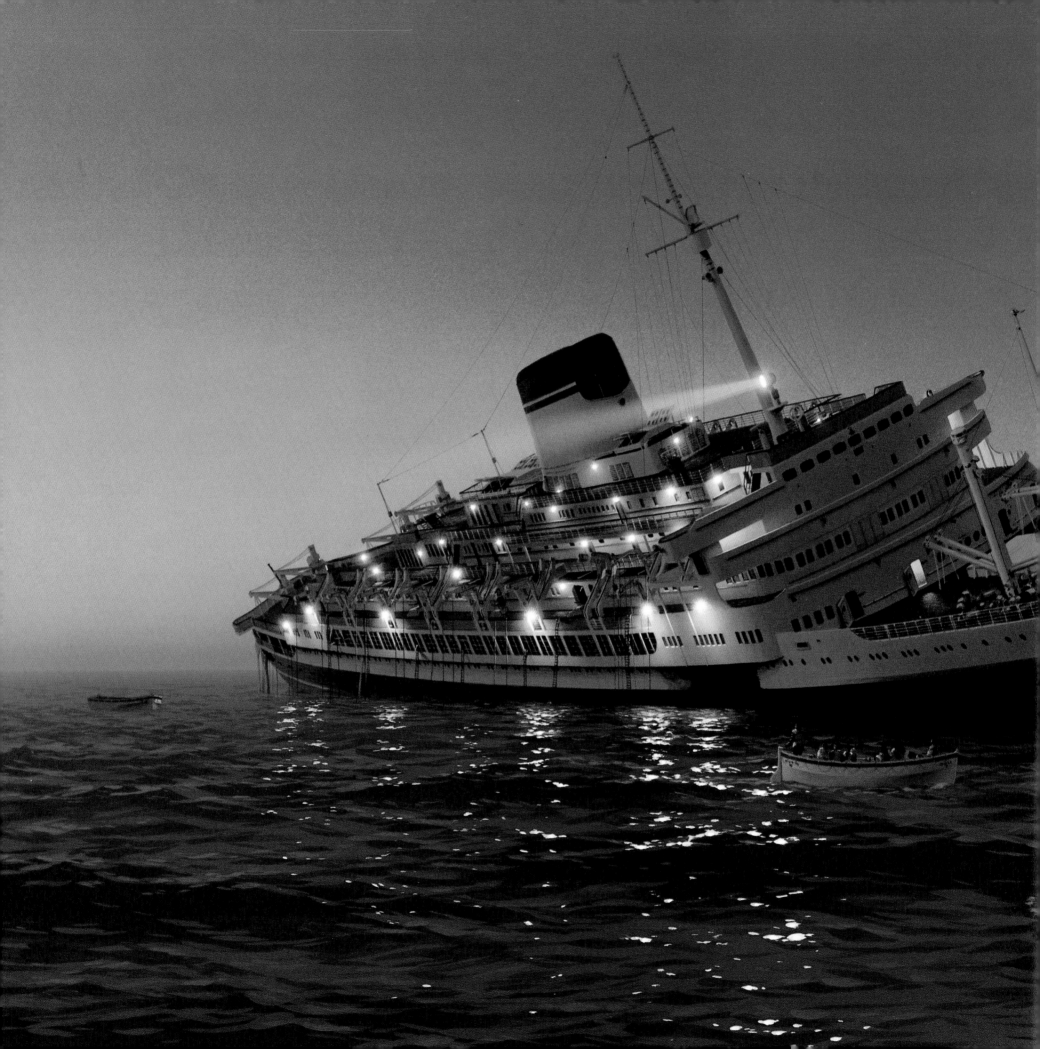

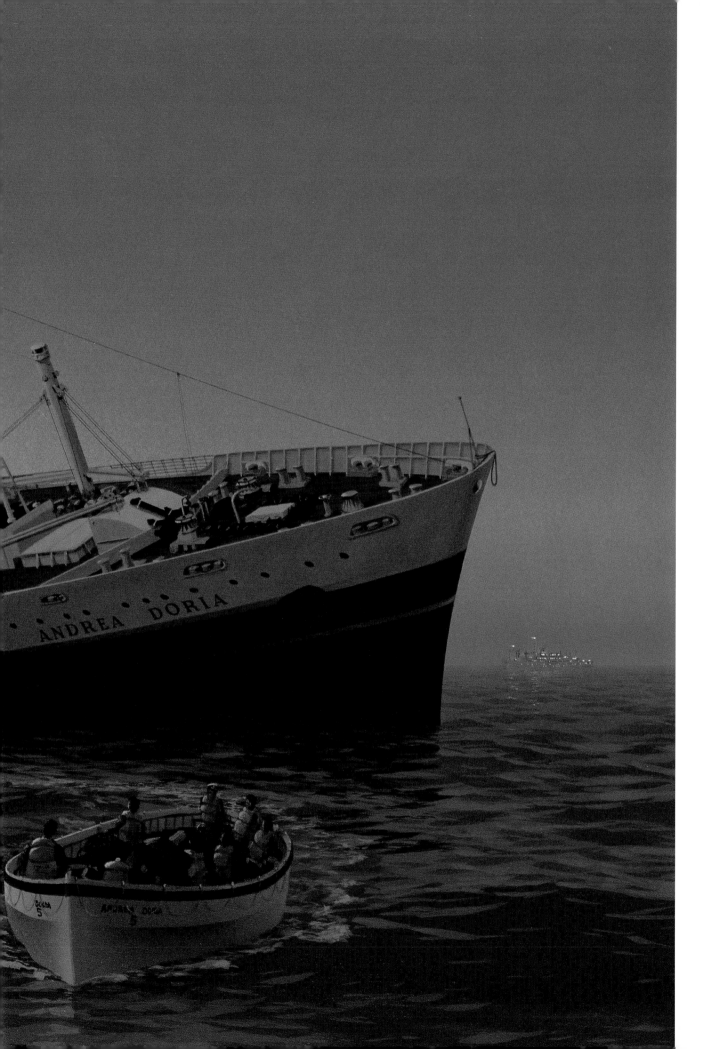

Andrea Doria

✦

More than forty years after the *Titanic* disaster, one of the last of the great Atlantic liners met a similar fate. On the evening of July 25, 1956, southwest of Nantucket Island, the Swedish liner *Stockholm* collided with the Italian luxury liner *Andrea Doria*, which sank eleven hours later. Despite the presence of sophisticated radar equipment on both ships, the collision happened at almost full speed. Advances in design and safety features could not keep the *Andrea Doria* afloat. Fortunately, other ships soon arrived on the scene and only the passengers and crew killed in the initial collision were lost.

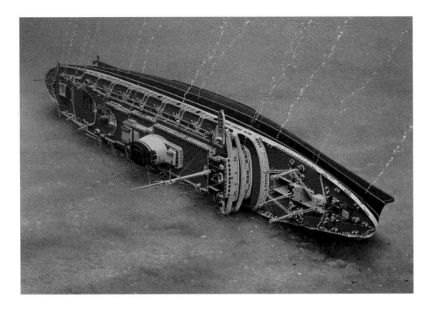

Marschall's two paintings of the wreck of the *Andrea Doria*,
first as she looked at the time of her sinking (above) and then as she
looks today, show the ravages of time. The hull remains intact,
but much of the superstructure has been rusted away and she is
shrouded in discarded fishing nets, which make the site particularly
dangerous for the few divers who risk a visit.

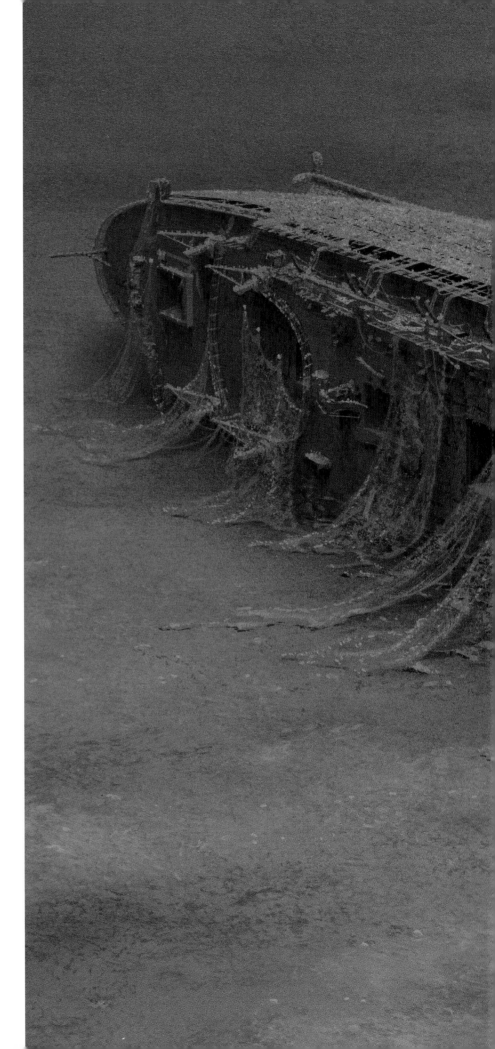

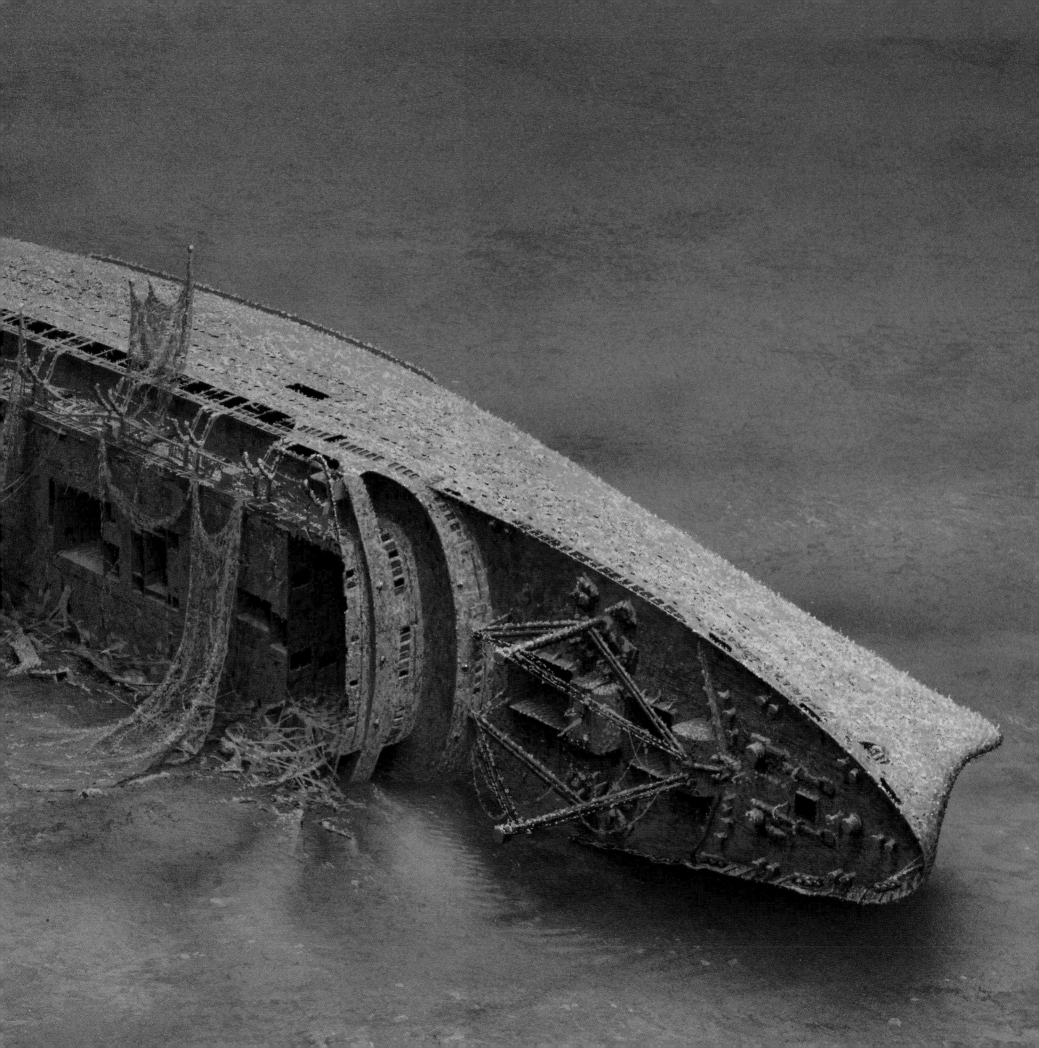

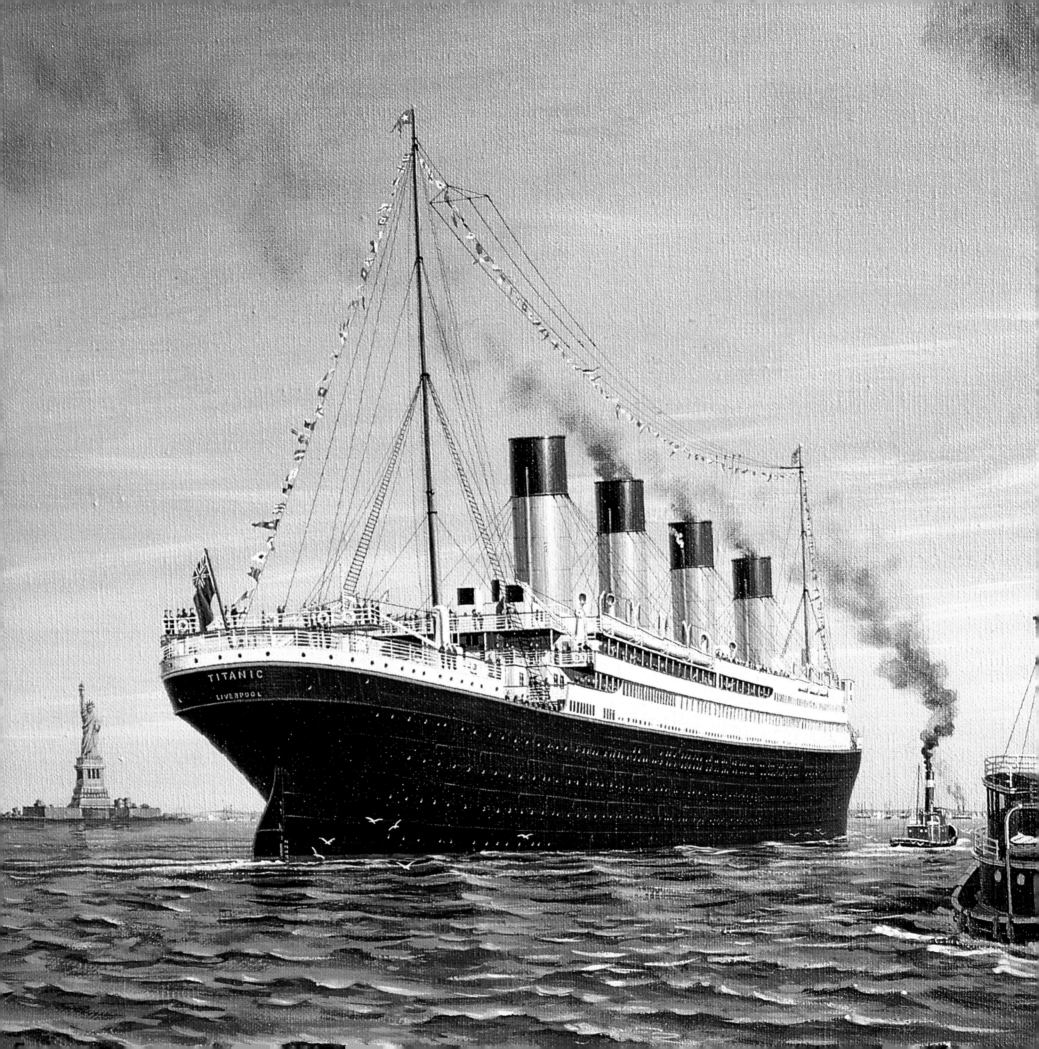

Epilogue

Had the Titanic completed her maiden voyage on schedule, she would have entered New York Harbor on the morning of Wednesday, April 17, 1912, to a triumphant welcome such as the one Ken Marschall imagines here. Instead, the 705 Titanic survivors who arrived on April 18 aboard the Carpathia disembarked into a world that seemed to have changed in some profound way. Certainty and self-confidence had given way to doubt and self-questioning. Years later, following the great historical divide of the First World War, it would appear to many that the sinking of the Titanic marked the beginning of the end of an era. Ironically, that era lives on in our enduring fascination with the Titanic story, a fascination that has been deepened and broadened by books and movies—and by the art of Ken Marschall.

Acknowledgments

A year or two after I began accepting commissions to do *Titanic* paintings, my mother said to me thoughtfully, "You know, honey, you can't paint *Titanic*s your whole life. You're going to have to get a real job."

I always felt my *Titanic* art was adding up to something, but I never seriously thought I'd see the day that a book like this, much less one so lavish and flattering, would be on bookshelves. It is the culmination of a thirty-year journey of research, discovery, hard work, and a bit of eyestrain, nurtured and inspired by a host of helpful and influential people who deserve acknowledgment here.

My heartfelt thanks, first, to Walter Lord. Without his early encouragement, guidance, and introductions to other *Titanic* students and historians—as well as his referrals for those first *Titanic* commissions—my life would likely have taken a greatly different course. Reading his classic *A Night to Remember* was a watershed experience for me. His kindness, patience, and willingness to share both his vast knowledge and his picture collection with me will always be remembered.

Robert Ballard has been a champion of my work since he saw my *Time* cover. Clearly, few of my underwater paintings would have been possible without the access he provided to his wreck photography. Cathy Offinger deserves special mention for her always friendly help in facilitating that access. Accompanying Ballard on two expeditions and seeing the *Lusitania* and the *Britannic* with my own eyes were profound experiences for which I will always be grateful.

Kudos to the skilled team at Madison Press, especially Hugh Brewster and Mireille Majoor. Their patience with my perfectionism, which has held up many a schedule, deserves special applause. Madison's award-winning books, made so elegant by designer Gordon Sibley, have given my art a worldwide audience on a scale I could not have imagined and have led to many other projects, the most stellar example being James Cameron's motion picture. Their impressive *Titanic: An Illustrated History* gave me instant credibility with Cameron and was my ticket to an unforgettable movie-making adventure. And working on the film's sets, in turn, increased my knowledge of the ship.

Rick Archbold has taken a series of phone interviews with me, held in fits and starts because of our hectic schedules, and expertly woven them into a very readable text that is quite on the mark. He has an uncanny way of getting to the core, of sensing what I am about. I think he knows me better than I know myself.

When I told James Cameron about this book and asked if he might be interested in penning a foreword, his response was so quick it cut me off in mid-sentence. Coming from an accomplished artist in his own right, his words mean that much more to me. I am tremendously honored.

My sincere gratitude to Eric Sauder, a loyal compatriot who has given me so much invaluable support over the

years. When life had drawn me into the film industry, his knowledge of the great liners and enthusiasm for my art rekindled a desire to paint ships and inspired me to higher goals. We've enjoyed many memorable research adventures and exciting discoveries, and I've learned so much from him. He has introduced me to many *Lusitania* survivors, and his familiarity with every detail of that ship made those paintings possible.

I cannot offer enough thanks to Don Lynch, valued friend, author of *Titanic: An Illustrated History*, and wizard on the comings and goings of the *Titanic*'s passengers and crew. The information he has between those ears is simply phenomenal. We've shared many journeys and fascinating visits with *Titanic* survivors, and he is always there with a quick response to a historical question.

And I will forever remember fondly those survivors I knew who, through sharing their detailed personal memories and first-hand impressions of the *Titanic*, greatly expanded my understanding of the voyage and the disaster. Particular among them were Ruth Blanchard, Frank Goldsmith, Eva Hart, and Edwina Troutt MacKenzie.

Several people were especially influential in my art education: As a child, science fiction artist Chesley Bonestell was my idol. High school art instructor Rollie Younger's mantra "Observation!" has always stuck with me. Later, my heros were Carl Evers, well-known maritime illustrator whose mastery of painting the sea has no peer, and Albert Whitlock, famed matte artist, whose magical transformations on celluloid taught me so much about light, color, and atmosphere. Gordon Legg, gentle artist and animator at Graphic Films, coached me in the use of the airbrush and imparted many more fine points in the art of photo-realistic painting.

My thanks to Ed and Karen Kamuda and the members of the Titanic Historical Society, Inc., for their longtime interest in my artwork; to Father Roberto Pirrone, cutaway-model builder extraordinaire with the patience of a saint, from whom I've learned much about the *Titanic*'s structure and appearance; to Bill Sauder, who always has a ready answer to a nautical engineering question; and to Bruce Block, for seeing that I was hired at Graphic Films (which provided several years of fascinating art education), for his procurement of so many matte painting jobs, and for his excellent counsel.

Much gratitude to my parents and family for their understanding and support, and for not thinking I was too crazy for painting *Titanic*s all these years—and to the many others who provided generous direction, encouragement, or assistance along the way, particularly (alphabetically) Chris Bragdon, Barrie Davis, Roland Hauser, Allen Hubbard, David Hutchinson, Dennis Kromm, Ray Lepien, Simon Mills, Tom Nicolai, John Shaum, and Terry Wade.

I would like to recognize the following people, who, as of this writing, are known to have in their collections artwork seen in this volume and who are not specified in the text: Ed Kamuda (pages 4-5, 44, 58-59, 135, 138), Dennis Kromm (6-7), Phyllis Nelson (22, lower left), Charles Marschall (30, lower left), Dennis Faenza (56-57), Allen Hubbard (60-61), David Felstein (63), Stanley Lehrer (73), Don Lynch (78-79), Michael Kohel (82-83), Charles Heebner (90-91), Eric Sauder (106-107, 130-131, 140-141, 143, 144, 146-148, 150-153), Robert Ballard (109, 116), Joe Sauder (124, bottom), Madison Press Books (126-127), Bill Young (134), Simon Mills (137), Tom Nicolai (149), and Mr. and Mrs. Howard Davis (154-155).

Finally, I am especially grateful for Rick Parks, gifted artist and lifelong friend, whose extraordinary talent was my first—and greatest—inspiration and who always challenged me to do better. "Remember—add variety," he would say, looking at my early painted seas or skies. I miss him terribly, and I only wish he could have seen what all this has come to.

—*Ken Marschall*

Acknowledgments *continued*

Having known Ken Marschall since we first collaborated on *The Discovery of the Titanic* by Robert D. Ballard, published in 1987, I wasn't surprised to discover that Ken has an amazing memory for the details of his past and is eloquently thoughtful about the connections between his life and work. Researching the text for *Ken Marschall's Art of Titanic* also provided an opportunity to make or renew the acquaintance of a number of important people in Ken's life who consented to be interviewed, including his mother, Phyllis Nelson, and his father, Charles Marschall. I'd like to thank them here, along with the others who made important contributions to the text: Bruce Block, Chris Bragdon, Hugh Brewster, Dennis Kromm, Don Lynch,

and Eric Sauder. As always, Ed and Karen Kamuda of the Titanic Historical Society provided ready support.

Thanks also to the team at Madison Press in an unusually stressful time: our skilful and valiant editor Mireille Majoor; copy editor supreme Kathryn Dean; administrative maestro Susan Aihoshi; permissions director Brian Soye; production co-ordinators Donna Chong and Sandra Hall; cheerful and adept frontliner Tina Gaudino; and editorial director/*Titanic* maven Hugh Brewster.

Finally, a special note of thanks to the staff of the Second Cup on Molson Park Drive in Barrie, Ontario, who provided emergency internet access at a crucial moment.

— *Rick Archbold*

Photograph *and* Illustration Credits

Every effort has been made to correctly attribute all the material reproduced in this book. If any errors have occurred, we will be happy to correct them in future editions.

All paintings and drawings, unless otherwise designated, are by Ken Marschall.

All photographs and other materials, unless otherwise designated, are from the collection of Ken Marschall.

13: Courtesy 20th Century Fox
15: Courtesy 20th Century Fox
22: Photos collection of Phyllis Nelson
25: (bottom) Collection of Charles Marschall
34: (left) Artwork by James Cameron; (right, all) Courtesy Orion Pictures, Inc.
35: (top left) Courtesy Columbia Motion Pictures; (top right) Courtesy Columbia Motion Pictures; (bottom left) Courtesy Home Box Office

36: Collection of Eric Sauder
37: (top) Collection of Don Lynch
38: (top) Collection of Don Lynch
39: *Time*, August 11, 1986
41: (middle and bottom) Woods Hole Oceanographic Institution
44: (top and bottom) Courtesy 20th Century Fox
45: (right) Courtesy 20th Century Fox
46: (top and bottom left) Courtesy 20th Century Fox

Prints and posters of Ken Marschall's work are available from:
Trans-Atlantic Designs, Inc., *P.O. Box 539, Redondo Beach, CA 90277, U.S.A. e-mail: TADesigns@aol.com*

Other Books Featuring *the* Paintings *of* Ken Marschall

The Discovery of the Bismarck, by Robert D. Ballard with Rick Archbold, with paintings by Ken Marschall, 1990 (Warner Books, U.S.; Viking, Canada)

The Discovery of the Titanic, by Robert D. Ballard, with paintings by Ken Marschall, 1987 (Warner Books, U.S.; Penguin, Canada; Weidenfeld & Nicolson, Australia)

Exploring the Lusitania, by Robert D. Ballard with Spencer Dunmore, paintings by Ken Marschall, 1995 (Warner Books, U.S.)

Hindenburg: An Illustrated History, by Rick Archbold, with paintings by Ken Marschall, 1994 (Warner Books, U.S.; Viking, Canada)

Lost Liners, by Robert D. Ballard and Rick Archbold, paintings by Ken Marschall, 1997 (Hyperion, U.S.; Little, Brown and Company, Canada; Allen & Unwin, Australia)

The Lost Ships of Guadalcanal, by Robert D. Ballard with Rick Archbold, underwater paintings by Ken Marschall, 1993 (Warner Books, U.S.; Viking, Canada; Allen & Unwin, Australia)

Titanic: An Illustrated History, by Don Lynch, paintings by Ken Marschall, 1992 (Hyperion, U.S.; Viking, Canada; Hodder & Stoughton, Australia)

Books *for* Children

The Disaster of the Hindenburg, by Shelley Tanaka, with paintings by Ken Marschall, 1993 (Scholastic, U.S. and Canada)

Exploring the Bismarck, by Robert D. Ballard, with paintings by Ken Marschall, 1991 (Scholastic, U.S.; Random House, Canada)

Exploring the Titanic, by Robert D. Ballard, paintings by Ken Marschall, 1988 (Scholastic, U.S.; Viking, Canada)

Ghost Liners, by Robert D. Ballard and Rick Archbold, paintings by Ken Marschall, 1998 (Little, Brown and Company, U.S.; Scholastic, Canada; Allen & Unwin, Australia)

Inside the Titanic, by Hugh Brewster, paintings by Ken Marschall, 1997 (Little, Brown and Company, U.S. and Canada; Allen & Unwin, Australia)

The Lost Wreck of the Isis, by Robert D. Ballard, with paintings by Ken Marschall, 1990 (Scholastic, U.S.; Random House, Canada)

On Board the Titanic, by Shelley Tanaka, paintings by Ken Marschall, 1996 (Hyperion, U.S.; Scholastic, Canada)

For more information about membership in the Titanic Historical Society, please write:
Titanic Historical Society, *P.O. Box 51053, Indian Orchard, Massachusetts, 01151-0053, U.S.A.*

DESIGN, TYPOGRAPHY AND
ART DIRECTION
Gordon Sibley Design Inc.

EDITORIAL DIRECTOR
Hugh Brewster

PROJECT EDITOR
Mireille Majoor

EDITORIAL ASSISTANCE
Susan Aihoshi

PRODUCTION DIRECTOR
Susan Barrable

PRODUCTION COORDINATOR
Donna Chong

COLOR SEPARATION
Colour Technologies

PRINTING AND BINDING
Friesens Corporation

Ken Marschall's Art of Titanic

*was produced by
Madison Press Books,
which is under the direction
of Albert E. Cummings.*